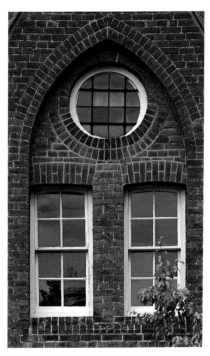

WILLIAM MORRIS &
RED HOUSE

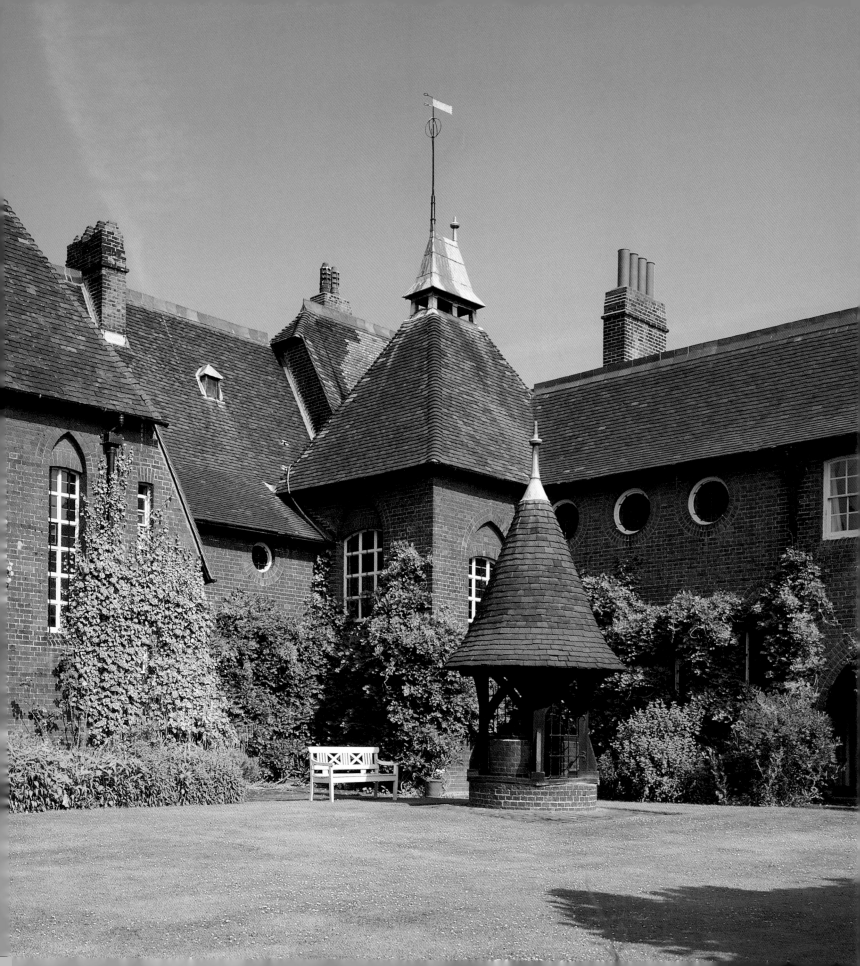

WILLIAM MORRIS &
RED HOUSE

Jan Marsh

NATIONAL TRUST BOOKS

This edition published in Great Britain by
National Trust Books 2005

An imprint of **Chrysalis** Books Group plc

Text copyright © Jan Marsh
Design and layout copyright © National Trust Books

ISBN 1 905400 01 2

A CIP catalogue record for this book is available from
the British Library.

Designed by Andrew Barron at thextension

10 9 8 7 6 5 4 3 2 1

This book can be ordered direct from the publisher.
Please contact the marketing department.
But try your bookshop first.

Contents

Chapter One	The First Attempt	6
Chapter Two	In the Beginning	10
Chapter Three	The House	18
Chapter Four	The Interior	34
Chapter Five	The Garden	54
Chapter Six	1860–61 Life in The Early Days	64
Chapter Seven	1862–65 Later Days at Red House	74
Chapter Eight	Morris and Friends After Red House	92
Chapter Nine	1866–1904 Red House After Morris	100
Chapter Ten	1905–1945 An Uncertain Future	116
Chapter Eleven	1946–2002 Private and Public Preservation	130
Chapter Twelve	Epilogue	148
	Endnotes	150
	Further Reading	154
	Acknowledgements	154
	Places to Visit	155
	Picture Credits	156
	Index	157

THE HOME OF WILLIAM MORRIS (ARTIST AND POET).

Red House
UPTON, BEXLEY HEATH
KENT

Three-quarters of a mile Bexley Heath and 1½ miles Bexley Stations, Electrified Train Service to Town in 30 minutes, 10 miles by road.

THE PICTURESQUE FINELY PROPORTIONED
Unique Freehold Red Brick Residence

In a quiet convenient position set in an orchard garden and containing:
Lofty Entrance Hall, Cloak Room, Three Handsome Reception Rooms, Tiled Loggia,
Six Bed Rooms, Two Bath Rooms, Complete Offices.
Co.'s *Electric Light, Gas and Water. Central Heating. Telephone. Independent Hot Water
System. Main Drainage.*

MANY EXAMPLES OF THE WORK OF MORRIS AND HIS FRIENDS ROSSETTI,
SIR EDWARD AND LADY BURNE-JONES.
LARGE GARAGE. STABLING.

Matured Old-World Gardens
well kept lawns, fine old trees and shrubs, kitchen, flower and rose gardens, 100 yards long
grass alley, in all about

2 Acres
VACANT POSSESSION. 5 minutes Bexley Heath Golf Club.

HARRODS

Have received instructions to offer the above for Sale by Auction (unless previously sold)
AT HARRODS' ESTATE SALE ROOMS, S.W.1
On TUESDAY, 30th OCTOBER, 1934
At 2.30 p.m.

Solicitors : Messrs. MURRAY, HUTCHINS & CO., 11, Birchin Lane, London, E.C.3.
Auction Particulars, together with Conditions of Sale and Order to View may be obtained
from the Auctioneers, HARRODS, LTD.,
62–64, BROMPTON ROAD, LONDON, S.W.1.

Surrey Office, West Byfleet.

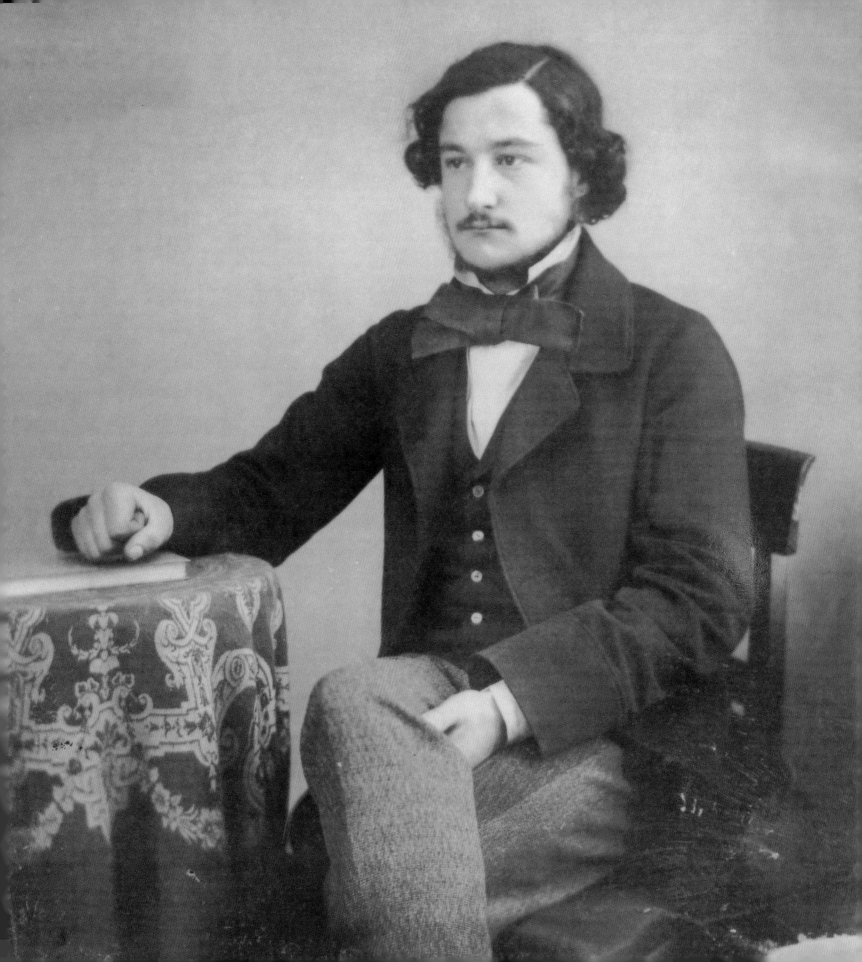

IS IT ALTOGETHER TOO LATE TO DO SOMETHING TO SAVE ... WHATEVER ELSE OF BEAUTIFUL OR HISTORICAL IS STILL LEFT US ON THE SITES OF THE ANCIENT BUILDINGS WE WERE ONCE SO FAMOUS FOR? WOULD IT NOT BE OF SOME USE ONCE FOR ALL, AND WITH THE LEAST DELAY POSSIBLE, TO SET ON FOOT AN ASSOCIATION FOR THE PURPOSE OF WATCHING OVER AND PROTECTING THOSE RELICS, WHICH, SCANTY AS THEY ARE NOW BECOME, ARE STILL WONDERFUL TREASURES ...

William Morris, to the Editor of *The Athenaeum*, March 1877

The centenary of William Morris' birth fell in 1934. Although no longer at the forefront of modern design, the company he had founded was still in business and his socialist and internationalist ideals had renewed relevance in the political climate of the inter-war years. The centenary prompted memories, exhibitions and events. Early in 1935, when his first property, Red House in Bexleyheath, was up for sale, an Appeal was launched to buy the house and preserve it as a memorial to his life and achievements.

The immediate surroundings were almost entirely built up. Houses with large gardens were in demand for development. English law provided no way to protect a building which, however significant its first owner, was less than a hundred years old. A group of people concerned with the fates of historic buildings came together to see if Red House could be 'saved'. Behind the scenes, the National Trust – itself only in existence for forty years – offered to hold and maintain the property, once it was acquired for the public. At a meeting in the house, the Appeal for funds was launched. The vendor agreed to accept £3100. 'We realise that at the present time the public are interested in other and very different movements in architecture and industrial art,' the Appeal began, 'We are however confident that, for the sake of its association with the work

LEFT The young William Morris (1834–96) in 1857 aged 23, by an unknown photographer.

RIGHT Detail from the Daisy wallpaper (1864) at Cragside in Northumberland. Developed from an illumination in a fifteenth-century manuscript of Froissart's *Chronicles* (see page 50), the paper lines the walls on the Gilknockie staircase.

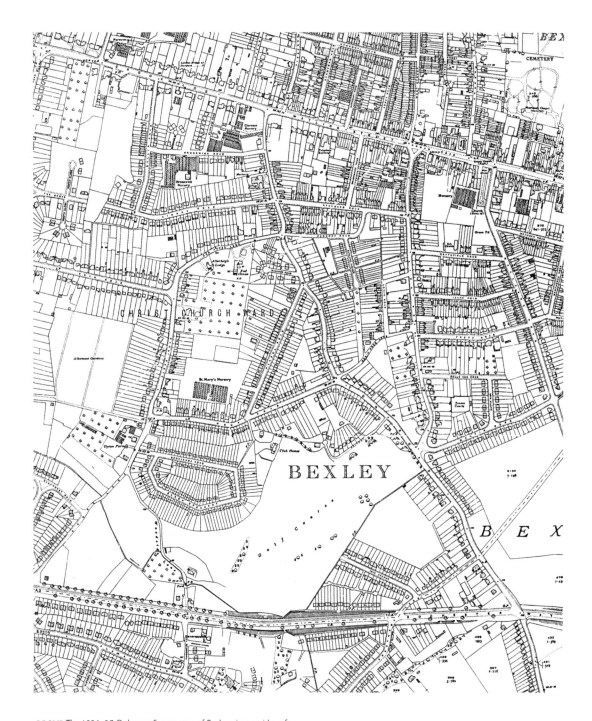

ABOVE The 1936–37 Ordnance Survey map of Bexley gives an idea of
how built-up the surrounding area had become since Red House was
built in 1859.

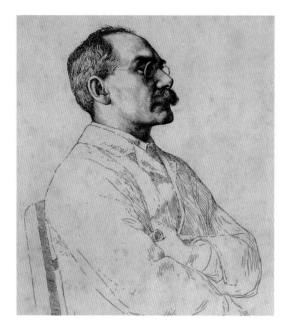 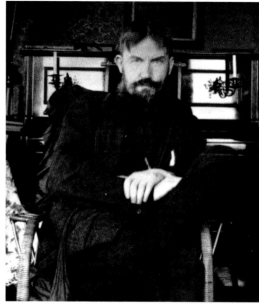

of William Morris and his group, the importance of this house will be appreciated in the future, and its loss in this regard will be recognised as irreparable.'[1]

Eminent supporters included architects Sir Edwin Lutyens, Sir Giles Gilbert Scott, Sir Herbert Baker and Sir Raymond Unwin, together with famous writers Bernard Shaw, H.G.Wells, Rudyard Kipling, John Masefield and former Prime Minister Ramsay Macdonald. The only female signatory was May Morris, who had been born in Red House seventy-three years before. Brochures were produced and donations solicited. Ideas were aired, new supporters came forward and funds rose. But by December, only £550 had been pledged. The vendor withdrew his offer and sold the house. The committee returned all donations.

Two years later, Red House was on the market again. 'That beautiful house is fated to have bad luck, it seems!', wrote May Morris, lamenting that interest in such matters was not high 'in these days of world chaos'.[2] Ten months later, May died at her home in Oxfordshire, while 'world chaos' worsened inexorably. In 1939, Britain declared war on Nazi Germany. There were more important matters than the future of Red House. It would be over sixty years before any rescue scheme was realised.

LEFT Rudyard Kipling (1865–1936) and **RIGHT** George Bernard Shaw (1856-1950), both at the height of their fame, lent their support to the Appeal to save Red House.

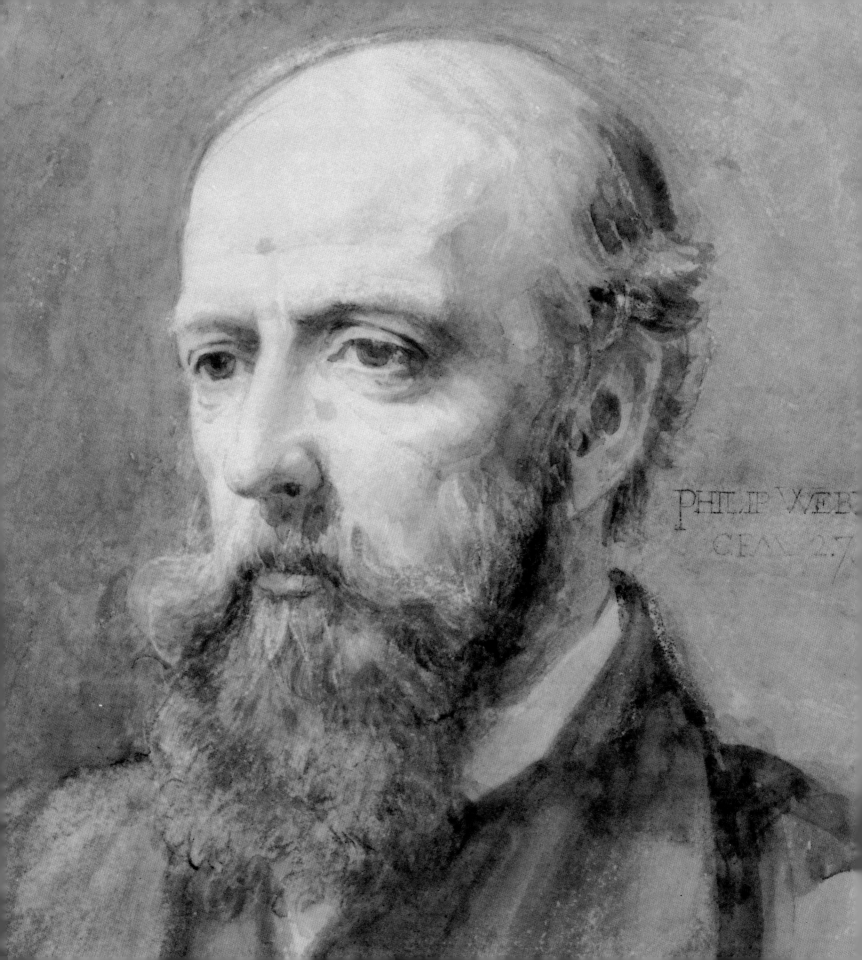

PHILIP WEB
ÆTA 27

IDO NOT HOPE TO BE GREAT AT ALL IN ANYTHING, BUT PERHAPS I MAY REASONABLY HOPE TO BE HAPPY IN MY WORK, AND SOMETIMES WHEN I AM IDLE AND DOING NOTHING, PLEASANT VISIONS GO PAST ME OF THE THINGS THAT MAY BE ...

William Morris, to his mother, November 1855

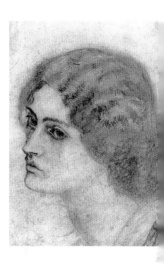

Born in Walthamstow in 1834, then an Essex village on the edge of Epping Forest some nine miles outside London, William Morris was the son of a City broker. His father had struck lucky with lucrative mining shares not long before his death in 1847, so at the age of twenty-one, William inherited an annual income of around £700. He had been brought up with a strong work ethic; it would not do to be 'lazy, aimless, useless ... all my life long.' [3] His first ambitions were idealistic: to work for social reform through church ministry, which chimed with his boyhood passion for things romantic and medieval. But at Oxford, religion gave way to music, art and literature. He became friends with fellow student Edward Burne-Jones, from Birmingham, and began to write poems and stories. Then, after a summer vacation touring northern France with Burne-Jones – nine cathedrals and twenty-four splendid churches – Morris told his mother he was going to train as an architect: 'It will be rather grievous to my pride and self-will to have to do just as I am told for three long years, but good for it too, I think.' [4]

In January 1856, he joined the office of George Edmund Street, architect for the diocese of Oxford. In the practice, his supervisor was Street's chief assistant Philip Webb and the two soon became lifelong friends. The same year, through Burne-Jones, Morris met painter Dante Gabriel Rossetti and other members of the Pre-Raphaelite Brotherhood, and was persuaded that he too should become an artist: 'Rossetti says I ought to paint, he says I shall be able...,' he wrote, 'so I am going to try, not giving up the architecture, but trying if possible to get six hours a day for drawing besides office work.' [5] Unsurprisingly, it was not possible. By this time Street's practice had moved to London and in the autumn, Morris gave up architecture for painting.

LEFT Philip Webb (1831–1915) by Charles Fairfax Murray (1849–1919). Murray acted as studio assistant to Edward Burne-Jones and Dante Gabriel Rossetti (1833–98), friend and assistant to Morris and copyist for John Ruskin (1819–1900). There are few portraits or photos of Webb, a self-effacing and modest man.

ABOVE Jane Burden (1839–1914) as drawn by Morris in 1858 before they were married. This small portrait was folded and kept in Morris' notebook or pocket.

He spent his time on drawing and illumination, on poems prompted by Rossetti's intense watercolour depictions of chivalric scenes, and on decorating archaic-style furniture for the rooms he shared with Burne-Jones in Red Lion Square, Holborn.

It was a time of vigorous and varied but rather unfocused activity. In Oxford in midsummer 1857, Morris and Rossetti met Benjamin Woodward, architect of the University Museum and the Union Society. Rossetti at once offered to lead a team of artists to decorate the debating chamber (now the Library) with murals depicting the tales of King Arthur and the Knights of the Round Table. On this project, undertaken with great high spirits and small skill, Morris was first to start and first to finish. Then he began a decorative pattern for the entire roof.

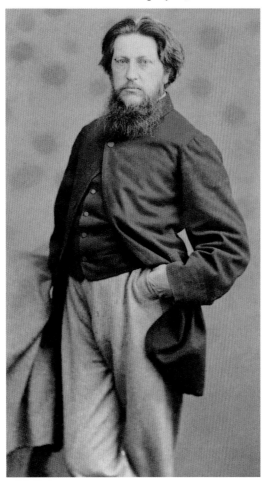

In October, Rossetti and Burne-Jones went to a touring theatre company performance, and in the audience spotted a local girl named Jane Burden, whom they persuaded to sit as an artist's model. Rossetti cast her as Arthur's adulterous Queen Guenevere. When Rossetti left Oxford to join his fiancée Elizabeth Siddal, Jane continued to pose, this time for Morris, as *La Belle Iseult*. By March 1858, when Morris' first book, *The Defence of Guenevere and Other Poems* was published, he was engaged to Miss Burden. The wedding was fixed for April the following year. Some of his friends were appalled: 'To think of his marrying her is insane,' joked the poet Algernon Swinburne; 'to kiss her feet is the utmost men should dream of doing.' [6]

Though discouraged by his inability to draw human figures, Morris worked

ABOVE Ford Madox Brown (1821–93), a fellow painter and close friend of Morris. He and his wife Emma were frequent visitors to Red House.

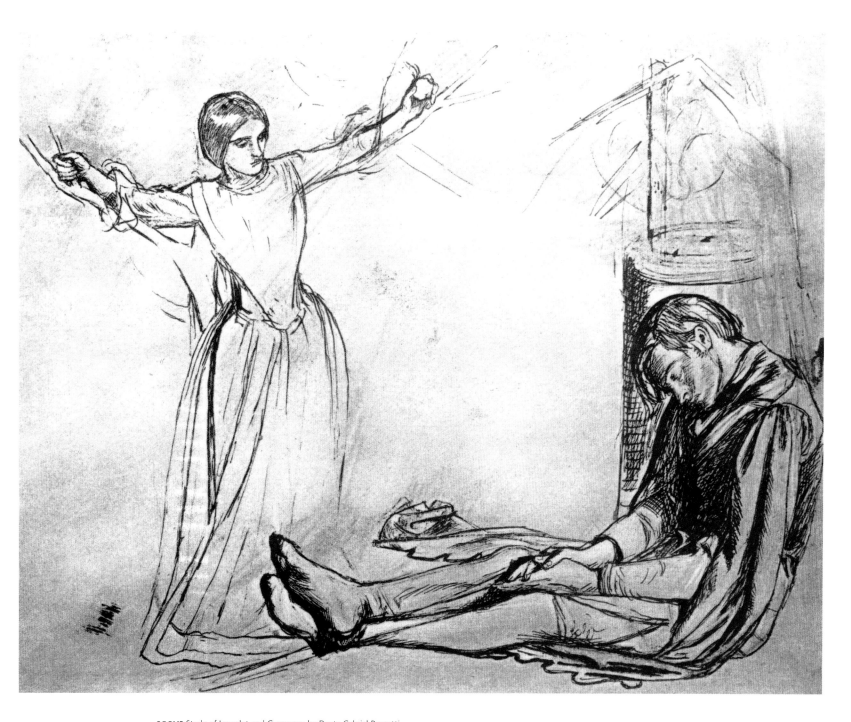

ABOVE Study of Lancelot and Guenevere by Dante Gabriel Rossetti
for the Oxford Union murals. The sleeping Lancelot is drawn from
Burne-Jones, while Guenevere has the features of Elizabeth Siddal.

intermittently on two paintings, one of Iseult in her bedchamber with Tristram's dog curled up on the bed, and the other of the dog recognising a disguised Tristram. In August, he took another trip to France, this time with Charles Faulkner, a mathematician and Oxford friend, and Philip Webb. Morris and Webb shared a lifelong pleasure in exploring old buildings and, *en route*, they conceived the house Morris and Jane would inhabit after their marriage.

Morris was short, robust and bushy-haired. He had a good appetite for wine and food, and a consequent tendency to stoutness that led to his nickname 'Topsy' (after the fictional character in *Uncle Tom's Cabin* who thought she 'just growed'). Temperamentally, he was self-reliant and good-natured, with a tendency to violent rages that his friends provoked, knowing the explosions would be over as swiftly as they began. 'He is plain spoken and emphatic, often boisterously,' observed a later acquaintance, but 'without an atom of irritating matter.'[7]

Tall, slender, dark-haired and reserved, Jane Burden was eighteen at the time of their engagement. By her own admission, she was not in love with Morris, but she was young, ignorant and very poor. Her father was a stableman and her mother a laundress; Jane, older brother and younger sister lived in a backyard hovel in the centre of Oxford. Overawed by Morris' admiration, she was dazzled by the proposal, which meant a life of comfort for herself and her family. Inspired by the chivalrous tales he was reading and writing, Morris saw no class obstacle to marriage, despite his mother's evident dismay.

During 1858, Jane was educated to become a rich gentleman's wife. Hitherto, she had belonged to the 'servant class'; henceforth, she would employ and instruct household servants. She became an avid reader and lover of music – learning to play the piano – and also a skilled needlewoman, who would become renowned for her embroidery. Her first trip abroad, indeed her first journey beyond Oxford, was on honeymoon to Belgium and Paris in May 1859. On their return, the young couple took lodgings near Holborn, and Jane was introduced to society. Quiet and shy in company, she was called 'Janey' by her husband and the close circle of his friends, who quickly became hers too: Gabriel Rossetti and Lizzie Siddal, Edward and his wife Georgiana Burne-Jones (familiarly known as Ned and Georgie), Ford and Emma Madox Brown, Algernon Swinburne (soon a loyal admirer), and particularly Philip Webb, who had also grown up in Oxford. By midsummer the plans for the new house were complete.

RIGHT Dante Gabriel Rossetti (1828–82) in a portrait photograph (1863) by Lewis Carroll (1832–98), creator of *Alice in Wonderland*.

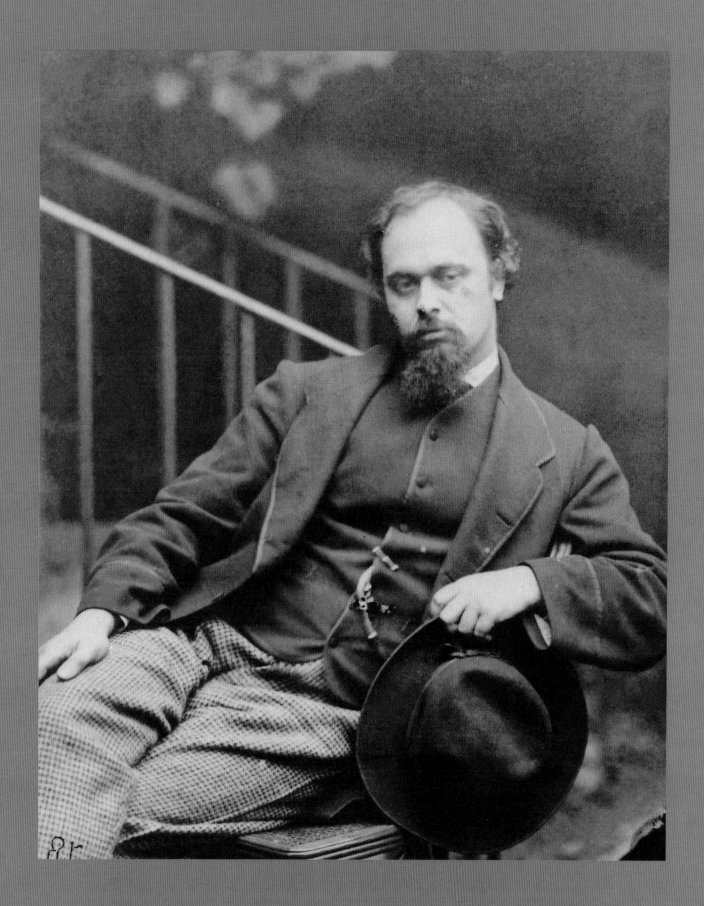

Philip Webb was three years older than Morris, the son of a physician and the second of eleven children. Trained by architect John Billing in Reading, he had joined G.E. Street's Oxford office in 1854 and moved with it to London in autumn 1856. Through Morris he met Rossetti and the rest of the Pre-Raphaelite circle, in which he became a valued and always self-effacing figure, well liked by male and female friends. His serious demeanour was leavened by a ready wit that made him a popular guest. Aiming 'to consume the least possible, yet without impoverishment', his taste was for simplicity and quality. [8] He refused to create a large practice, preferring to design everything himself, knowing this meant a modest income, which was insufficient in Victorian eyes to keep a wife and family. Disliking attention, he also declined to publish or publicise his work. Perhaps the key figure in the creation of Red House, Webb is the most elusive, but his architectural commissions and correspondence testify to personal integrity and long, faithful friendships. He refused to take a fee for designing Morris' house; this was a commission between friends and an opportunity to display his skill. As the plans proceeded, Webb remained in Street's office until building began and then set up his own practice in Great Ormond Street, close to the Morrises. Before Red House was complete, he received a second commission for an artist's house (Sandroyd, now Benfleet Hall near Cobham in Surrey), from Pre-Raphaelite painter and friend John Roddam Spencer Stanhope.

The Bermondsey firm of William Kent was contracted to build the house. After a difficult start, Webb had to issue a stiff letter complaining that work was proceeding 'in a most irregular and unsatisfactory manner'. [9] Morris and Jane moved into neighbouring Aberleigh Lodge, so that Morris could effectively act as site manager. Incapable of idleness, he was doubtless also planning the interior decoration and preparing the garden. Around the beginning of April 1860, Janey became pregnant: Red House would be a family home.

Towards the end of his life, Webb declared that no architect should design a house before he was forty. But had he followed this precept, not only would Red House have taken a wholly different form, but Webb's career would have followed a different trajectory. As it was, his ideas and Morris' money combined at a unique moment to create a building that commands historical attention.

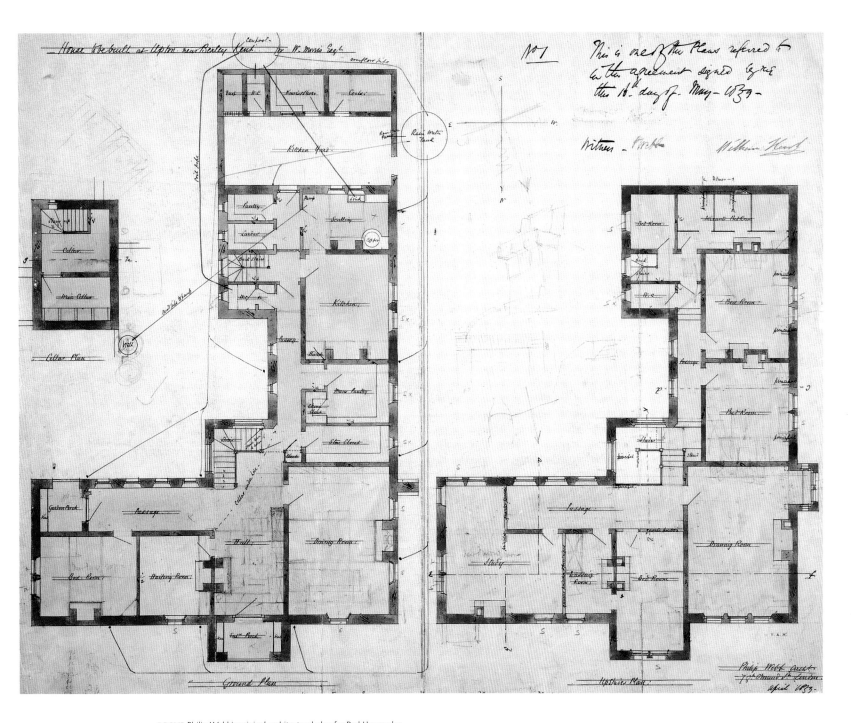

ABOVE Philip Webb's original architectural plan for Red House also acted as the contract between architect and future owner with their signatures in the top right-hand corner.

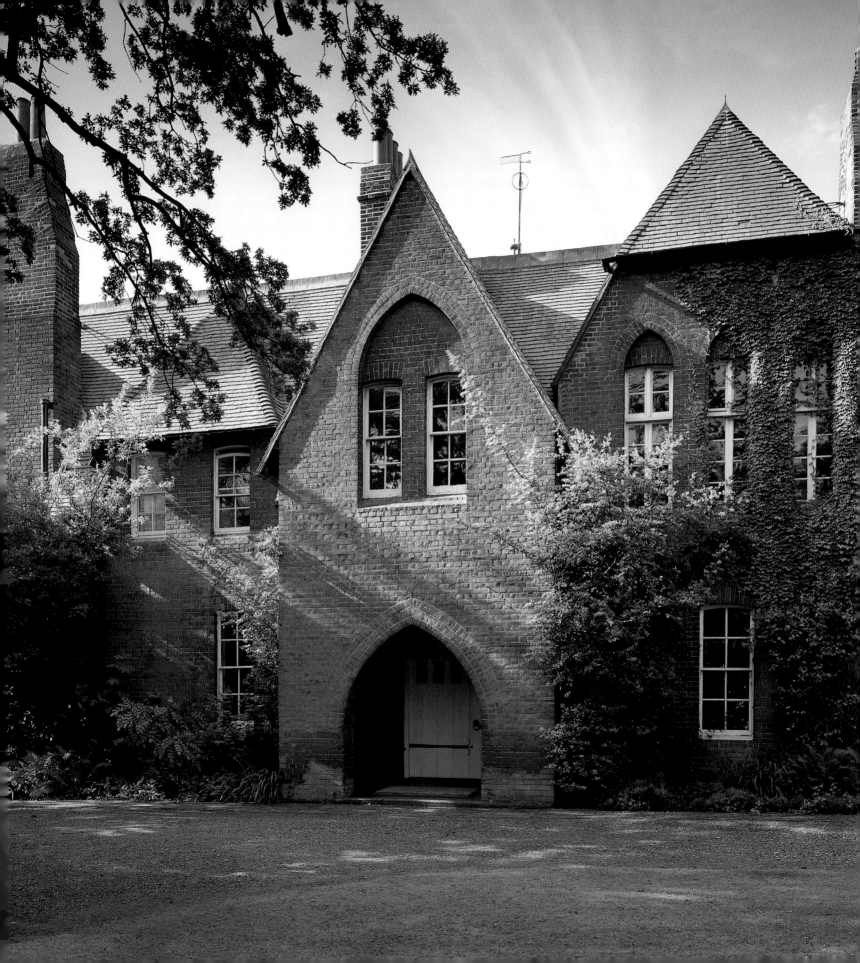

Chapter 3 The House

I GOT A FRIEND [PHILIP WEBB] TO BUILD ME A HOUSE VERY MEDIEVAL IN SPIRIT IN WHICH I LIVED FOR 5 YEARS, AND SET MYSELF TO DECORATING IT; WE FOUND, I AND MY FRIEND THE ARCHITECT ESPECIALLY, THAT ALL THE MINOR ARTS WERE IN A STATE OF COMPLETE DEGRADATION, ESPECIALLY IN ENGLAND ...

William Morris, to Andreas Scheu, September 1883

The site chosen by Morris and Webb, after lengthy and wide-ranging independent searches, lay at Upton in northern Kent, amidst market gardens and orchards, looking south into the gentle valley of the river Cray. It is not known how the plot was found, but the well-wooded and well-drained area pleased both architect and client. But the idyllic picture painted by Morris' biographers of a location close in spirit to an 'earthly paradise', amid fields and flowering fruit trees, is somewhat misleading. Though pleasant, the district was hardly heavenly. If Rossetti described 'the towers of Topsy' as 'more a poem than a house', he also chuckled to learn that the immediate location was known as 'Hog's Hole', which brought the hyperbole down to earth. [10] In some ways it is hard to appreciate the compelling attractions of Upton, which in the 1850s was a hamlet in the large parish of Bexley, lying between the riverside village and the upland known as Bexley Heath. The village had picturesque water meadows, an ancient church, quaint cottages and a flint-and-brick Tudor mansion. In contrast, the uncultivated heath was pitted by sand and gravel diggings and traversed by Watling Street, the Roman road between London, Canterbury and Dover which had been the haunt of footpads in the eighteenth century.

For Morris, with his antiquarian passions, Upton lay between the medieval ruins of Lesnes Abbey to the north of the heath and Hall Place, the Tudor mansion in Bexley which, he wrote after re-visiting many years later, 'made the stomach in me turn round with desire of an old house.' [11] Closer at hand, though less immediately attractive to a medievalist's eyes, lay the large Danson estate, with lake, classical temple and Palladian mansion designed by Robert Taylor and

LEFT North front and main entrance to Red House in the early morning sunshine.

RIGHT Three bull's-eye windows on the first floor of Red House overlooking the well and well court.

decorated by William Chambers, Charles Pavillon and others. But even before the site for Red House was chosen in 1859, the surroundings were starting to be developed. 'The land between Deptford and Dartford was poor and ugly,' declared social commentator William Cobbett in the 1820s, 'to which ugliness there has been made … a considerable addition by … the sticking up of some shabby-genteel houses, surrounded with dead fences and things called gardens.' Together, bricks and sticks proclaimed 'Here dwell vanity and poverty.' [12]

By 1830, Bexley 'New Town' was growing in popularity and population. In 1841 it had 2115 inhabitants, which led the vicar of Bexley to instigate the building of a new chapel close to Watling Street for these parishioners.[13] Soon after, the railways arrived in the area: one line running through Bexley via Lewisham and another further north, through Woolwich. The fortunes of nearby Danson Park mirrored the changing economic times: in 1862, it was purchased as a country residence by Alfred Bean, partner in a railway engineering business. Lying just east of Danson Park, Upton itself was unremarkable. Its name presumably denotes an 'upper' or higher settlement within Bexley parish. In 1861 it mustered a total of ninety-seven

ABOVE *Bexley Heath* by John Tennant (1841). Although this landscape is a romantic representation of reality, Bexley Heath was wild open countryside before the railways brought development to the area.

ABOVE The main road, Watling Street, running through
Bexleyheath (as it had become) in 1889 (top) and 1900 (below)
give some idea of the relative open space of the surroundings
despite being a built-up residential district.

dwellings, inhabited by farmworkers, gardeners, carriers, an alehouse-keeper at the Royal Oak and farmer Samuel Woods with thirty acres. At Providence Row – probably the Hog's Hole cottages adjoining the Red House site – lived haydealer Alfred Mace and farmworkers John Follows, Stephen Green and Emmanuel Gills, with their families. On the west side of Red House site stood Aberleigh Lodge, a new villa erected not long before Red House; both plots were carved from the same triangular orchard. Aberleigh had a projecting porch flanked by square window bays, and its back extended towards Red House, albeit screened by a large garden filled with fruit trees.

The Red House plot occupied about an acre of land. Site and building are said to have cost £4000, which represented a large sum both historically and personally, for this was over five times Morris' annual income from his father's legacy. This large cost may explain the relatively constricted site. Morris was rich, but he could not afford a country estate. Rather than a unique house in rural seclusion, Red House looks like an early example of suburban development, a detached villa, heralding the 'march of bricks and mortar' over the fields of Bexley, as London's population sprawled ever-outwards. The 1862 Ordnance Survey map shows other new buildings to the south-east, with paired villas arranged on rectangular plots.

The reputation of Red House is such that first-time visitors may expect to see something with the capacity to amaze in the manner of a prodigy house, *cottage ornée* or even a fairytale dwelling. Rather, Red House is a plain brick house that, to be frank, is neither curious nor welcoming. It might, indeed, house a miser or maybe a small religious community. First, there is the high, excluding wall and gate; no glimpse of Red House for passers-by. Once through the gate, the approach still deters. The elevation is severe: is this the front door, or is there another entrance round the side? The porch is low, dark, uninviting; the windows plain and uninformative.

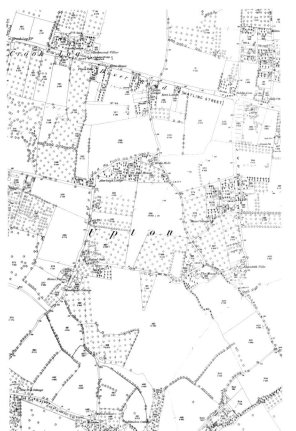

ABOVE The Ordnance Survey map of 1862 shows that Morris had chosen a site amidst orchards, fields and rolling countryside. The development that followed completely changed the character of the former heath.

Red House is in no sense a 'show house', presenting a best feature for public admiration. Walking round outside, it remains private. To the right, along the west elevation, are pleasant brick paths and lawns. But no doors open onto the garden, there are no wide windows or sunny terrace: only an enclosed kitchen yard with outhouses beyond. Further round to the east is the well-garden, which feels more hospitable. But the windows are all high, there are no interesting rooms to look into and the porch entrance is half-hidden. From this viewpoint, Red House looks secretive and very tall, with steeply pitched roofs, hipped gables, double ridges, a squat pyramidal stair-tower and conical well-head like a witch's hat.

Returning to the front, the visitor has no notion of how the interior will look. The front door opens into a wide entrance hall with red-

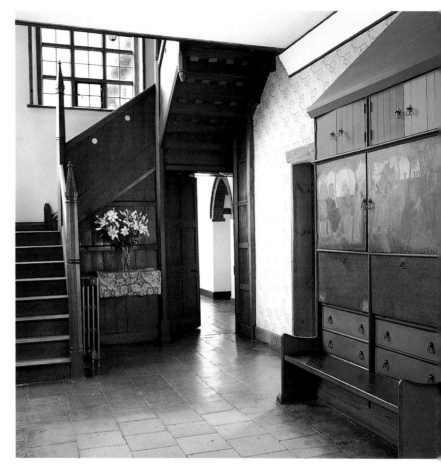

flagged floor and unpainted woodwork. It looks plain, robust, generously lit from all directions and full of promise. But there are no interior views, no sense of hierarchy, no indication of which rooms are where. The visitor stands uncertainly. Only the solid staircase with its extended newel posts draws the eye. Red House still refuses to display itself. It is worth standing in the doorway to absorb the atmosphere and allow the house to take time to reveal itself. To sweep in and round, like tourists or prospective buyers, is to miss the particular quality of Red House and misunderstand its nature.

As with the exterior, the initial impression is of plainness: there are no cornices, no mouldings, no ornamentation, only plain windows, architraves, skirting-boards and banister

rail. Neither a rustic nor stylish simplicity, this is a frank sturdiness that would suit a village school. Yet at the same time, it is not mere functionality. The absence of conventional decoration is countered by variety of detailing. The exterior has recessed relieving arches, sloping sills and windows of all shapes, including the lancets of the oriel on its slim brick pillar. For some contemporaries, the mix of pointed arches with sash-windows was striking; for others, an example of practicality above quaintness.

Inside, some roof beams and trusses are exposed, as are some brick arches, forming external features brought indoors, and asymmetrically positioned. The fireplaces reinforce the idiosyncrasy, marking each principal room with more exposed red brickwork in a series of scaled-down medieval shapes including a tall hood which, despite their unconventionality, do not dominate. There are no mantelpieces. The grates have not survived, but Webb took especial care of all ironwork fittings; one wide shallow grate with turned posts installed in Morris' later houses may in fact be original to Red House.

All such features contribute to the unified feeling, even though little is either as expected or

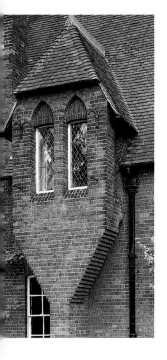 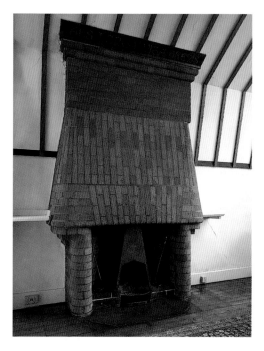

ABOVE LEFT The oriel window is one of the unique features of Philip Webb's design. The diamond panes are a later insertion.

ABOVE CENTRE The deep-set entrance porch showing the ironwork hinges on the front door.

ABOVE RIGHT The Webb-designed brick fireplace in the drawing room.

as regular as it might be. The irregularities are not fussy or whimsical, but blunt and quirky by turns. The whole is a creation of severe structure and original elements with satisfying proportions, both forthright and playful, held within an austere beauty.

Why is Red House like this? Like others influenced by the architect Augustus Pugin who advocated a pointed Gothic style yoked to personal notions of moral reform, Webb backed away from decorated stonework towards spatial values and plainer styles. His mentors George Edmund Street, George Frederick Bodley and William Butterfield all preferred stark, big-boned churches rather than the English Decorated style favoured by other Gothic-influenced architects. On their trip to France in 1858 with Morris and Faulkner, Webb had rhapsodised on the 'gaunt amplitude' of the church at Mantes near Paris, likening it to a great Ark. [14]

Other conversations that took place on this trip can be imagined ... Where was Morris to live after his wedding? ... Not in a vertical London townhouse, nor in a stuccoed suburban villa ... Webb must design an alternative: commodious but not grand, handsome but not flashy, 'medieval in spirit' but modern in function ... No pastiche ... There must be family rooms, guest rooms, servants' quarters and a studio ... It would be an artist's house and a gentleman's residence. On the back of a map in his guidebook, Webb sketched a staircase tower as if already thinking how to articulate a house with two wings.

Victorian Gothic at this date was largely devoted to church building, so there were few models for what Pugin called 'the smaller detached houses which the present state of society has generated'. [15] But no class of building was so in need of such ideas, according to George Gilbert Scott, for 'surely nothing was ever half so villainous as the villa buildings about London'. [16] Church architects had, nevertheless, designed rectories, schools and almshouses: some examples remain by Pugin, Butterfield and Street himself. Several were in unrendered brick, thanks to ideas about 'honesty' of materials. Some used polychrome to offset the brick, but all were relatively plain in style.

According to Sheila Kirk, Webb's most recent biographer, Red House is 'a well-controlled, beautifully composed and proportioned assemblage of varied parts', the first 'parsonage-manner' house of its time to be built without Gothic ornament and an 'unsurpassed masterpiece' of this type. Its elements were 'chiefly inspired' by Butterfield, whose work Webb

OVERLEAF The well court on the east side of the house with the service wing to the left, staircase tower in the centre and garden porch to the right. Morris' studio was above the porch and has windows on three aspects.

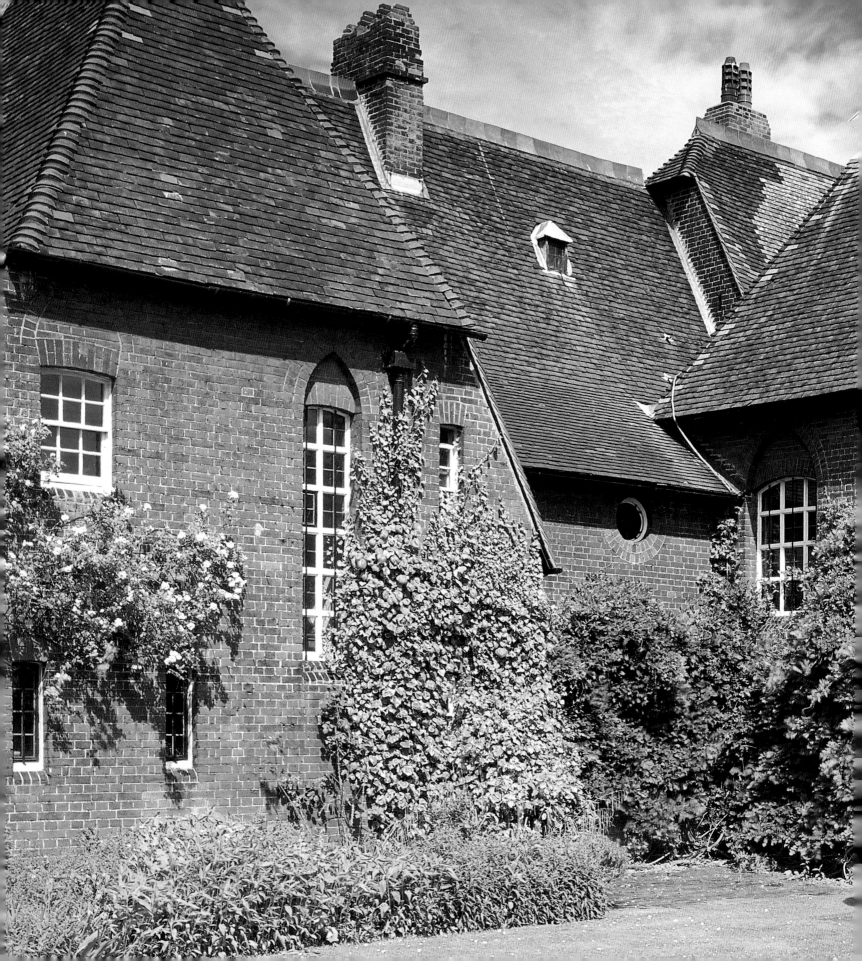

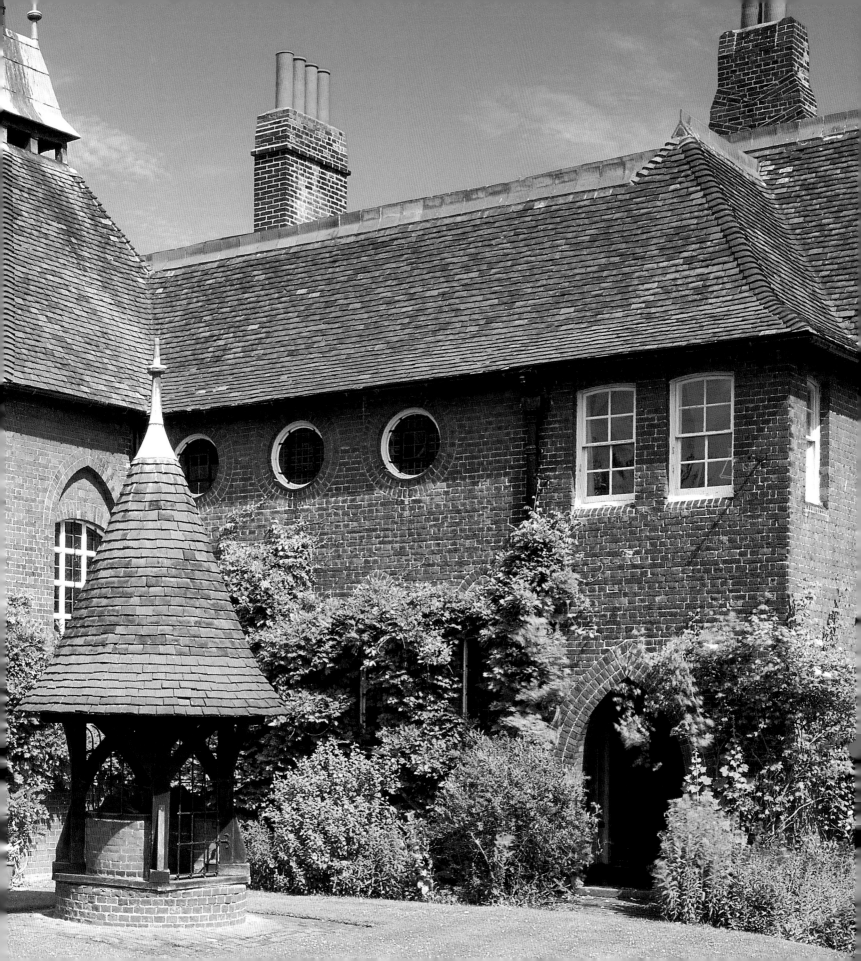

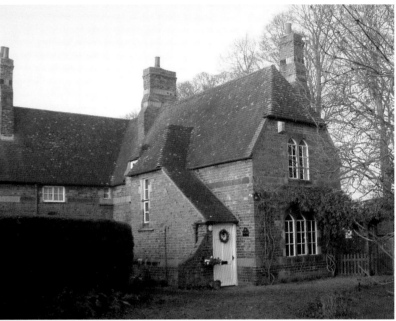

knew well. [17] One contemporary project was the ensemble of church and allied buildings at All Saints, Margaret Street in central London; here is seen an example of the recessed relieving arch also used at Red House. Another was Butterfield's new village at Great Baldersby in Yorkshire where, as Michael Hall observes, 'virtually all the motifs of Red House are present', including bold geometry and a 'punchy outline of hipped roofs and cat-slides'. [18]

Other influences came from Tudor mansions, brick-built barns and oast-houses in Kent and the Thames valley, while the pitched and conical roofs recall French *manoirs*. But Red House did and does not masquerade as an old house. In concept and in fact it was progressive and forward-looking, however 'medieval' Morris imagined its spirit. Moreover, despite the severity, Red House is covertly exuberant, with its excess of roofs and gables, its varied fenestration and its rising lines. Visually pulling the diagonal roofs skywards, the well-head finial reaches up towards the splayed lantern on the stair-tower, topped by a tall thin windvane flying its iron pennon: 'WM 1859'.

The internal layout pivots on the quasi-Jacobean staircase in dark oak which rises from the

ABOVE Houses in the model village of Baldersby St. James in Yorkshire designed by William Butterfield (1814–1900). Webb admired Butterfield's work and adopted several features including Butterfield's use of red brick and half-hipped gables.

wide hall, which in homage to the hall of a medieval house, can also function as a living room with its settle and fireplace. With tall pyramid newels like the seventeenth-century one at Chastleton, the stair leads up to the principal rooms in the 'front' wing – the drawing room, main bedroom and studio – the latter two opening on to a broad gallery with three bull's-eye windows. The rear wing contains lesser bedrooms, maids' quarters and lavatory, all reached by a narrow passage. Downstairs, the hierarchy is maintained, with dining room sited below drawing room and a generous hall passage leading to other reception rooms and garden porch. Along a lower corridor to the rear, are scullery, kitchens, larders, backstairs and kitchen yard. In keeping with prevailing ideas, servants and cooking smells were well away from the rest of the house. Rather intriguingly, the plan has some affinities with Morris' later home Kelmscott Manor in Gloucestershire, and Webb may well have taken ideas from similar sixteenth-century sources. The conveniences were modern with water closets fed from a roof tank: one for women and children upstairs, one for gentlemen downstairs and one for servants in the yard. There was no bathroom; as was customary, baths were taken in moveable hip-baths, filled from hot-water jugs.

Late in life Webb declared that he never wanted to see Red House again, adding that no architect should design a house before he was forty. [19] Perhaps he was a little embarrassed by the way, given his head aged twenty-seven, he had put everything he pleased into Red House. Since it was his first commission and first domestic building, there are surprisingly few errors of judgement; virtually no amendments were necessary as building proceeded. The only alteration concerned the stable. Sited in the north-eastern corner of the plot to minimise manure smells, its orientation altered between plan and construction so that the back of the stable was built against the eastern, not the northern wall. The carriage house is not shown on the original plan, and must have been a later addition.

The northward orientation of most rooms was not originally perceived as a defect: south-facing rooms were undesirable in 1860 as the Victorian upper classes feared the effect of the sun on their skin and interior furnishings. Nevertheless, the design is such that on winter mornings, sunlight streams into the hall through stairwell, windows and internal doors, reaching right to the front door. This diminishes as the day and season progresses, keeping the main rooms cool in the heat of summer. The orientation compounds the main problem: an

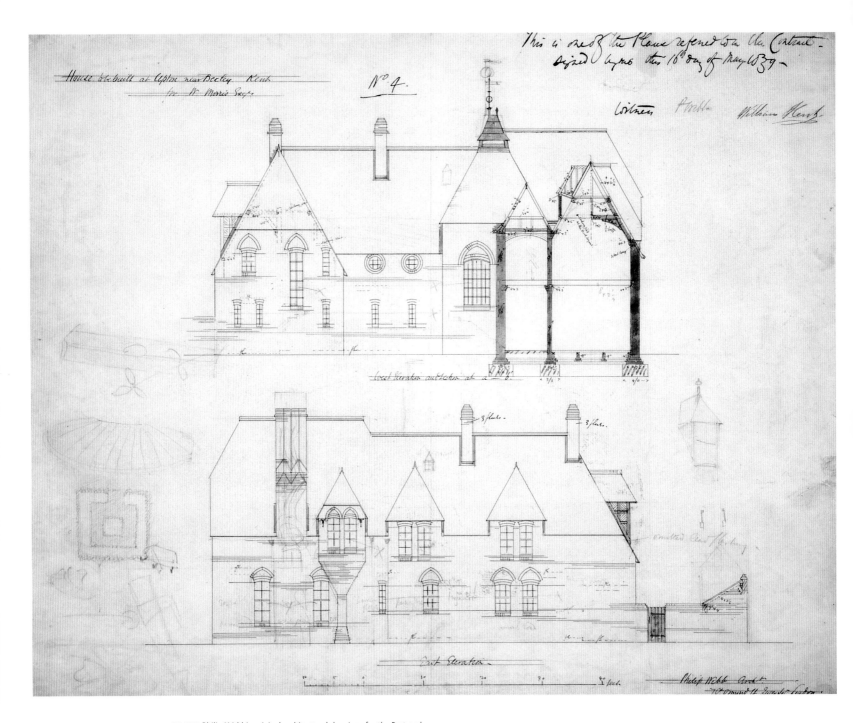

ABOVE Philip Webb's original architectural drawings for the East and
West elevations of Red House. It appears that Webb mislabelled the
elevations as the house is in fact built facing the opposite way.

almost medieval disregard for heating. Facing north, the principal rooms are extremely cold, even in summer. The fireplaces are small and can seldom have heated a whole room, however many scuttles of coal were burnt. Furthermore the fires also smoked: a serious design flaw. In 1861 the main chimneys had to be heightened in order to remedy the problem.

Strangely for such a meticulous man, Webb titled his drawing of the house's western elevation its 'East Front'. Evidently a slip of the pen, this nevertheless raises the possibility that the orientation had originally been differently conceived, with the domestic offices to the north and the well-garden facing west. On the Red House site, this would have meant taking the carriage drive through the garden, and made the bowling lawn very shady below a cool east wall, which would have been unfavourable to espaliered fruit.

Another disadvantage of the chosen layout was that the kitchen was in the warmest part of the house, taking afternoon sun just as water was heating and the evening meal being prepared on the range. The larders were also in this part of the house, which must have been a problem for keeping food cool. Though destined to be its hostess, Jane was too inexperienced to have any input into its design, but towards the end of her life, she joked with Webb, reminding him the Red House cellar was too small, as indeed it is. [20] Unlike other Victorian houses, which have cellars beneath most of the

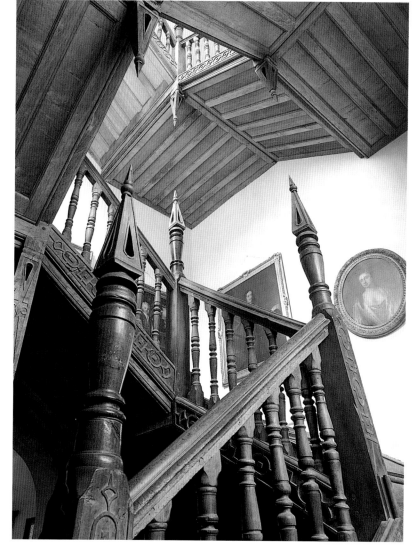

ABOVE The tall pyramid newels (before restoration) on the staircase at the Jacobean Chastleton House in Oxfordshire (National Trust), which closely resemble those at Red House. Webb probably visited Chastleton while working as an architect in Oxford.

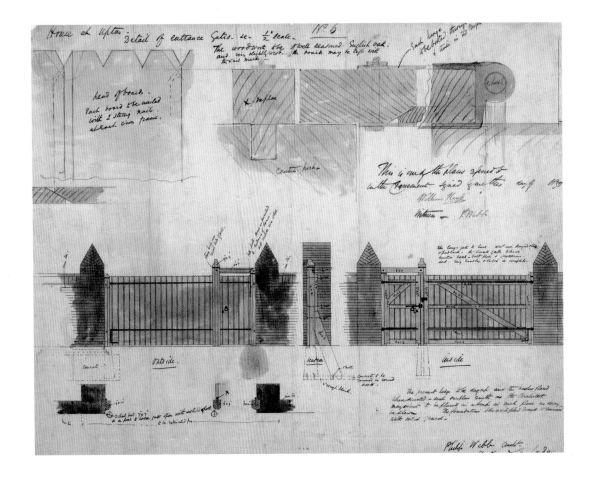

building, that at Red House occupies only the area below the stairwell. Although a structural anchor, the spaces are cramped and insufficient for cold larders and storage space. A famous recollection has Morris coming up the stairs with bottles under both arms and in each hand, but the image evoked of an extensive wine cellar is belied by the reality. No doubt the supply was equal to the demand.

The lack of rear access is another surprising omission, meaning that deliveries, including coal, had to come through the garden. Since separate entrances were almost universal during this period, this is an odd oversight. On Webb's first rough plan, however, a path is shown skirting the bowling lawn to reach the kitchen yard, which would plainly provide service access

Philip Webb's designs for the gates **ABOVE LEFT** and well-head
ABOVE RIGHT demonstrate the care and detail on which he insisted.
Both construction and materials are spelt out for the contractor; as a
result both gate and well survive in original condition.

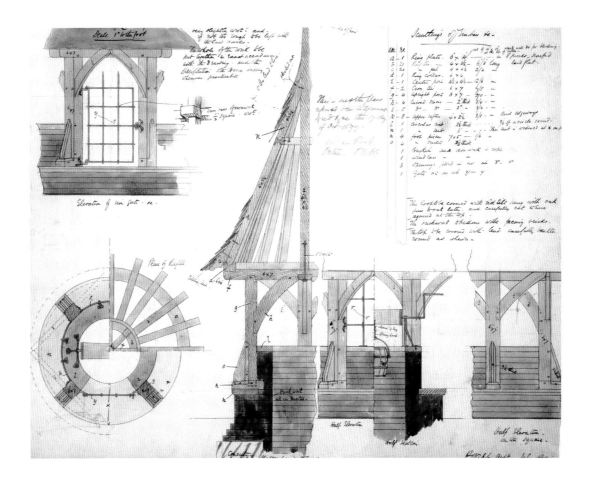

to the rear. [21] As this is not shown on later maps, it must have been deemed unnecessary.

Although it's sometimes said that William Morris built Red House, he was not its architect. Like any client, he contributed to the design by discussing specifications, budget and schedule, but all the architecture was Webb's. As with any client, the interior decoration and furnishing were Morris' responsibility. Walls and ceilings were left unpainted and unpapered. When in late summer 1860 Morris and Janey prepared to move in, some contractors were still at work; it had been an unusually wet season. The house must have smelt of fresh plaster, paint, varnish; and was almost as bare as it is today.

And so the house began its life.

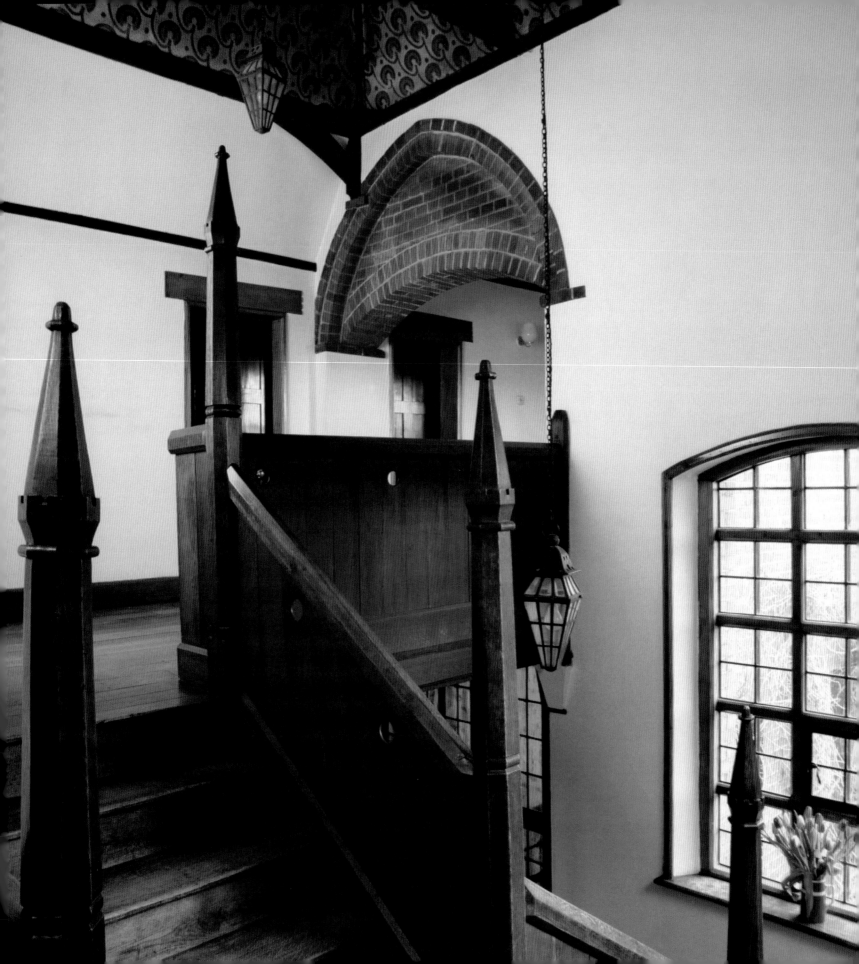

THE TRUE SECRET OF HAPPINESS LIES IN THE TAKING A GENUINE INTEREST IN ALL THE DETAILS OF DAILY LIFE ... THE AIM OF ART IS TO INCREASE THE HAPPINESS OF MEN, BY GIVING THEM BEAUTY AND INTEREST OF INCIDENT TO AMUSE THEIR LEISURE, AND PREVENT THEM WEARYING EVEN OF REST, AND BY GIVING THEM HOPE AND BODILY PLEASURE IN THEIR WORK; OR, SHORTLY, TO MAKE MAN'S WORK HAPPY AND HIS REST FRUITFUL. CONSEQUENTLY, GENUINE ART IS AN UNMIXED BLESSING TO THE RACE OF MAN ...

William Morris, *The Aims of Art*, 1887

'When the shell of the house was completed and stood clean and bare among the apple trees,' wrote Morris' first biographer, 'everything, or nearly everything, that was to furnish or decorate it had to be likewise designed and made.' [22] Walls and ceilings were limewashed, pine woodwork was primed, oak was stained or waxed. Morris had strong views on the furniture available from commercial firms, calling it 'costly rubbish', from which we may infer that he and Janey did visit showrooms and consult catalogues, like any couple setting up home, and that very little appealed to Morris' aesthetic sense, or was felt to complement Red House's architectural style.

They must have acquired some pieces from his mother, including the elegant Regency four-poster in which Morris and his siblings had been born, which is now at Kelmscott Manor. There was also their wedding present, the Prioress' Tale wardrobe decorated by Burne-Jones, which Morris further embellished on the inside of the doors with images of a medieval lady at her toilette. In addition, there were his earlier experiments in furniture-making, including the two giant planked chairs, variously described as 'like incubi and succubi' and 'such as Barbarossa might have sat in', and which are unlike any chairs before or since. [23] These were made to

LEFT Staircase within Red House.

RIGHT Detail of the hinges from the ox-blood dresser in the dining room at Red House.

Morris' design by a Holborn carpenter, who recalled how 'a gentleman who in after years became a noted socialst [sic], and Poet ... called at our shop and got the guv'ner to take some orders for some very old-fashioned furniture in the Mideaval [sic] style.' [24] Both were tall, virtually immoveable, their backs painted with two scenes both taken from Morris' early poems: a knight receiving a lady's favour, and Rapunzel letting down her golden hair. Accompanying these were two awkward semi-circular chairs, built like wooden pails and painted with patterns, another in oak, 'like a throne, with beautifully carved arms', [25] and a large circular table, 'as

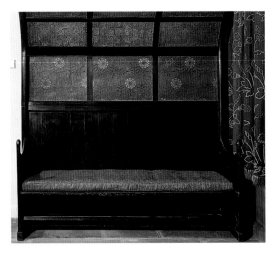

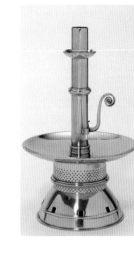

heavy as a rock'. [26] Renowned for punching walls and furniture to express his rages, Morris liked solidity.

Morris' painting equipment – easel, drawing stool, lay figure (a mannequin used by artists to show the arrangement of drapery), brushes, pigments and props – furnished the L-shaped studio, which was used as a sitting room during the first few weeks. There was also a piano, for home-made music. Morris had sung plain-chant at Oxford and was enthusiastic about English carols, then emerging from obscurity; in 1860 his version of 'French Noel' for four parts was published in a collection of *Ancient Christmas Carols*. The previous October, his birthday present to Janey was a two-volume edition of *Popular Music of the Olden Time*, containing tunes like *Greensleeves*.

Gradually, other furnishings arrived, made to Morris' order. Moveable items included chairs, two stout oak dining tables that could be arranged in a T-shape for feast days and, in due course, a moveable settle with a curving canopy decorated with gilded and painted leather. All were designed by Webb, together with a cheval mirror, a round oak table, copper candlesticks, fire-dogs and table glass (including sugar bowl, covered jam dish, water carafes, tumblers and wine goblets). More prosaic elements were also necessary: Webb's account book for 1861 includes designs for plain, low-cost furniture: an iron bedstead, a chest of drawers, a

ABOVE LEFT *Glorious Gwendolen's Golden Hair* (left) and *Arming of a Knight* (right) painted by Morris and Rossetti on two massive chairs designed by Morris (c.1856). The subjects were taken from Morris' early poetry. Chevrons and other patterns in green and red decorate the backs and legs of the chairs.

ABOVE RIGHT Candlestick designed by Webb in June 1863 for Morris & Co. A few examples were made both in copper and brass. Webb's account book gives his fee for the design as £1.10s. 0d.

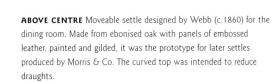

ABOVE CENTRE Moveable settle designed by Webb (c.1860) for the dining room. Made from ebonised oak with panels of embossed leather, painted and gilded, it was the prototype for later settles produced by Morris & Co. The curved top was intended to reduce draughts.

washstand, a dressing table and a towel horse. Examples of these, painted dark green, are now in the attic bedrooms at Kelmscott Manor, and it is quite possible that they started life at Red House, in the nursery and servants' bedrooms.

Elsewhere around the house was Morris' collection of antique items. A brass jug features in both Morris' *La Belle Iseult* and Burne-Jones' *Sir Degravant* mural, reminding us that since his time at Oxford Morris had been buying armour, metalwork and engravings as well as making brass rubbings.

The only other recorded furniture are the fitted pieces still in situ: the green settle-cupboard in the hall, the fine ox-blood red sideboard in the dining room – both designed for the house by Webb – and the settle in the drawing room, once part of the Red Lion Square ensemble and

ABOVE Semi-circular chair designed and painted by Morris (c.1856)
and part of the furniture originally at Red Lion Square.

 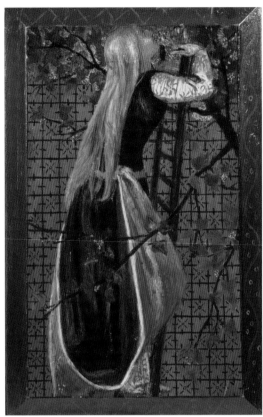

originally painted a deep ox-blood colour. While this was dismantled, Rossetti had decorated two of its cupboard doors as his wedding gift to Morris and Janey; they were due to be re-fixed, along with four 'Seasons' panels. At the end of November 1860, the Morrises visited Gabriel and Lizzie in their apartment at Blackfriars where comparable decorative schemes were planned. Lizzie, who was four months' pregnant, went back to Red House with them, followed by Gabriel soon after, who had 'to paint a panel there'. [27] This was probably the central settle cupboard, entitled *Dantis Amor*, showing the heads of Christ and Beatrice, encircled by sun and moon, with an angelic figure of Love and a sky of sun's rays and stars. It looks as if Rossetti painted only the heads; the rays and stars were filled in later, possibly by Morris. The flanking panels showing Dante and Beatrice meeting on earth and in heaven were not replaced on the

ABOVE AND OPPOSITE Four 'Seasons' panels painted by Rossetti (c.1857), whose original function is unknown. Two of the panels were found in Romford market before being sold to the V&A Museum.

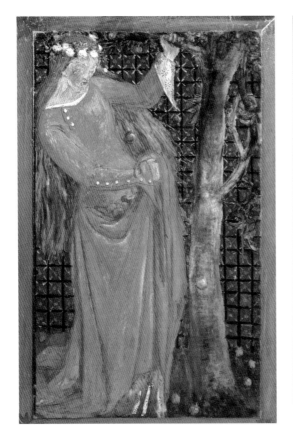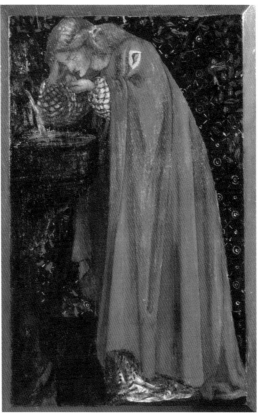

settle. Perhaps they no longer fitted, or the task was postponed – there was much other decorating to be done – or Gabriel was characteristically dissatisfied with his earlier work, promising to make improvements.

As well as furniture, Morris planned an ambitious decorative scheme, begun by himself and Janey, with assistance from Burne-Jones, Charley Faulkner and any other visitors who could be persuaded to help. The involvement of friends in decorating Red House during this first autumn and winter, coupled with Morris' own inexhaustible energy, is an indication of how intensive the activity was, and how the decorative scheme was conceived to cover all surfaces. As Fiona MacCarthy writes, 'a Morris interior is a disciplined amalgam of patterns, colours, textures: wallpapers, friezes, curtain fabrics, wallhangings, painted ceilings, layer upon layer'. [28] At this

OVERLEAF *Salutation of Beatrice on Earth* and *Salutation of Beatrice in Eden* by Rossetti (1859) comprised the left and right panels of the settle now in the drawing room of Red House. The two panels were removed for further work but were never returned to the settle. They were mounted together in their current frame in 1863.

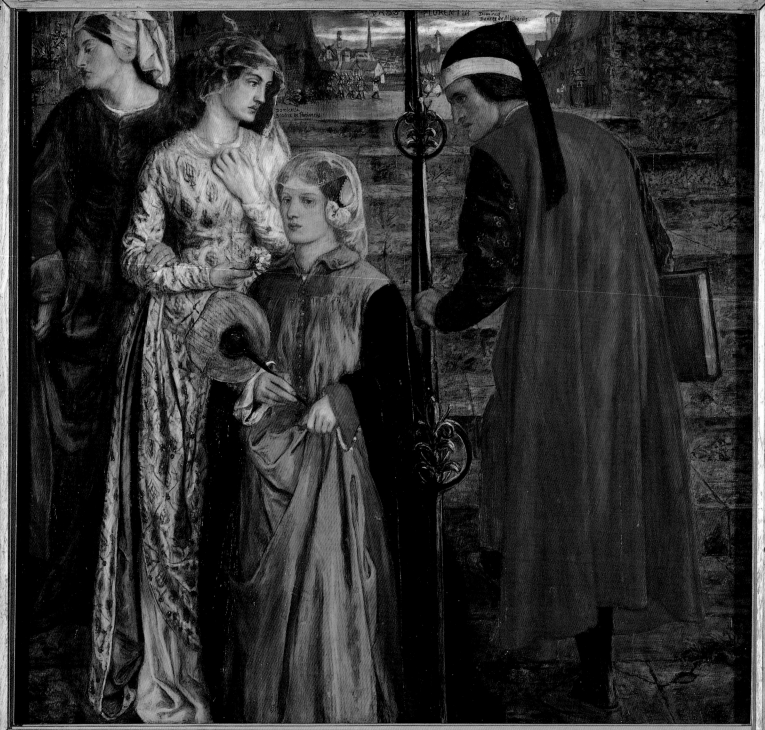

Questa mirabile Donna apparve a me, vestita di colore bianco, in mezzo di due gentili donne di più lunga etade. (VITA NVOVA. Cap. II.)

Negli occhi porta la mia Donna amore.

Chortus Eden

POETA:
DANTES DE ALIGHERIIS
DE FLORENTIA

BEATA
BEATRIX

Chortus Eden

Guardami ben: ben son, ben son Beatrice.

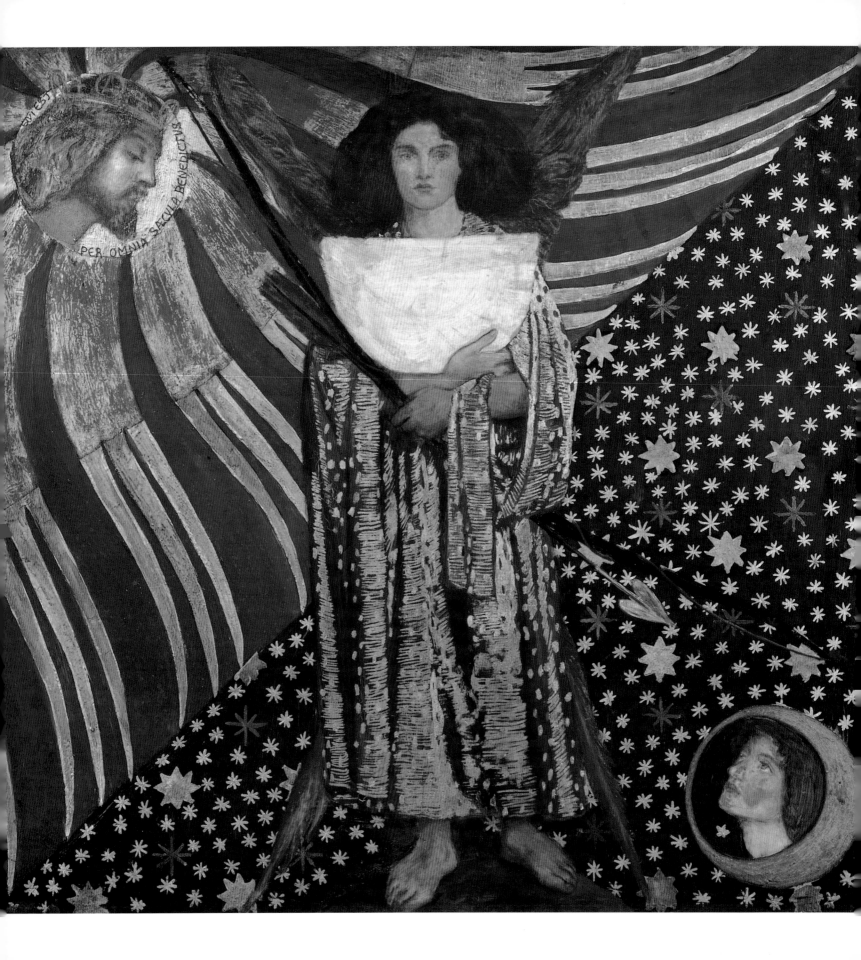

stage there were no wallpapers and window shutters took the place of curtains, but the principle was established. It followed the advice of G.E. Street, former employer of Webb and Morris, in a lecture from 1858, where he argued for the importance of wall-painting, stained-glass, fabrics and metalwork in buildings, stressing that architects should be concerned with more than structure. 'We should be better artists and greater men if we did a little less in architecture and a little more in painting', he declared. [29] This precept underpinned the all-over decoration of Red House which, moreover, was home-grown; no commercial decorators were employed, the roughness of the result being a Ruskinian tribute to the pleasure of making art for its own sake.

Working from the top, the ceilings came first. In the studio, gallery, stairwell, drawing room, hall, two bedrooms upstairs, dining room and bachelor's bedroom, each ceiling had a pattern pricked into the damp plaster as a template for repeat painting. Morris, Janey and Faulkner worked on these, probably using the builders' ladders and scaffolding. Some have been repainted; others appear to be in their original state. One pattern is utterly simple: three-stripe blocks set at right angles. That in the studio has graded arcs like stylised peacock feathers. The stairwell pattern above the exposed beams consists of chunky crescents with a looping line and dots. In the drawing room, the ceiling of the oriel window has a bold matrix of yellow discs within a grid, echoed by the pattern on a gown in the adjacent *Sir Degravant* mural. The main drawing room ceiling was differently adorned in reds and browns with decorative leaf motifs above a geometric pattern like a corbel table. Since painted over, this is visible under strong light; it is thought to be largely Morris' own work and is reminiscent of his patterning at the Oxford Union.

The rest of the drawing room had polychromatic decoration whose rich contrasts are being revealed by paint sampling. On the upper walls, where no murals were planned, were solid areas of purple, orange-green, orange-red and crimson. Much of the woodwork was scarlet: door, dado panels and north window. The oriel woodwork was green with some silvery leaf decoration. The north window-seat was painted in deep reds and greens, the door architrave in red and yellow-green. The skirting was also yellow-green. Contributing to the overall effect were the ox-blood settle and the brick chimney breast, resulting in a warm, dark, colourful interior, vigorously painted.

LEFT *Dantis Amor* by Rossetti (1860). This was originally intended as the central panel on the drawing room settle. Amor, or Love, stands centrally between day and night. Christ looks down from the sun, Beatrice up from the moon.

The Romance of Sir Degravant

Degravant was fond of music and hunting, but not interested in women until he fell in love with the daughter of his neighbour and enemy. At dusk he went with his squire to his neighbour's orchard where they saw his enemy's daughter Melidor on her way to Mass. Degravant declared his love; Melidor was scared, but her maid helped Degravant out through a secret gate. Then came a tournament, where Degravant jousted in disguise against rivals to win Melidor's hand. Victorious, he later secretly visited Melidor in her chamber, decorated with statues and rich hangings, and after supper asked for a husband's privileges. She bade him wait till they were married, so the secret meetings continued for a year. Eventually they were married – the festivities lasted a fortnight – and lived together for over thirty years. When Melidor died, Degravant went to the Crusades and was slain; 'May Heaven reward him!'. [35]

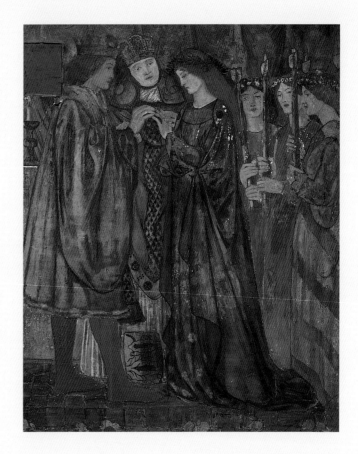

LEFT TO RIGHT
Marriage of Sir Degravant and Lady Melidor, *The Wedding Procession*, *The Wedding Feast* (Degravant and Melidor bear the faces of William and Jane Morris).
Seven scenes inspired by the Romance of Sir Degravant were planned on the walls of the drawing room by Burne-Jones (1860), although four showing earlier scenes in the romance were never executed. It is said that the quotations from the romance (written above the murals) were concealed in the late nineteenth century when the murals were framed and glazed.

One the Trinité day
Thus in romance herd y say
He toke hyr in Godus lay
 Tylle hys lyvys ende.
Solempnely a cardinal
Revescyd with a pontifical
Sang the masse ryal
 And wedded that hend.
And the ryche Emperoure
Gaff [hyr] at the kyrke dore
With w[orschy]p and honoure
 As f[or hi]s owne frend.

Said to be inscribed above Marriage image

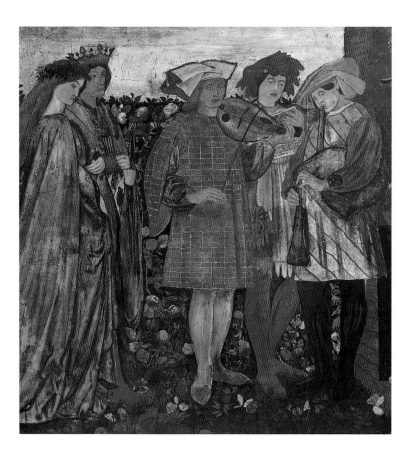

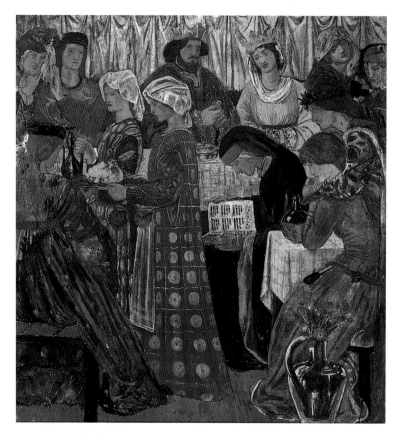

Thrytty wyntur and mare
Thei lyvede to-gydur without care
And sevevne chyldur she hym bare
 That worthly in wede;
And sene sche dyed, y understond,
He seysed hys eyre with hys hond
And went into the Holy Lond
 Hevene be hys mede!

Said to be inscribed above Procession image

Lord God in Trynité
Yeff home hevene ffor to se
That lovethe gamene and gle
 And gestys to ffede.
Ther ffolke sitis in ffere
Shullde mene herkene and here
Off gode that beffore hem were
 That levede on arthede*.

Said to be inscribed above Wedding Feast image

on arthede*
in honour

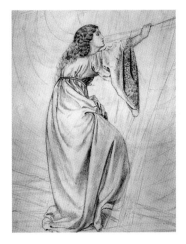

The hall too was patterned. The inside of the front door had a zigzag motif like that seen today, which was re-painted in the 1950s, while walls and ceiling were covered with roughly painted bands of foliage that struck one early visitor as bizarre and primitive. [30] Painted mottoes accentuate the colourful effect. Reminiscent of Biblical mottoes in Gothic revival churches, themselves derived from medieval exemplars, those mottoes at Red House are more secular: 'Our Content is Our Best Having' in the downstairs guestroom (from Shakespeare's *Life of King Henry VIII: II, iv*); 'Ars Longa Vita Brevis' above the drawing room fireplace (a Latin saying translated by Chaucer as 'the lyf so short, the art so long to lerne'); that over the front door 'Dominus Custodiet Exitum Tuum et Introitum Tuum', from Psalm 120, translating as 'The Lord shall preserve thy going out and thy coming in'.

Somewhere around the house hung Morris' picture collection, made when he and Burne-Jones first met the Pre-Raphaelite circle. Woodcuts by German masters such as Albrecht Dürer and Hans Burgkmair mingled with modern pictures, including Burne-Jones's intricate pen and ink *The Knight's Farewell* and Arthur Hughes's purple and green study of a young couple, *April Love*, which Morris had instructed Ned to 'go and nobble ... as soon as possible lest anyone else should buy it' in 1856. [31] This same year, Rossetti had discovered that Morris, in his estimation, was 'a millionaire and buys pictures', and at once persuaded him to buy *Hayfield*, a small landscape by Madox Brown, followed by several of Rossetti's own watercolours on medieval themes. [32] The first were *Fra Pace*, showing a monk illuminating a manuscript (an art Morris himself practised in this period), and *Paolo and Francesca*, whose illicit love echoed that of Lancelot and Guenevere. In 1857–58 came a fanciful 'chivalric' group: *The Blue Closet*, *The Tune of Seven Towers*, *The Chapel before the Lists*, *The Death of Breuse sans Pitie* and the small *Damsel of the Sanct Grael*. Testifying to friendship and shared artistic endeavour, some were created in response to Morris' poems. In 1862 Morris also acquired Rossetti's *The Wedding of St George*, although this may have been intended for re-sale, rather than for display at Red House. [33] The others were probably displayed in close formation within gilt frames and mounts; later, Rossetti drew

ABOVE LEFT Jane wearing medieval costume by William Morris (1860). Thought to be a preparatory study for an unexecuted mural at Red House.

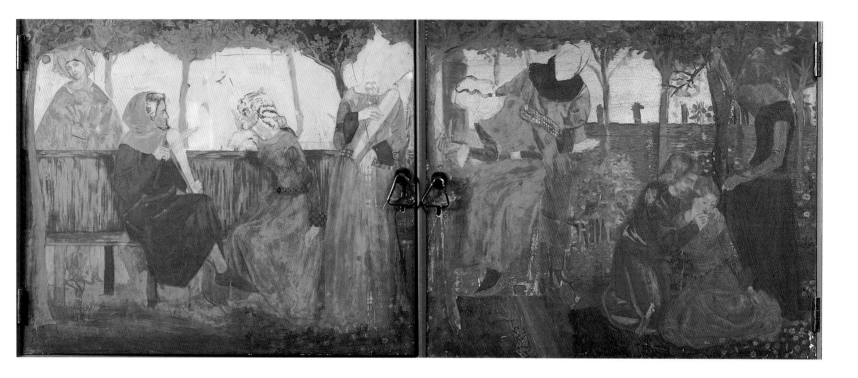

a diagram of how they should hang.[34]

Generally speaking, Red House walls were not envisaged as picture-hanging space, since they were themselves decorated with murals, designs and embroidered hangings. Again, this was 'home-made' rather than 'through designed', in an inventive mix of materials and matter. On Webb's plans of the house, a fabric hanging is suggested above the dado in the drawing room, but this space was claimed by Burne-Jones for his sequence relating the medieval tale of *Sir Degravant*, one of the verse romances rescued from oblivion by the Camden Society in 1844 and a book Morris would reprint at the end of his life; 'I will tell you the story of Sir Degravant, distinguished in war, nephew of Arthur and Guenevere and member of the Round Table...'

Ned planned seven scenes, beginning at the end with the Wedding Feast, by the oriel window. Morris presides as Sir Degravant, with Jane as Melidor. On the other side of the settle, knight and lady are serenaded by three musicians in one scene, with their marriage before a cardinal in another. Painted in tempera, these three scenes were done during the Burne-Jones'

ABOVE Courtly scenes painted on the doors of the hall settle by Morris (1860–61). As yet unidentified, they are thought to be based on Malory's *Le Morte Darthur*.

first extended visit to Red House in late summer 1860. But the scheme never progressed. Even further from achievement were 'Scenes from the Fall of Troy' showing the Homeric warriors in medieval guise. 'We schemed also subjects from Troy for the hall,' recalled Ned, 'and a great ship carrying Greek heroes ... but these remained only as schemes'. [36] According to Mackail's biography, Morris' Troy had spires, towers and gables like a medieval city; it would have derived from Caxton and Chaucer rather than any classical sources. The subject was one Morris had also projected as a cycle of twelve poems, from the arming of Paris to the departure of Aeneas. Fragmentary texts survive; for the wall paintings nothing is left save a sketch by Morris of Janey in medieval dress, about to climb into a high-sided ship. Though the Red House Troy sequence is always credited to Burne-Jones, it may have been intended as a collaboration with Morris. It is equally possible that the medieval woman is not Helen of Troy, but Iseult, and belongs to a different project altogether.

Morris also began painting courtly scenes on the hall settle, which show medieval men and women in a garden. On one panel, they play music and flirt; on the other, they seem in distress. Clearly inspired by manuscript illustration, the subject may one day be determined; currently it is described as a scene from Malory's fifteenth-century *Le Morte Darthur* (The Death of King Arthur), where Sir Lancelot takes Iseult and Tristram to the castle of Joyous Gard. [37] It could instead be from *Le Roman de la Rose* (The Romance of the Rose); we know that Morris had seen manuscripts of both works at the British Museum in London and the Bodleian Library in Oxford.

In the main bedroom is a wall painting, recently re-discovered behind a cupboard. To date, this has so far resisted explanation owing to its unfinished and damaged state. All that can be deciphered are two full-length figures on a dark-blue background above some illegible script. One figure in a red gown appears to be female, the other is less certain but leans on a tall pillar or tree, with a short ladder at its foot. The text, disposed on folds as in an illusory scroll, is too

ABOVE LEFT The remains of a wall painting in the main bedroom thought to be by Lizzie Siddal (1861) and now enclosed in a cupboard. More painting is due to be uncovered in the course of 2005. Below the figures is a scroll with an illegible inscription.

fragmented to be read, but appears to be a quotation, possibly from the Bible – certainly 'GOD' is one word. Two traditions attach to this mural: one, that the figures represent Adam and Eve, naturally in medieval guise; two, that it is the unfinished work of Elizabeth Siddal. The identity of the artist can be approached by elimination. The tall, naïve figures are not the work of Madox Brown, Rossetti or Burne-Jones, three of those who are known to have painted at Red House, while Georgie Burne-Jones, who recorded so much, never claimed to have painted there. The remaining candidates are Morris, Jane or Lizzie, who was at Red House in July 1861 at work on a mural: 'If you can come down here on Saturday evening, I shall be very glad indeed,' she wrote to Rossetti, 'I want you to do something to the figure I have been trying to paint on the wall. But I fear it must all come out for I am too blind and sick to see what I am about'. [38] Although far larger than anything else Lizzie drew, the figures' stiff naivety is reminiscent of her handling of the human form and unlike that of Morris or Jane (who is not known to have painted any figures).

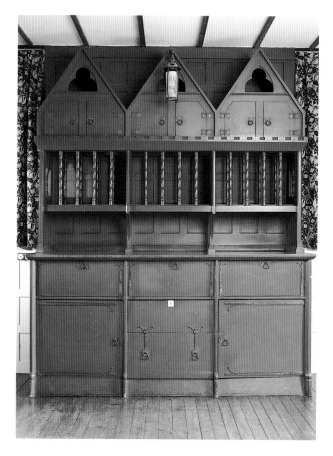

In the dining room, Webb's dresser, painted in the favourite ox-blood colour, filled one side of the room. The other walls were intended for embroidered textiles, the next form of decoration envisaged for Red House. In fact, this preceded the building, for while at Red Lion Square Morris had begun a heavy, close-stitched hanging, some two yards (2m) in width. 'He started his experiments in embroidery before he knew me, got frames made, had worsted dyed to his taste by an old French couple, and began a piece of work with his own hands,' recalled Jane fifty years later. 'This was the celebrated "If I Can" bird and tree hanging of which I still have a piece at Kelmscott Manor.' [39] The pattern of fruit trees, birds and scrolls was inspired by a fifteenth-century manuscript of Froissart's *Chronicles*, one of Morris' favourite late-medieval texts, while the 'If I Can' motto on the scrolls was adopted by Morris from that of Jan van Eyck:

ABOVE RIGHT Dining room dresser designed by Philip Webb. Painted in 'ox-blood' colour, it was surrounded by walls hung with embroidered textiles of Illustrious Women.

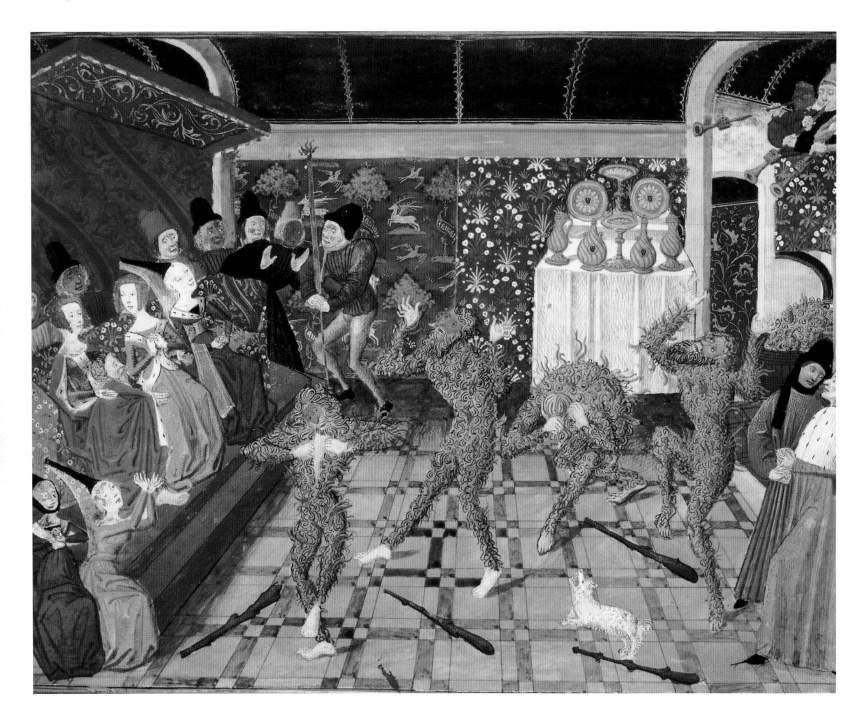

ABOVE *Masquerade at the French Court* from British Library
Manuscript Harley 4380, f.1. The heavily illuminated fifteenth-century
manuscript contains one version of Froissart's Chronicles and inspired
designs for various textiles by Morris. The Daisy pattern is taken
directly from the red backdrop in the background of the illumination.

'Als ich kann'. Now much faded, the hanging originally had bright green trees, yellow and red fruits and 'gaily coloured birds' like parrots; all motifs that feature in his later designs. This fabric is probably that sketched on Webb's plans in the space now occupied by the *Sir Degravant* murals. Below these murals, Morris is said to have painted a version of his textile and, during one of his visits, Rossetti found empty scrolls on it, awaiting their motto 'If I Can'. Next morning, Ned recalled, Morris found that 'all the labels were filled with "As I Can't" – and that pleasantry was of Gabriel's devising – and there was a scene – and it might have puzzled the discriminator of words to say which of these two was most eloquent in violent English.' [40]

In fact, the recent removal of later panelling reveals not a version of 'If I Can', but a painted pattern of rough floral shapes and the words 'Qui bien aime tard oublie' ('who loves best loves longest') from Chaucer's *Parlement of Fowles* – a motto Morris later used for a textile design exhibited in 1862.

Other textiles were hangings for the main bedroom, worked primarily by Jane, to designs taken directly from the Froissart manuscript of daisy plants, with flowers, stems and leaves in couched stitches on a plain ground. 'The first stuff I got to embroider on was a piece of indigo-dyed blue serge I found by chance in a London shop,' she recalled. 'I took it home and he was delighted with it, and set to work at once designing flowers. These we worked in bright colour in a simple rough way – the work went quickly and when finished we covered the walls of the bedroom at Red House to our great joy'. [41] Finished at the lower edge with a coloured wool fringe, when hung they must have given the bedroom a warm, dark appearance. The dark blue background of Lizzie's unfinished mural would have complemented the *Daisy* hangings, five lengths of which survive at Kelmscott Manor. In addition, a length of once-green broadcloth survives, embroidered with large bold sunflower motifs, also in a simple couched style. This is long enough to have been a door curtain, but there is no record of its intended position. Indeed, it appears to have been forgotten until the Morris centenary in 1934 when it was lent for exhibition by May Morris, described as 'Curtain: Sunflower. Wool on serge. From Red House'. Then it was forgotten again until found in 1962 'crumpled and moth-eaten' at the bottom of a chest at Kelmscott Manor. [42]

In Jane's words, 'another scheme for adorning the house was a series of tapestries for the dining

ABOVE RIGHT Detail of Daisy wall-hanging stitched by Janey and friends for the bedroom at Red House.

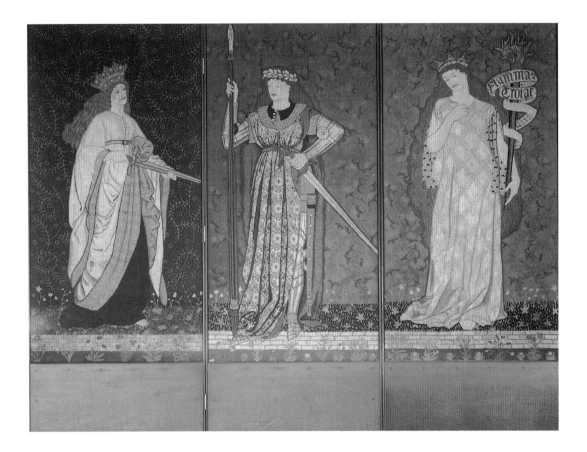

room of twelve large figures with a tree between each two, flowers at the feet and a pattern all over the background'. [43] These were to hang above the dado, a crowded sequence of six trees and six pairs, representing Illustrious Women. Loosely based on Chaucer's *Legend of Goode Wimmen*, these were also inspired by the antique embroideries at Hardwick Hall in Derbyshire, which Morris knew from visits to his sister at nearby Clay Cross, where her husband was the vicar. Dating from the early seventeenth century and the time of Elizabeth Shrewsbury, otherwise known as Bess of Hardwick, the Hardwick embroideries show Christian virtues and classical heroines: Artemisia, Penelope, Cleopatra, Zenobia, Lucretia. Of the projected twelve figures for Red House, seven were finished, according to Jane, though not all were appliquéd onto their curtains. Those surviving are St Catherine, Penelope, Guenevere, Hippolyta, Helen ('Flamma Troiae'), an unnamed queen with a

ABOVE LEFT Three-fold screen with embroidered panels featuring heroines inspired by Chaucer's poem the *Legend of Goode Wimmen*. The figures are Lucretia (with sword), Hyppolyte (with sword and lance) and Helen (of Troy). Based on the Red House scheme, these were exhibited in 1888 and bought by George Howard, 9th Earl of Carlisle.

sword, and an unfinished Aphrodite that may or may not belong to the original scheme. Each figure is between thirty-six and forty-five inches high (90–110cm). St Catherine alone has an accompanying tree, hung with lemons and a shield bearing the saint's wheel. This later hung as a *portière* in the Burne-Jones' home, and is now at Kelmscott Manor. An orange tree and part of a pomegranate tree survive separately.

Several needlewomen, including Jane's sister Elizabeth (Bessie) Burden and Georgie's sister Alice Macdonald took part in this 'gigantic work', which was in progress for a long time. Indeed, it was still incomplete when the Morris family left Red House. It is unknown how many, if any, Illustrious Women were actually hung round the dining room, stitched on their original blue and green serge panels that were 'almost certainly' dyed by one of the few firms still using woad. [44] Against the brick fireplace and ox-blood dresser they would have made a splendid sight.

ABOVE RIGHT Two of the Illustrious Women (1860–62) based on Chaucer's *Legend of Goode Wimmen* that were to hang in the dining room. *Guenevere* (left) and *Penelope*.

Altogether, we may surmise that the interior decoration in Red House was well underway by the end of 1860. Despite the half-finished nature of some elements of the decoration, the whole ensemble must have been one of some splendour. Moreover, the richly primitive profusion of colour, pattern and pictorial images made Red House unlike any other domestic building of the period. Conjuring up a decorated late-medieval interior, with painted beams, coloured friezes, tapestries, painted furniture and turkey table-carpets, this mode of decoration struck a chord with several medievalist architects and is seen to perfection (or perhaps excess) in the later interiors designed by William Burges, a friend and colleague of Morris and Webb in the Medieval Society. As it happens, Burges was one of the first architects to visit Red House in the summer of 1861. [45] The riot of colours and rich decoration in Red House probably fed into Burges's more elaborate schemes for the Marquess of Bute at Cardiff Castle in Wales and Mount Stewart in Scotland. But these were professional productions, whereas Red House wore its rough, half-finished decoration as a badge of pride, where youthful exuberance outran ability.

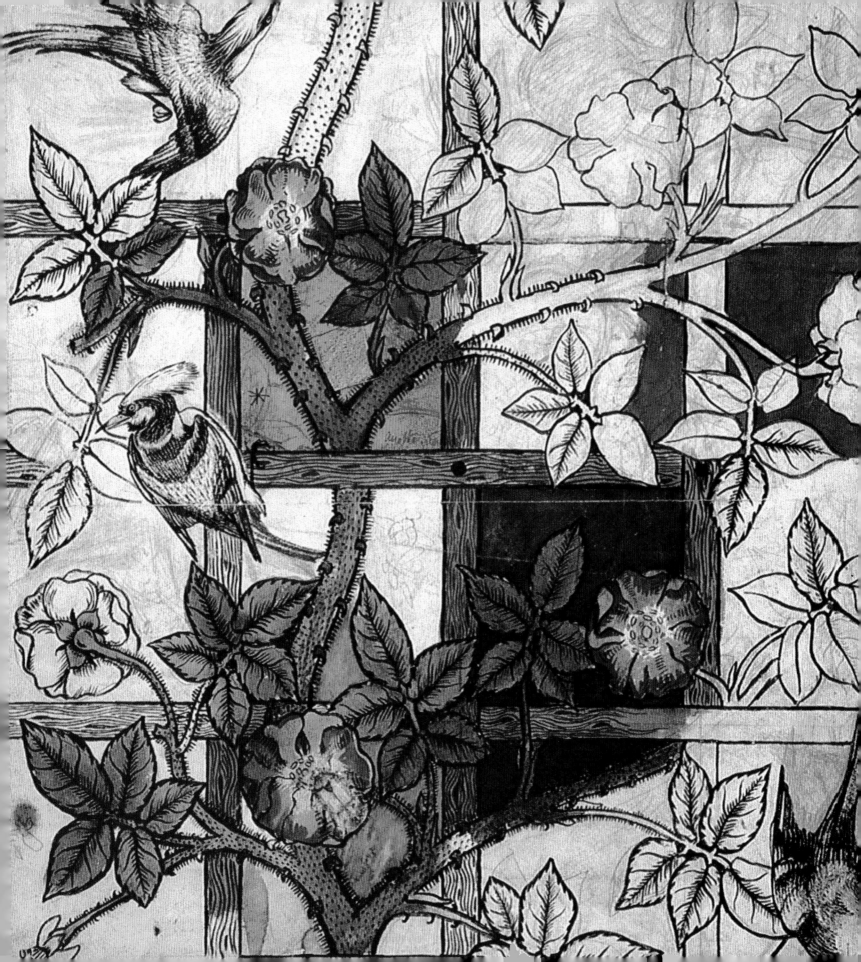

Chapter 5 *The Garden*

FORGET SIX COUNTIES OVERHUNG WITH SMOKE,
FORGET THE SNORTING STEAM AND PISTON STROKE,
FORGET THE SPREADING OF THE HIDEOUS TOWN;
THINK RATHER OF THE PACK-HORSE ON THE DOWN,
AND DREAM OF LONDON, SMALL, AND WHITE, AND CLEAN,
THE CLEAR THAMES BORDERED BY ITS GARDENS GREEN; ...

William Morris, Prologue to *The Earthly Paradise*, 1868–70

'In one of the Red House plans you will see written the names of flowers that are to be put in beds at the foot of the [west] wall and to climb up it,' wrote Georgie half a century later, recalling 'how successful the laying out of the garden was, and that the house never looked *bare.*' [46] Rather than create a garden from a building site, as is usual with new properties, Webb and Morris carefully planned to create the garden alongside, or even ahead of the house. Though now largely lost, their aim is thought to have been a conscious adaptation of medieval images for romantic Victorians, grouping varied features – a bowling green and enclosures described as *herbers* or *plaisances* – within an orchard and linked together by lawns. [47]

Morris had evoked an imaginary medieval garden in his 'Story of the Unknown Church' from 1856. Surrounded by poplars, this had:

> ...trellises covered over with roses, and convolvulus, and the great-leaved fiery nasturtium; and especially all along by the poplar trees were there trellises, but on these grew nothing but deep crimson roses; the hollyhocks too were all out in blossom at that time, with their soft, downy leaves. I said that nothing grew on the trellises by the poplars but crimson roses, but I was not quite right, for in many places the wild flowers had crept into the garden from without; lush green briony, with green-white blossoms, that grows so fast one could almost think that we see it grow; and deadly nightshade, La bella donna, O! so beautiful: red berry and purple, yellow-spiked flower, and deadly, cruel-looking dark green leaf, all growing together in the glorious days of early autumn. [48]

LEFT *Trellis* wallpaper design by Morris and Webb (1862), inspired by the gardens at Red House and one of Morris' first wallpapers. The birds were drawn by Philip Webb. Morris later chose *Trellis* for his bedroom at Kelmscott House in Hammersmith, where it remained for the last eighteen years of his life.

RIGHT Border of wild roses looking towards the west side of Red House.

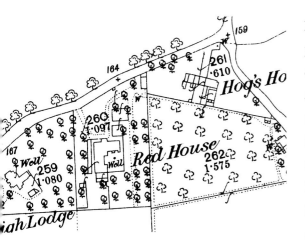

ABOVE Detail from the 1862 Ordnance Survey map showing (Plot 260) the layout of the Red House garden with two of the enclosed *herbers* clearly visible north of the house. The building to the left is Aberleigh Lodge; that to the right are the Hog's Hole cottages.

In the middle of this imagined garden stands a stone conduit, whose place was taken at Red House by the conical well-head. The site's original orchard trees were a mixture of species; Webb recorded a total of eighty, the majority being apple, followed by damson, plum, cherry and some whose names cannot be deciphered. [49] The apples included russets, ribstons, pearmains, flower of kent and blenheim orange. Those that survived the building – the 1862 map shows forty – lay mainly to the east and south of the house. Space was cleared for a kitchen garden and shed in the south-west corner, while the stable occupied the opposite corner, so that prevailing winds would blow smells away from house and garden.

Initial planting against the walls of the house included climbing roses, passion flowers and white jasmine together with espaliered 'eating pears'. The beds below the windows held moss roses, lavender, Aaron's rod and bergamot. The ground around the well was grassed and enclosed with a tall trellis that supported rambling roses: 'This little court with its beautiful high-roofed brick well in the centre summed up the feeling of the whole place,' according to Georgie. [50]

In November 1859 Webb ordered 185 yards (170m) of wattle fencing from a Bexleyheath supplier, who was probably also a maker. Woven like hurdles from hazel wands, this was all for use within the garden. Later, Morris explained the reason for this choice, arguing that iron railings were so destructive of beauty in a garden that any garden fencing should use a live hedge, or stones, or timber, or wattle, 'or, in short, anything but iron'. [51] North of the house, the wattle-fenced small plots formed secluded *herbers*, draped with dog-roses and planted with old-fashioned flowers, as in a Tudor garden. According to Georgie, these were 'four little square gardens making a big square together; each of the smaller squares had a wattle fence around it with an opening by which one entered, and all over the fence roses grew thickly'. [52] Called *plaisances* in 1866, two of these 'richly-flowered square garden plots' are clearly marked on the 1862 map, which shows that one was roughly eight metres (nine yards) square, another a little wider. [53] The smaller *herber* lay close to the house, under what is now part of the gravelled

forecourt, the larger – which survived until the Second World War – a little further away towards the stable. The sites of the third and fourth are unclear, and indeed the symmetry implicit in Georgie's description was perhaps rather rough and ready, if the *herbers* were unequal in area.

To the west of the house the seventy-five yard (68m) bowling lawn was also marked by wattle fencing and shaded by a row of fruit trees shielding the site from Aberleigh Lodge. The overall effect, swiftly established, was that of a series of compartments around the house, beyond which lay grassy walks beneath gnarled fruit trees. One early visitor described it as 'vividly picturesque and uniquely original'. [54] The planting was especially unusual. In 1860 the dominant fashion in garden design was annual 'carpet bedding', accompanied by the display of ornamental species imported by plant-hunters. For these, a heated greenhouse was required. When built, Red House had no greenhouse, though it is probable that Webb was well aware that the south-facing wall of the kitchen yard was a perfect site, especially as it backed onto the laundry room with its coal-heated copper.

ABOVE Bench against the sunny west side of the house.

The Backgrammon Players by Burne-Jones (1861). The design was repeated in watercolour and oils on a cabinet exhibited by Morris & Co. in 1862. Its mood suggests the atmosphere at Red House was similar, with its enclosed arbours and garden porch. The Morrises played chess together and may also have known backgammon.

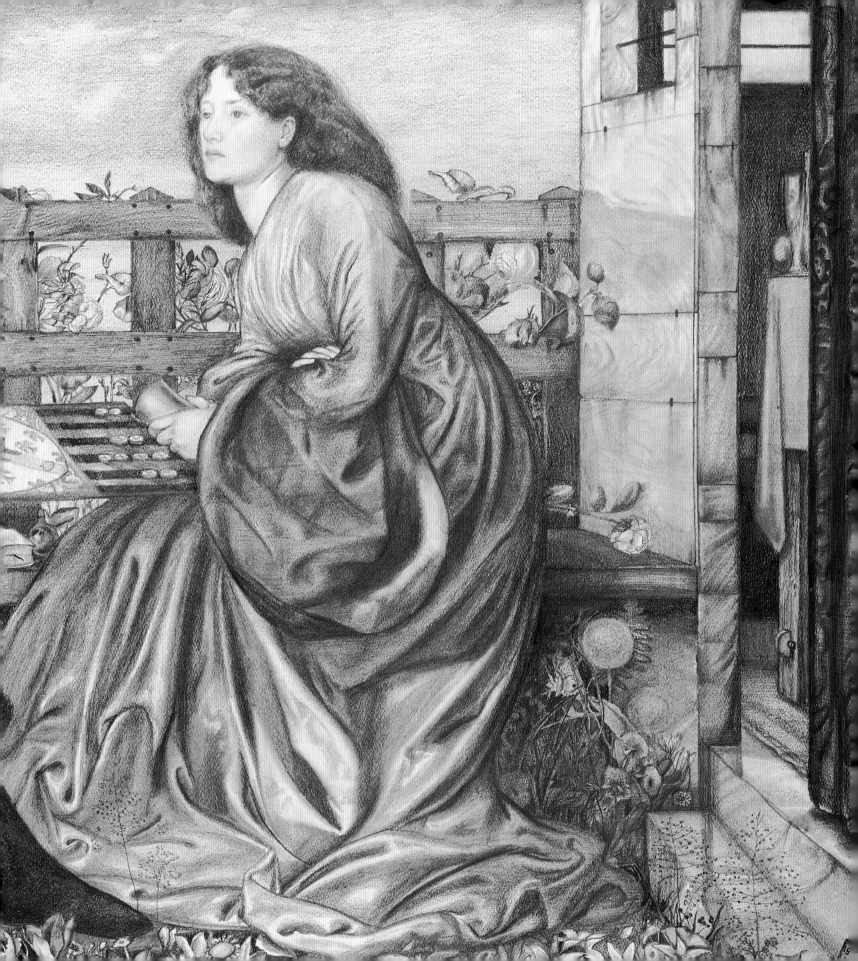

In its contemporary context, the originality of Red House's garden is clear. To date, no obvious precedents or models have been identified, apart from those depicted in fifteenth-century manuscript illustration. One manuscript motif, with which all the Morris circle were familiar, was the walled or fenced garden. In such a garden, medieval ladies sat or walked, as in one Bodleian version of the *Le Roman de la Rose*, variations of which reappear in Burne-Jones's later illustrations to Chaucer's *Canterbury Tales*, published by Morris at the Kelmscott Press in 1895. [55] Other suggestive images are the gardens of medieval men and women painted by Morris on the hall settle and by Burne Jones on the *Backgammon* cabinet.

In the late 1870s, Morris expounded his idea of garden design:

Large or small, it should look both orderly and rich. It should be well fenced from the outside world. It should by no means imitate either the wilfulness or the wildness of nature, but should look like a thing never to be seen except near a house. It should, in fact, look like a part of the house. It follows from this that no private pleasure-garden should be very big, and a public garden should be divided and made to look like so many flower-closes in a meadow, or a wood, or amidst the pavement. [56]

He also disliked 'the florist's rose … as big as a savoy cabbage'; ferns that properly belonged by rock and waterfall; exotics, 'which nature meant to be grotesque not beautiful'; and the great masses of colour called carpet-gardening. 'Need I explain it further? I had rather not, for when I think of it even when I am quite alone, I blush with shame at the thought.' His preferences, which develop the ideas behind Red House's original planting, were outlined thus:

Be very shy of double flowers; choose the old columbine where the clustering doves are unmistakeable and distinct, not the double one, where they run into mere tatters. Choose (if you can get it) the old china-aster with the yellow centre, that goes so well with the purple-brown stems and curiously coloured florets, instead of the lumps that look like cut paper, of which we are now so proud. Don't be swindled out of that wonder of beauty, a single snowdrop; there is no gain and plenty of loss in the double one. [57]

The idea of the 'garden-close' recurs within Morris' writing as a site of repose and nostalgia. 'I know a little garden close\Set thick with lily and red rose', he wrote longingly in 1870, 'Where I would wander if I might\From dewy morn to dewy night\And have one with me wandering...'. [58] It is probably no exaggeration to say that his successful pattern designing also owes its essence to Red House's garden. The very first wallpaper design, *Trellis*, showing briar roses with birds and created by Morris and Webb in November 1862, was partly inspired by the well-garden, while Morris' earliest recorded printed textile design, *Jasmine Trail*, is based on a similar but simpler motif of stems curling in and out of a trellis. Thereafter other patterns repeated the idea, with invisible fretwork, as it were, supporting rambling plant forms such as honeysuckle

ABOVE Wrought iron seat in the garden at Red House.

and vine. Typically, in Morris patterns, the square grid on which all repeats are based is obscured by climbing diagonals, tendrils and buds curling this way and that, like a fence overrun with foliage.

Though without precedents, Red House's garden had its successors. Indeed, it became a forerunner of early twentieth-century fashions for herbaceous planting and 'garden rooms'. The Webb-Morris style easily pre-dates the polemic against bedding and greenhouse forcing issued by William Robinson in 1870. Gertrude Jekyll, who pioneered a more natural style from 1890, was an early customer of Morris & Co., although she is not known to have visited Red House.

The Morrises employed gardeners to mow the grassy walks, roll the lawns, weed the flower-beds and prune the briars. But their garden was not labour-intensive. Its best season would have been spring, when early *prunus* blossom was followed by cherry and apple, and then the profusion of dog-roses and jasmine. Elements of the original garden may yet remain. Preliminary surveys suggest that the oldest fruit trees, the large arbutus to the east of the house, the pears against the house walls and an overgrown flowering quince by the back kitchen yard could date from the 1860s.

Originally, the width of the site was 175 ft (about 50m). Today it is 100 ft (30m) wider, thanks to later alterations of the western boundary. There were few if any trees between the lane and the house, but otherwise the impression of being surrounded by leaves in summer must have been comparable. All the flower-planting was probably confined to the beds below the windows and the hedged garden-closes, the rest of the site being orchard and vegetable beds. Somewhere out of sight of the main rooms would have been a drying ground for laundry. Though the present brick paths date from the 1950s, similar tracks are shown on the 1862 Ordnance Survey map, and it is likely that those we see now are in fact built in the same places.

A decade after leaving Red House, the Morris family began to re-make Kelmscott Manor's garden to their own taste. Although also now altered and simplified, its style, with walled, hedged and fenced compartments near the house and orchard and meadow-closes beyond is reminiscent of that created at Red House. In some respects, Morris was no gardener: there are no accounts of him digging or weeding. In other accounts, he was a keen observer of plants, with a clear vision of the paradise on earth that gardens can become.

LEFT *Kelmscott Manor from the Summer House* by May Morris
(c.1880). Kelmscott was Morris' later country home (now in
Gloucestershire) and the garden was redesigned to Morris' taste.
Some aspects of the partitioning of the garden are similar to that
known to exist at Red House.

WITH THE ARROGANCE OF YOUTH, I DETERMINED TO DO NO LESS THAN TO TRANSFORM THE WORLD WITH BEAUTY. IF I HAVE SUCCEEDED IN SOME SMALL WAY, IF ONLY IN ONE SMALL CORNER OF THE WORLD, AMONGST THE MEN AND WOMEN I LOVE, THEN I SHALL COUNT MYSELF BLESSED, AND BLESSED, AND BLESSED, AND THE WORK GOES ON …

William Morris

After Morris and Janey moved in, Ned and Georgie Burne-Jones were their first visitors, for an extended stay in August 1860. 'I think Morris must have brought us down from town himself,' wrote Georgie of their first arrival, 'for I can see the tall figure of a girl standing alone in the porch to receive us.' [59] Janey was not yet twenty-one, Georgie a year younger. A few days later Charles Faulkner arrived, contributing to his keep by decorating walls and ceilings. Ford Madox Brown came in September, while Webb's professional visits must have continued until all work was complete. Arriving by train, friends were met at the station by a specially built wagonette with canopy and leather seats, and driven over the heath through fields and orchards to winding Upton Lane.

The studio was 'used for living in … a most cheerful place … with windows looking three ways' and another over the door giving glimpses of birds hopping about on the new red-tiled roof. [60] On the piano Georgie and Janey played old French and English songs, from *Popular Music of the Olden Time* and *Echos du temps passé*. Georgie was the daughter of a Methodist minister and was still marvelling at the world of art and music that was opening to her through Ned and his friends. She had attended art classes herself and was proud possessor of a set of wood-engraving tools, which she planned to use for illustrations to poems and stories; favourites were *Grimms' Tales* and *The Arabian Nights*.

LEFT View of the upstairs studio showing the decorated ceiling. Although re-painted in the 1960s, it is likely that the pattern and colour is the same as the original, as the prickings in the plaster have not been altered. The studio was used as a sitting room until the rest of the house was decorated.

ABOVE RIGHT Caricature of Morris by Burne-Jones.

At mealtimes, Morris was mercilessly teased because it was so easy to wind him into a paroxysm of rage and then laugh him out of it again. Once, the whole company conspired to converse with him only through Jane. Then, the table would erupt in mirth. In the intervals of painting, the men were apt to indulge in 'triangular bear-fights', made easier because the rooms were still only sparsely furnished. In the middle of one 'scrimmage' that surged up the steps to the top of the great settle, Faulkner 'suddenly leapt clear over the parapet into the middle of the floor with an astounding noise'. Another time, he 'stored windfall apples in the gallery and defended himself with them against all comers until a too well-delivered apple gave Morris a black eye'; all was very boisterous and boyish.[61] One evening they had a game of hide-and-seek in the half-empty house. Ned disappeared into the black depths of an unlighted room for so long that Janey, 'who is the seeker, grows almost terrified'. Georgie watches her creep closer and closer, 'and at last I hear her startled cry and his peal of laughter as he bursts from his hiding-place'.[62]

Outside in the orchard, the apple trees were studded with fruit. One imagines the men in the garden, Faulkner smoking his pipe while the others paced the bowling lawn. Perhaps the women watched from the oriel bay in the drawing room, busy with their ever-present sewing and mending, or in stitching the dark blue *Daisy* hangings. 'The work went quickly,' as Janey recalled.[63] At other times they sat in the porch leading to the well-garden, which Morris named 'the Pilgrims' Rest', as if Chaucer's Canterbury-bound characters might have sat there. With its wooden benches and solid red-painted table, this was a small garden room. One morning Georgie saw in Janey's workbasket a tiny, new garment, 'fine, small and shapeless; a little shirt for him or her'.[64] By September 1860 Janey was five months' pregnant.

Indoors, Ned was at work on the mural of Sir Degravant and Melidor. That is, unless Rossetti was correct in describing Ned's wall painting of September as 'images of the Chaldeans' in vermilion 'after the manner of no Babylonians of any Chaldea', which is otherwise mystifying.[65] Madox Brown was also at work; probably helping Morris with his picture of Janey as *La Belle Iseult*, which has some passages very typical of his style and, when abandoned by Morris, found its way into the Browns' London home.[66] Morris, who never sat still, decorated the inside of the Chaucer wardrobe with naïve images of a medieval lady,

ABOVE Side view of the settle in the drawing room. Originally painted 'ox-blood' red, the settle came from Morris and Burne-Jones' lodgings in Red Lion Square and was reassembled and built into the structure of the house. The ladder leads to a small 'musicians gallery' and a door into the roof space.

appropriate to a dressing room and began painting the hall settle with its as-yet unidentified courtly garden scenes.

In the afternoons while the men carried on painting, the women went out driving, exploring the countryside. Janey later relayed Morris' account of buying the Red House horse at a gypsy fair in Clay Cross in Derbyshire. 'Would that she could have given the very words!', lamented May, 'for it was all presented to her dramatically, dialogue and action: what the horse-dealer said to him and what he said to the horse-dealer'. According to Janey, 'it was very, very funny!'. [67] The wagonette that the horse pulled was built in Bexley by a local wheelwright and coachbuilder. It had a tilt or canopy 'like an old-fashioned market cart' made of oilcloth lined with chintz. The Morris family coat-of-arms was painted on the back. Despite this sign of gentility, the equipage aroused amusement in the neighbourhood, being taken as the advance guard of a travelling circus. It was driven by a groom, one of the team of servants who supported or indeed ran the household in the early days. [68] They were headed by cook Charlotte Cooper, who was seven years older than her mistress. Housemaid Jane Chapman laid fires, heated water, made beds, cleaned floors, served and cleared meals, scoured the pots and fetched in coal. The groom was twenty-five year-old Thomas Reynolds, responsible for horse, wagonette and stable. A little later, they were joined by a nursemaid or nanny, Elizabeth Reynolds, who like Thomas was born in Essex and was in all likelihood his relation recruited by Morris' mother.

The housekeeping had its problems. Later William and Janey looked back laughingly at the minor disasters – 'every fantastic failure' of the early days – as they learned the ropes. Janey was new to the role, while Morris was accustomed to his mother's well-run household. Supplies must have come from grocers and butchers in Bexley village and there were enough gentry houses in the neighbourhood for a message and delivery system to operate. Coal deliveries probably came from a depot near the station, and must have been carried through the garden to the kitchen yard.

One of Morris' notebooks, the kind carried in a pocket for sketches and memoranda, survives from this period. [69] As May Morris later wrote, 'in turning its leaves, holding the book this way and that, you enter at once into the happy, busy atmosphere of Red House.' [70]

Some pages have small caricatures, one showing Morris as François I, whose portrait in the Louvre Rossetti said was his spitting image. Others show room plans with measurements, sketches of ceiling patterns, 'Good Wimmen' designs, notes for poems or stories, floral patterns, heraldic birds and figure sketches. Some, though not all, fed into the intensive decorating and embroidery.

Friends continued to travel up and down for most of the autumn. Lizzie, now pregnant, came to stay in December, Gabriel going back and forth as he completed outstanding picture commissions. Lizzie was tall and stately, with copper hair and fair skin to contrast with Janey's dark hair and complexion. The two women could have had many discussions on pregnancy and childbirth, except that in Victorian times these were not topics for conversation. Georgie had only learnt of Janey's condition through the small garment in the workbasket.

Nevertheless, Janey and Lizzie may have shared their comparable Cinderella stories. As shopkeepers, Lizzie's family was by no means as poor as Janey's, but she too had been lifted into another social and cultural sphere through meeting the group of artists who placed Rossetti at their centre. Now thirty-one, Lizzie had been a dressmaker and milliner when first 'discovered' by one of the painters. Like Janey she had modelled for various pictures, including the now-notorious image of Ophelia floating to her watery death, painted by John Everett Millais. Then Rossetti had claimed her as exclusive model, sweetheart and fellow artist. They were too young and impoverished to marry, but long engagements were commonplace. Gabriel refused to make their engagement public and after a while seemed to tire of it, flirting with other models and allowing them to fall for him, as Janey had done in the first weeks of posing for him as Guenevere. As if aware of the danger, he had then fled to join Lizzie again. They spent six months together in Derbyshire, followed by an unexplained estrangement. In 1859 Gabriel took up with a buxom blonde who called herself Fanny Cornforth. Meanwhile, Janey married Morris.

In May 1860, Gabriel finally married Lizzie, and against expectations proved a caring husband. She met Georgie and Ned for the first time in July. Janey and Morris were already at Upton, so may have first seen Lizzie on a visit to Red House sometime in October, or on their own visit to the Rossettis at the end of November. They took her back to Kent with them, to keep Janey company during the last weeks of pregnancy. Gabriel joined them for Christmas,

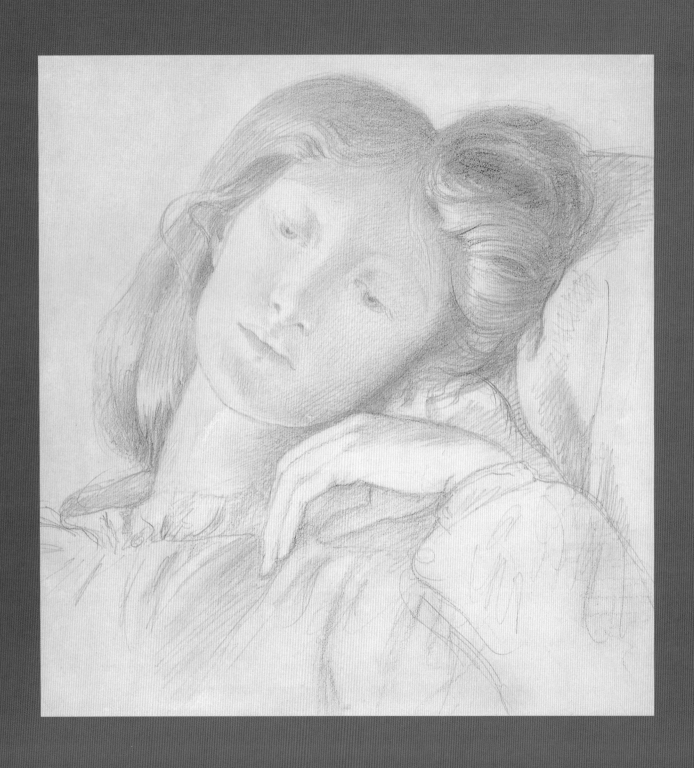

and took the opportunity – the first since summer 1858 – to draw Janey's head, seeing it as an apt model for that of Mary in the Nativity altarpiece he was painting for Llandaff cathedral. It is signed and dated 'Upton / Xmas 1860'.

Though the Burne-Joneses were elsewhere for Christmas, Webb may have come to Red House. Perhaps the holiday season brought Charley Faulkner again, with his sisters Lucy and Kate. By New Year, the Rossettis were back in Blackfriars, Lizzie still never very well. A little while later Emma Madox Brown, mother of three, came to Red House to assist when the Morrises' first child, Jane Alice (known as Jenny), was born on 17 January. Morris affected to take this in his stride, writing laconically to Ford: 'My dear Brown, Kid having arrived, Mrs Brown kindly says she will stay till Monday. P.S. Janey and kid (girl) are both very well.' [71] But somehow, the birth marked a new departure.

Morris was temperamentally active and impatient with what his business manager George Wardle later called 'a certain *impetus* in his manner as if he would still go at twenty miles an hour and rather expected everything to keep pace with him'. [72] Indeed, Morris had written prophetically of himself, that 'if it were possible, and I made up my mind to do it, then and there I began it, and in due course finished it, turning neither to the right hand nor the left till it was done. So I did with all things that I set my hand to'. [73]

Janey would have been confined to her room for at least a month after Jenny's birth, in company with the maternity nurse. Hospitality was temporarily curtailed; the interior decoration of Red House put on hold. Now Morris had a new project. 'You will see that I have started as a decorator which I have long meant to do when I could get men of reputation to join me,' he told an old friend a few weeks later. [74] The idea was probably hatched at Christmas or New Year. On 26 January Ned announced that he 'and Morris and Rossetti and Webb were going to set up a sort of shop where they would jointly produce and sell painted furniture'. [75] Gabriel gave further details: 'We are organising a company for the production of furniture and decoration of all kinds for the sale of

LEFT Pencil sketch of Lizzie Siddal by Rossetti (1860). Although the couple had a turbulent relationship before their marriage, once married, Gabriel proved an attentive husband.

ABOVE RIGHT Morris & Co.'s shop front at 449 Oxford Street, London (1911). Originally located in Red Lion Square, the business moved first to Queen Square. In 1877 a shop was opened at 264 Oxford Street (re-numbered 449 in 1882), while the workshops moved to Merton Abbey in south London.

which we are going to open an actual shop!', he wrote. 'The men concerned are Madox Brown, Jones, Topsy, Webb … Peter Paul Marshall, Faulkner and myself. Each of us is now producing at his own charges one or two (and some of us more) things towards the stock … we expect to start in some shape about May or June, but not to go to any expense in premises at first.' [76]

This was the launch of the artists' partnership formally known as Morris, Marshall, Faulkner & Co. (and later just Morris & Co.), but commonly called the Firm, which grew from and superseded the decorative schemes at Red House. Morris' prodigious energies were diverted: mural and cupboard decoration was laid aside along with easel painting, and other plans abandoned almost as soon as projected, like the scenes of Troy for the hall. Probably sometime this winter, as the coldness of the house was felt, the moveable settle with leather panels and curved top was designed by Webb; it was a foretaste of things to come. [77]

Several members of the projected Firm gathered again for Jenny's christening on 21 February. It was wet and windy. 'I remember the flapping of the cover of the wagonette and a feeling of hurry-skurry through the weather,' recalled Georgie. [78] The ceremony took place at the Christchurch chapel, built on Bexley Heath in the 1830s to Pugin-style designs by architect Robert Browne. Local residents recalled high-backed pews, a very high pulpit, and alternating

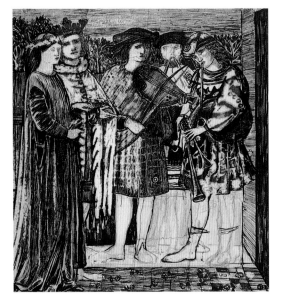

curates dubbed 'Brimstone' and 'Treacle' according to their sermon styles. The meal after Jenny's christening was set on tables in the hall and must have resembled the scene in the Degravant mural. The Burne-Joneses, Browns, Marshalls and Rossettis were there, together with Swinburne. 'Janey and I went together to look at the beds strewn about the drawing room for the men,' Georgie continued, 'Swinburne had a sofa; I think Marshall's was on the floor.' [79] Georgie was now also pregnant; perhaps she and Ned enjoyed the privilege of a guest bedroom, though quite possibly she slept with Emma Madox Brown and Mrs Marshall. Lizzie was close to her confinement, and always nervous unless Gabriel was at her side.

The Marshalls' presence at the christening suggests that plans for the Firm were being finalised. Indeed, the initial idea of a shop,

ABOVE Study for the *Wedding Procession of Sir Degravant*, one of the Sir Degravant murals in the drawing room, see pages 44–45.

stocked with items designed by the partners but manufactured by others, soon turned into a showroom with some in-house production. Premises were leased at 8 Red Lion Square from 25 March; Morris was never one to dawdle. Glass-painter George Campfield was employed as foreman. 'Morris Marshall Faulkner & Co, Fine Art Workmen in Painting, Carving, Furniture and the Metals', was formally incorporated on 11 April. A business prospectus was issued offering mural decoration (pictures, patterns, colour schemes), wood- and stone-carving, stained-glass, furniture (both painted and plain), embroidery and 'every article necessary for domestic use'. [80] With virtually no experience or capital, the company was launched.

By this date Arthur Hughes had joined the enterprise, only to resign almost immediately. 'I was living far in the country while the others were in town, and attending the meetings was inconvenient for me,' he explained. [81] Partners' meetings took place on Wednesday evenings, so Morris stayed overnight in town. And thus from Easter 1861, only seven or eight months after moving to Red House, life there changed, as Morris became a commuter, travelling up and down from Abbey Wood to Holborn.

Generally, the weekends remained convivial. Guests usually arrived on Saturday. Swinburne, whom Georgie described as 'restless beyond words ... almost dancing as he walked, while even in sitting he moved continually, seeming to keep time by a swift movement of the wrists', was there again on Census night, 7 April 1861. [82] Faulkner came the same month, writing an interrupted letter: 'You see I did not succeed in completing it when staying down at Topsy's,' he explained, 'the day was so beautiful and there was so much to do in the way of playing bowls and smoking pipes that the day passed without leaving time to do anything.' [83] One friend – perhaps the self-effacing Webb – nostalgically recalled the beautiful sight of 'Morris coming up from the cellar before dinner, beaming with joy, with his hands full of bottles of wine and others tucked under his arms', while Georgie's memory was evergreen: 'Oh the joy of those Saturdays to Mondays at Red House!' she wrote, 'the getting out at Abbey Wood station and smelling the sweet air, and then the scrambling, swinging drive of three miles or so to the house; and the beautiful roomy place where we seemed to be coming home just as much as when we returned to our own rooms. No protestations – only certainty of contentment in each other's society. We laughed because we were happy.' [84]

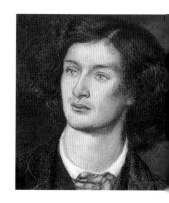

ABOVE Poet Algernon Swinburne (1837–1909) drawn by Rossetti in 1861, when Swinburne was a frequent guest at Red House. He met Morris at Oxford and his early poetry reflects their shared fascination with medieval subjects and forms.

IN ARTHUR'S HOUSE WHILEOME WAS I
WHEN HAPPILY THE TIME WENT BY
IN MIDMOST GLORY OF HIS DAYS.
HE HELD HIS COURT THEN IN A PLACE
WHEREOF YE SHALL NOT FIND THE NAME
IN ANY STORY OF HIS FAME:
CAERLIEL GOOD SOOTH MEN CALLED IT NOT,
NOR LONDON TOWN, NOR CAMELOT;
YET THEREIN HAD WE BLISS ENOW.

William Morris, *In Arthur's House*

On Monday mornings the visitors went back to town with Morris, taking the conviviality of the weekends with them, and the social focus of the circle shifted to Red Lion Square. By June Janey was pregnant again and must have been rather lonely, with her husband away each day and some weekends too, for he was a member of the volunteer militia corps. They did not go to church, and made no friends in the district. If they knew the new occupants of Aberleigh Lodge, the family of Henry Bailey, a manufacturer of lace trimmings, no record has survived. There are indeed hints that neighbours regarded the household as too bohemian for the usual courtesies.

The Burne-Joneses were occupied with their own preparations for parenthood and at the beginning of May, the Rossettis suffered the distress of a stillborn daughter which drove Lizzie into deep depression. When Georgie and Ned visited, they found Lizzie rocking an empty cradle, bidding them hush. She was taking large quantities of laudanum, an opiate drug, to blot out the pain, to help her sleep and to calm her nerves. Gabriel did not like her to be alone while he was working, so she stayed with the Browns for the first week of June, and a month later went to Red House. This must have been the visit when she asked her husband to come and help with the figure she was painting, which she feared would have to be started all over again, 'for I am too

ABOVE Small glass pane designed by Webb from the windows of the ground floor passage leading to the Pilgrim's Rest porch (c.1862–63). Various birds are featured, here the details shows a flying duck, see page 79 for other examples.

ABOVE LEFT Jane and Jenny Morris by local photographer H. Smith of Bexley Heath (c.1864). Born in 1861, Jenny developed epilepsy in her teens and required permanent care thereafter. Morris cared deeply about his daughter and wrote many affectionate letters to her in the 1880s.

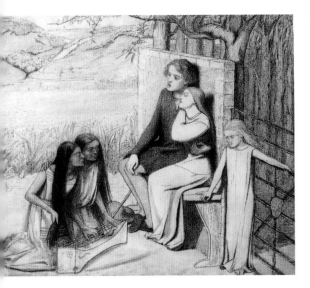

blind and sick to see what I am about'. [85] Morris' small notebook from this era, which also contains a draft of the Firm's prospectus, holds a tiny sketch of a grieving woman with heavy wings of hair, and a baby angel or soul rising from her arms. [86] Just possibly, this is an imaginative reference to the death of Lizzie's child.

In October Philip Burne-Jones was born, further curtailing his parents' visits to Red House. Janey went up to town to see Georgie and her son just before Lizzie again went to stay with the Morrises, while Gabriel went north for a portrait commission. The second Red House Christmas was quiet. In the New Year of 1862, Ned fell ill and before he was better, Lizzie died of a laudanum overdose. In his grief Gabriel consigned his manuscript notebook of poems to her coffin in a sacrificial gesture: art and poetry had been his main hope of helping Lizzie overcome their loss. He then withdrew from normal social life and spent no further weekends at Bexleyheath. Though Ned told a friend that 'Top thrives ... and is slowly making Red House the beautifullest place on earth', there was no gathering at Red House to celebrate the birth of baby May at the end of March, nor her baptism two months later. [87]

Indeed, all concentration was on items for the Firm to display at that year's International Exhibition. 'I wish you could see a painted cabinet with the history of St George and other furniture of great beauty which we have in hand,' Gabriel had written in January. 'We have bespoke space at the Great Exhibition and hope to make the best show there that a short notice will permit of.' [88]

Several items of furniture are similar to those painted at Red House. Most, including the St George cabinet with its narrative panels painted by Morris, were produced at Red Lion Square. A second heavily stitched textile was also produced there, with a motto taken from Chaucer's *Parlement of Fowls*: 'Qui bien aime tard oublie'. The design, on a deep pink or red ground, consists of a tree, a scroll and a heron taking flight. Like the 'If I Can' textile, this was probably stitched by a team of needlewomen, not including Janey, who was occupied with motherhood, domestic needlework and other works

ABOVE *Lovers Listening to Music* (1854), an early drawing by Elizabeth 'Lizzie' Siddal (1829–62). After the loss of her unborn daughter, Lizzie became dependent on laudanum and died from an overdose. It is said that when summoned by a distraught Rossetti, Madox Brown destroyed a farewell note pinned to her nightgown. The inquest recorded a verdict of accidental death, but it is now regarded as almost certainly suicide.

BELOW Cabinet designed by Webb and painted by Morris with scenes from the legend of St. George. This was exhibited by the newly formed Firm at the 1862 International Exhibition on the site of what is now the V&A (V&A).

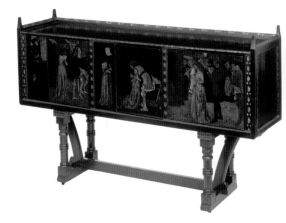

for the Firm. It is thought she contributed to the wares for the 1862 Exhibition by embroidering a crimson altar-frontal with pomegranates and Tudor roses. [89]

The Burne-Joneses were in Italy with the critic John Ruskin when the Exhibition opened. Though they probably went to Bexleyheath later in the summer, there are few further references to Red House for that year. One visitor was the painter William Bell Scott, who purchased the 'Qui bien aime' hangings for a tower he was helping to restore in Ayrshire. He later recorded his impressions. 'The only thing you saw from a distance was an immense red-tiled steep and high roof,' he wrote, 'and the only room I remember was the dining room or hall, which seemed to occupy the whole area of the mansion.' However, it was not one room that Scott recalled but a confused amalgamation of features, including 'a fixed settle all round the walls, a curious music gallery entered by a stair outside the room … and no furniture but a long table of oak.' He remembered too a lofty, open-timber ceiling in the 'vast empty hall' that was 'painted coarsely in bands of wild foliage' and can only have been the exposed trusses above the stairwell. [90] Another visitor the following year had a better memory. 'The first sight of the Red House in 1863 gave me an astonished pleasure,' he wrote:

> The deep red colour, the great sloping tiled roofs; the small-paned windows; the low wide porch and massive door and surrounding garden divided into many squares, edged by sweetbriar or wild rose, each enclosure with its own particular show of flowers; on this side a green alley with a bowling green, on that orchard walks amid gnarled old fruit trees; – all struck me as vividly picturesque and uniquely original. Upon entering the porch, the hall appeared to one accustomed to the narrow ugliness of the usual middle class dwelling of those days as being grand and severely simple. A solid oak table with trestle-like legs stood in the middle of the red-tiled floor, while a fireplace gave a hospitable look to the hall place. [91]

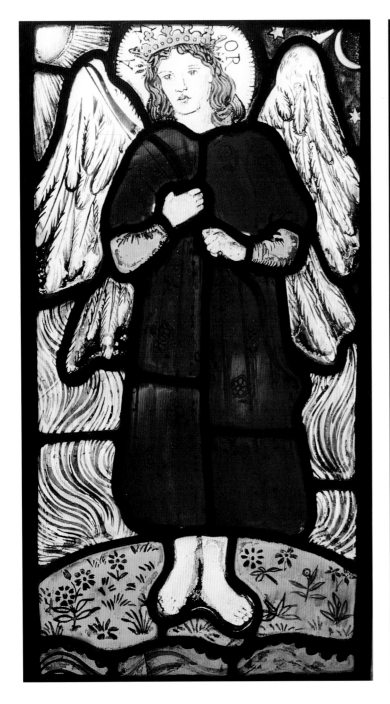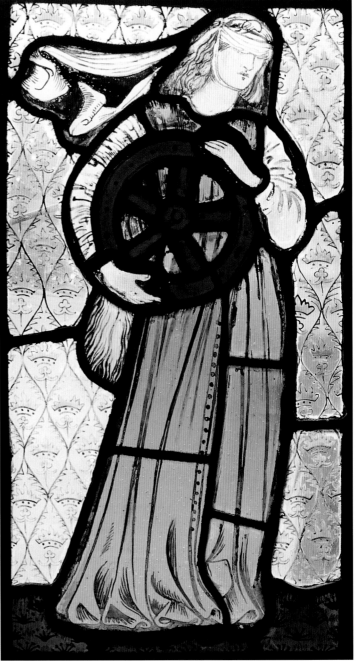

ABOVE LEFT TO RIGHT Love and Fate or Fortune. Stained glass panels (c.1863) designed by Burne-Jones and inserted into the window of the ground floor garden passage.

The dining room held its richly painted dresser, the moveable settle 'with high back, the panels of it filled with leather, gilt and coloured' and simple rush-seated Morris chairs, one of the Firm's early products. The walls were pale – no *Good Wimmen* embroideries as yet in place – and the ceiling pattern yellow on white. Upstairs, the drawing room held 'a panelled bookcase or cabinet – one scarcely knows how to describe it correctly. This great cabinet, of which the effect was gorgeous, nearly filled the end of the room. At one side was a wooden ladder stairway by which one could mount to the upper part of it and find room to sit as if on a balcony. From this stage another short ladder led into a storage loft in the roof beyond.' [92] Writing in 1897, this anonymous visitor 'who used to know the house in the old days' was probably George Campfield, workshop foreman in Red Lion Square. [93]

By the time of his visit, the Firm had left its mark on Red House. As well as the ebonised settle, heavy oak tables and dainty rushed chairs, the workshop in Holborn produced painted glass and tiles. The decorated quarries in the windows, with Webb's lively birds, must date from around 1862-63, while the figures of Love in red and Fortune or Fate in green, both drawn by Burne-Jones, are later, imperfectly-fitting inserts. A similar pair was set into bottle glass in the Burne-Jones' later home in

ABOVE Glass panels of farmyard birds by Philip Webb for the windows of the ground floor passage garden passage (c.1862–63). The various birds shown are (left to right) a hen and chick, crowing cockerel and a farmyard duck.

Fulham. The tiles in the garden porch – perhaps a trial run from the Firm's workshop – display the Morris family's coat-of-arms and like the upstairs panes are adorned by his adopted motto in French: 'Si je puis'.

Red House also made its mark on the Firm, in the form of wallpaper designs. In the original design for *Trellis*, the green and pink motif is outlined against three possible grounds, pale-green, brick and grey, but in the finished paper the most popular colour was the sky-blue that on a fine day was glimpsed through the rambling roses at Red House. *Daisy*, the first to go into production in February 1864, was a simple but lively reworking of the navy blue serge hangings for the main bedroom, re-cast on a pale, medium or dark ground. Then came *Fruit*, as if commemorating the orchards of Upton, although here the fruits are not Kentish apples and

cherries but Mediterranean lemons, oranges and pomegranates. All three papers are still around today, in enduring tribute to the inspiration of Red House.

In late spring 1864, Ned and Georgie, again pregnant, came to stay bringing Georgie's sisters Louisa and Agnes Macdonald. Working in Morris' studio, Ned gave visual expression to idea of harmonious life away from urban bustle in the little painting *Green Summer*, which shows Georgie reading to a group of girls in the garden. Jenny and May later recalled one of Swinburne's midsummer visits when he lay on the grass under the orchard trees as the little girls gathered rose petals to scatter on his face. Poet William Allingham arrived one Sunday in July, losing his way from the station. 'After some wandering, find the Red House in its rose garden,' he recorded in his diary, with 'William Morris, and his queenly wife crowned with her own black hair.' Leaving at 7.30 the next morning, he just had time to note the famous rose-trellis, together with Jenny and May 'bright-eyed, curly-pated' saying goodbye to their 'brusque, careless' father on his way to the city. [94] Ned drew a comic sketch of Morris trying to eat, his arms encircling both daughters.

But the inference is that the idyll was fading. The Firm had yet to become profitable and though Morris' private income for 1864-65 was still over £600 a year, his expenses were high. To raise additional funds, his picture collection was up for sale. Liverpool banker George Rae bought *April Love* and 'six and a half' watercolours by Rossetti (the small *Damsel of the Sangrael* being the half), while Brown re-purchased his *Hayfield*. [95] Next to go were Rossetti's painted panels of Dante and Beatrice for the drawing room settle, sold as a diptych. Above all, Morris had to give more and more time to the business, as Mackail's biography tells us, 'and the expense and fatigue of managing it from Upton both increased likewise.' [96] This was not how Joyous Gard was meant to be; commuting killed the idyll.

In the summer he came up with a solution: establish workshops near Red House, so as to manage most of the production from home, while keeping a showroom in London. In addition, the house should be extended with the Burne-Jones family occupying a separate wing. Webb prepared the plans. The proposed addition was to enclose the well-garden like a cloister. But it complemented rather than matched the existing house, being partly timber-framed, with some lower walls in ragstone and others tile-hung. The design illustrates the development of Webb's

LEFT Ebonised and rush-seated settee or low settle from the *Sussex* range sold by Morris & Co. from around 1865. Seen here in the Pomegranate Passage at Wightwick Manor in Wolverhampton (National Trust) in front of tapestries by the Royal School of Needlework to designs after Burne-Jones' *The Mill*.

ABOVE Detail of Daisy wallpaper (1864) at Cragside in Northumberland, owned by the National Trust.

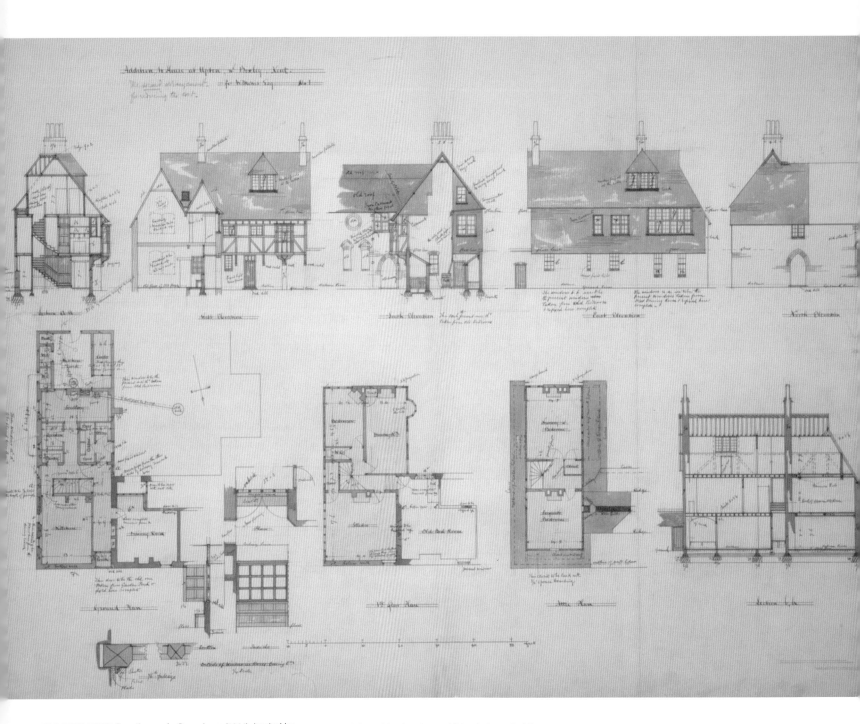

PREVIOUS PAGES *Green Summer* by Burne-Jones (1864). Inspired by Venetian art, this depicts an idyllic scene. The figure in black, loosely modelled on the artist's wife Georgiana, is reading to a group of girls.

ABOVE Philip Webb's plans for an additional wing to Red House, designed for the Burne-Jones family in 1864, but unexecuted. The design complemented, but did not copy the original building.

ideas. Within a year or so of designing Red House, Sheila Kirk comments, Webb had become convinced that 'new buildings should reflect – but not copy – only the traditional local and national architecture.' [97] In its mixture of materials the proposed addition recalls the patchwork fabric of Ightham Mote, near Sevenoaks. Described as 'the oldest and loveliest of medieval manor houses', this was a favourite of the Society for the Protection of Ancient Buildings founded in 1877 by Morris and Webb, and is now also in the National Trust's care.

The Morrises and Burne-Joneses likened the potential home to the 'lordly pleasure-house' in Alfred Tennyson's *The Palace of Art*, which Rossetti and friends had illustrated in 1857:

> Four courts I made, East, West and South and North,
>
> In each a squared lawn ...
>
> And round the cool green courts there ran a row
>
> Of cloisters, branch'd like mighty woods ...
>
>
> Full of great rooms and small the palace stood
>
> All various, each a perfect whole,
>
> From living Nature, fit for every mood
>
> And change of my still soul.

In the poem, some rooms are hung with green and blue tapestries, while another 'seem'd all dark and red'. In this realm of art, remote from the world, the soul prospers for three years; in the fourth, she falls, struck 'with pangs of hell' and 'dread and loathing of her solitude'. The analogy is false but the familiar phrases surely hit chords when the proposed wing was thwarted by a series of disasters. Morris certainly understood the moral message of Tennyson's poem about the escapist uses of art. Ned recalled: 'A lovely plan was made, too happy ever to come about ... it was that Morris should add to his house, making it a full quadrangle, and Webb made a design for it so beautiful that life seemed to have no more in it to desire – but when the estimates came out it was clear that enthusiasm had outrun our wisdom and modifications had sadly to be made.' [98]

Nor was expense the only hindrance. In September both families took a seaside holiday with Charles Faulkner, his sisters Kate and Lucy and his mother, a foretaste of renewed companionship. Georgie recalled 'three most happy weeks' with housekeeping responsibilities lifted from Janey and herself, and evenings 'always merry with Red House jokes revived and amplified: laughs with so little cause, and yet the cause remembered still!' [99] Then she and Ned went again to Red House, still full of plans. But their son Phil had scarlet fever and back in London Georgie caught the infection, causing the premature birth of her second son, who died aged three weeks while she was still dangerously delirious. Ned wrote to withdraw from the lovely plan of building their own wing to Red House.

Morris himself was in bed with rheumatic fever when he replied:

> As to our palace of art, I confess your letter was a blow to me at first, though hardly an unexpected one – in short, I cried, but I have got over it now. As to our being a miserable lot, old chap, speaking for myself I don't know, I refuse to make myself really unhappy for anything short of the loss of friends one can't do without. Suppose in all these troubles you had given us the slip [i.e.died] what the devil should I have done? I'm sure I couldn't have had the heart to go on with the Firm: all our jolly subjects would have gone to pot – it frightens me to think of, Ned. But now I am only 30 years old, I shan't always have the rheumatism, and we shall have a lot of jolly years of invention and lustre plates together I hope. [100]

The letter is lengthy and goes on to describe other possibilities, including a shared studio in London, and meantime suggests a long visit to Red House, where Ned could work 'quietly and uninterruptedly' and Georgie and Janey 'will be able to drive about with the kids jollily … Janey is exceedingly anxious that you should come …' There was yet no suggestion of leaving Red House, but the collapse of the plan was a blow. The problem of running glass-painting and furniture workshops in the country must also have been plain. Then in the New Year, Jane fell ill, and the deficiencies of Bexleyheath became evident. The once-idyllic location was unsuited 'for medical or other aid in emergencies'; the top doctors were all in London. [101]

Janey went to convalesce at Hastings. In Oxford, her father died, and her sister Bessie was

invited to live at Red House to keep Janey company and perhaps in the hope that she would find a husband among Morris' eligible acquaintances. When Janey returned home, Georgie and Ned took Agnes Macdonald on a short visit to Bexleyheath. 'Janey is very kind and nice indeed, but so weak and delicate as really to make one uneasy', she reported, 'she looks very pallid in deep mourning, for she needs bright colour you know.' Because the house was full, Aggie was obliged to sleep in the housekeeper's room, which was so small that 'I and my crinoline can't be contained in it'. [102] To make way for Aggie, the cook had no doubt been put in with the housemaids. Janey and Morris slept in the north wing bedrooms, and the two rear bedrooms were occupied respectively by the Burne-Joneses and Jenny and May with their nurse. Bessie probably had the ground floor bachelor's bedroom.

Bessie was twenty-two, a shy girl seemingly without Janey's aptitude. 'Miss Burden is a little pleasanter I think, but as she doesn't talk it doesn't very much matter,' noted Aggie brutally. [103] She lived with the Morris family for several years, but did not blossom; indeed, she appears to have been a curiously disregarded sister and aunt. Morris found her a bore, even while recognising Bessie's usefulness to the Firm as a skilled needlewoman, and later a teacher of embroidery.

Around Easter 1865, Morris took the decision to leave Red House. He looked for new premises that would house both the family and the business, and a lease on 26 Queen Square in Bloomsbury was taken from midsummer. Red House was put up for sale.

It was the location not the house that failed: commuting wasted several hours a day, and the drive to the station was often wet and windy or icy in winter. Doctors could not be easily summoned. Possibly the journey deterred friends like Madox Brown and Rossetti who saw Morris at meetings of the Firm. And across Upton the 'march of bricks and mortar' was visibly advancing. There were other, unspoken troubles. Despite his energy, Morris' brusque manner was often gruff and surly. 'He wouldn't say or unsay a thing to please you,' noted Ned, 'and it wouldn't trouble him if you didn't like him.' [104] Janey was reserved, still insecure, and weakened by illness, even though she was only twenty-five. Her husband was absorbed in business worries; their relationship seemed to be shutting down.

Today, Red House is seen as such a unique and attractive house that, as Morris, Ned,

Georgie and others have recalled in passages quoted here, we want to believe that the time they spent there was all happiness and delight. However, life there had not lived up to the promise of 1860; it was not a perfect house, and the Morrises' social isolation aggravated its defects. Morris was disappointed, and perhaps critical of himself for failures of foresight. But, as he himself stated, as well as sticking to what he had begun, he also let things go:

> I could soon find out whether a thing were possible or not to me, then if it were not, I threw it away for ever, never thought of it again, no regret, no longing for that, it was past and over to me. [105]

As friends arrived for final visits, the last summer at Red House almost matched the first. Before that, there were tastes of a future social life to be enjoyed in London. One party that the Morris family attended was on 12 April at Rossetti's new home Tudor House, facing the river at Chelsea. The Morrises dined beforehand with the Burne-Jones family in Kensington; other guests included the Madox Browns, with their daughters Lucy and Cathy, the Hugheses, the Munros, William Rossetti (Gabriel's brother), Swinburne, Bell Scott and French artist Alphonse Legros with his English wife.

Soon after, another party was thrown by the Madox Browns; this time the Morris family were accompanied by Bessie. As well as the usual crowd, guests included Christina Rossetti (Gabriel's sister), and the artist James Whistler. Morris was never much of a party-goer, but it was always preferable to complain about having too many social engagements than not have any.

Rossetti was especially eager for his friends to return to London. In widowhood he had found comfort (and comedy) in the company of his old flame Fanny Cornforth. She was often in residence at Tudor House, alongside Swinburne and the poet George Meredith, who for a while were Gabriel's housemates. But above everything he loved drawing Janey, with her firm features, dark mass of hair and grave repose. He began promising patrons pictures painted from this 'very Queen of Beauty'. [106] At the party on 12 April, she must have agreed to sit for him. But she would not be leaving Bexleyheath until the autumn, and Rossetti evidently did not want to travel there. Instead he organised a photographic session: 'My dear Janey,' he wrote on 5 July, 'the

RIGHT From a series of photos of Janey Morris, photographed by John R. Parsons and commissioned and posed by Rossetti in the garden of his Chelsea home. These portraits were to serve as studies for future paintings (1865). Rossetti had first admired Jane's dark hair and features in Oxford in 1857.

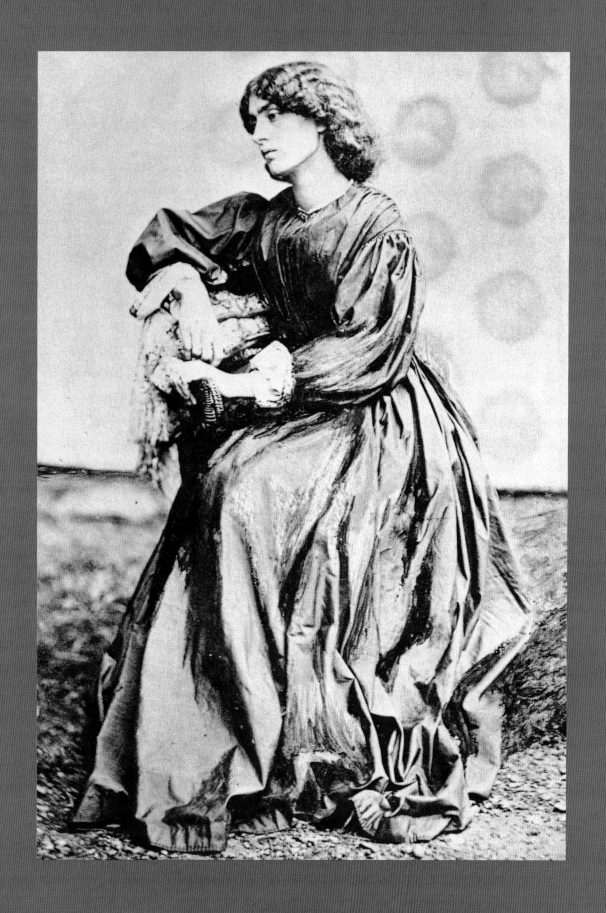

photographer is coming at 11 on Wednesday. So I'll expect you as early as you can manage. Love to all at the Hole.' [107] She travelled up with Morris and Bessie, he going on to the Firm and Bessie acting as chaperone. In Gabriel's garden Janey stood, sat and reclined in a variety of poses, to be used as the basis for new compositions. In time, Janey's features would become an obsession.

'The last visit we paid to Upton was in September 1865,' wrote Georgie, 'when on a lovely afternoon Morris and Janey and Edward and I took a farewell drive through some of the beautiful little out-of-the-way places that were still to be found in the neighbourhood. Indoors, the talk of the men was much about *The Earthly Paradise*, which was to be illustrated by two or three hundred woodcuts, many of them already designed and some even drawn on the block.' Morris had thrown himself into a new project even while masterminding the Firm's removal and some major new commissions.

Imaginatively at least, this poetic endeavour can be seen as compensation for the loss of Red House. Based on Chaucer's sequence of tales by different narrators, *The Earthly Paradise* is an epic poem framed by a fictional voyage of Norsemen, sailing in search of an Eden-like place 'where none grow old' and which proves non-existent. Settling instead in a distant city, they swap stories – alternately classical and northern – with the residents. The introductory poem was first entitled *The Fools' Paradise*, then *The Wanderers*, then *The Terrestrial Paradise*, and the whole project occupied Morris for five years. One wonders if the false starts – the poem opens in March – began during the dreary rail journeys to and from Upton, when enforced inactivity must have pained Morris as much as the views from the window, prompting him to evoke an earlier idealised age:

> I tell of times long past away
> When London was a grey-walled town,
> And slow the pack-horse made his way
> Across the curlew-haunted down. [109]

As well as compensation, *The Earthly Paradise* was a farewell. As the autumn drew near, the Morris family moved into smoky central London, into a house without a garden.

LEFT Self-portrait as if for stained glass (c.1865). One of many caricatures by Burne-Jones, who liked to contrast Morris' rotundity with his own attenuated figure.

So 'the beautiful Kentish home was deserted and the sunny rose-garden with its fragrant rosemary and lavender borders no longer sounded with the laughter of guests and the knocking of bowls over the green,' [110] Thus wrote May Morris nearly fifty years later. Just three-and-a-half years old when the family left Red House, she confessed to retaining only 'dream-pictures' of life there, 'too intimate and tender for description' but 'strangely intense' too. What she eventually recorded was what she, like later generations, had read in other works. Although rose-tinted, it nostalgically recreates the best of life at Red House:

ABOVE Morris eating with his daughters Jenny and May (1864–65). Caricature by Burne-Jones.

The story of how he built a beautiful home to receive his wife and his friends, of the happy, vivacious days the young circle spent among the blossoming orchards in a forgotten corner so near the rush and hurry of the city, all this has been told time and again, though I think the charm of the busy life, at once so gay and so full of seriousness, will never grow stale in the telling. Laughter sounded from the half-furnished rooms where the young people painted the walls with scenes from the Round Table histories; laughter sounded from the fragrant little garden as the host, victim of some ingenious practical joke, fulfilled the pleased expectation of his guests by conduct at once vigorous and picturesque under the torment; laughter over the apple-gathering, laughter over every new experiment, every fantastic failure of the young housekeepers; but amid the delight in mere existence and in the beauty of the earth, these young lives were ripening and developing in all seriousness, and their laughter was not the crackling of thorns under the pot. If I linger a little in touching upon the light-hearted exuberance of all these closely bonded personalities ... it is partly because the contemplation of work and play so interchangeable, so thoroughly enjoyed, is itself stimulating to a more languid (and perhaps a less hard-working generation). And though they one and all settled down to the responsibilities of London life very soon, the Red House days remain typical – an intensified illustration of much that William Morris felt and said later regarding the nature of human toil. [111]

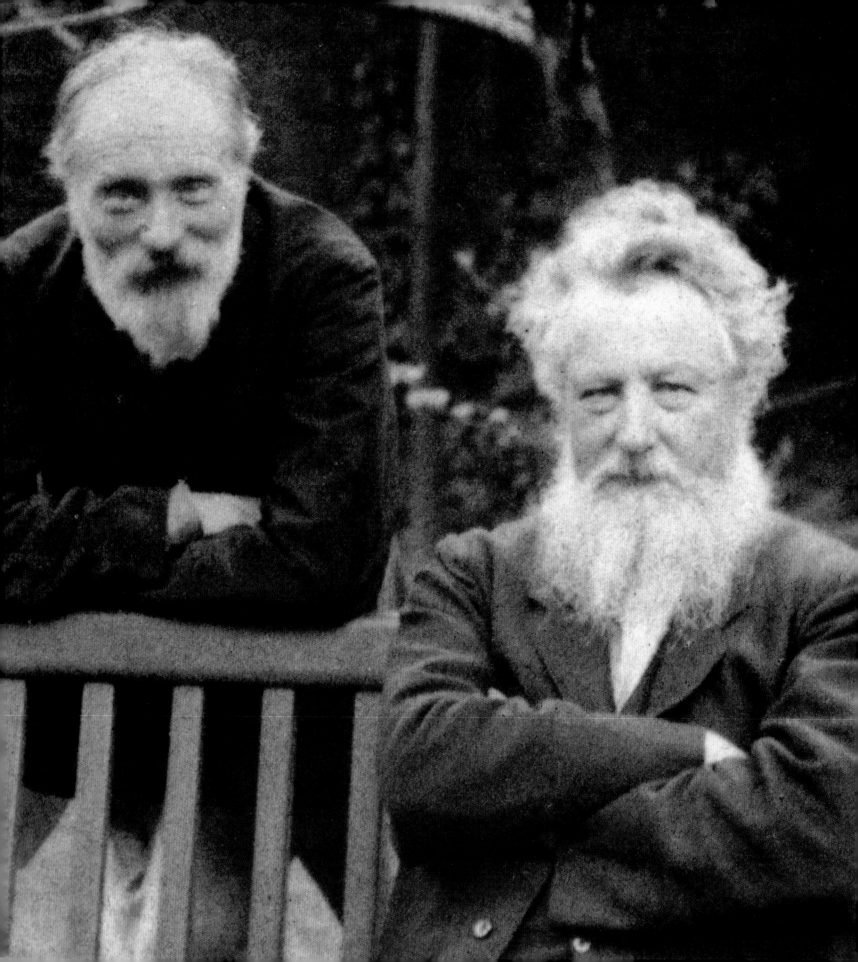

I

T IS NOT AN ORIGINAL REMARK, BUT I MAKE IT HERE, THAT MY HOME IS WHERE I MEET PEOPLE WITH WHOM I SYMPATHISE, WHOM I LOVE ...

William Morris, *How we live and how we might live*, 1887

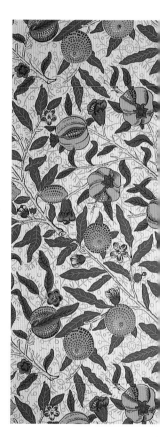

So William and Janey, their daughters and their friends left Red House. They would look back on it as a charmed era when worries about health, wealth and happiness hardly impinged on the enjoyment of life. But illness had brought anxieties, as did Morris' declining income from his family investments; by 1867–68, it was down from £700 to £440 a year. Charley Faulkner returned to teaching maths at Oxford, so for a while the major burden of managing the Firm fell on Morris' shoulders. Even so, in many ways he was less interested in business than in poetry. *The Life and Death of Jason*, published in 1867, was followed by three volumes of *The Earthly Paradise*, which appeared from 1868–70, containing over 40,000 lines of verse.

George Wardle, who became the Firm's manager in 1866, described Morris' daily workload with some amazement:

> While he was designing for painted glass, for wallpapers, textiles and occasionally for wall
> decoration, superintending also the whole of the business[,] he was engaged also with his poems,
> more or less as opportunity served. His faculty for work was enormous and wonderfully versatile.
> He could turn his mind at once to the new matter brought before him and leave the poetry or the
> design without a murmur ... I always admired the easy way in which he turned from this
> extraordinarily engrossing pursuit to attend to any other and to resume his favourite work without
> apparently the loss of a single thread, as calmly as a workman goes back to the bench after dinner. [112]

The other partners (with the exception of Marshall) continued to supply designs as and when required. Rossetti was particularly active in securing commissions, utilising his contacts with private and public patrons; as his own painting practice developed in the 1860s, more wealthy customers were persuaded of the Firm's merits. One highlight was the commission to

LEFT Morris (right) and Burne-Jones (left) photographed by Frederick Hollyer in the garden of Burne-Jones' house *The Grange* in Fulham.

ABOVE *Fruit* wallpaper (1864), designed by Morris in 1864 and hanging at Cragside in Northumberland (National Trust). Several houses now owned by the National Trust were originally furnished and decorated with products made by Morris & Co.

ABOVE Looking from the Green Dining Room in what was the South
Kensington Museum (now the V&A) decorated by Morris & Co., 1866–69.
A sequence of panels with figures by Burne-Jones is interspersed with fruit
and foliage designs and surmounted by painted gesso decoration. The
adjoining room seen through the door was decorated in neo-classical style
by Edward Poynter, Burne-Jones' brother-in-law.

decorate state rooms in St James's Palace; another was for the Green Dining Room at the museum now called the V&A.

For a while, the conviviality of Red House was transferred to Queen Square, where the Morrises often invited friends for dinner. Janey recalled weekly evenings with Webb and the Burne-Joneses, talking about *The Earthly Paradise*; Georgie remembered digging her nails into her palms to keep awake as Morris read aloud the latest epic. May described the room with its long oak table, old silver, blue-and-white china and greenish glass designed by Webb, which gleamed like air-bubbles in the candlelight and was reflected in the small mirrors of the mantelpiece. At one larger gathering she woke in the dark to hear laughter downstairs: 'I had to go and find lights and company. The small night-gowned thing standing at the door and requesting comfort was received with kind laughter and applause, and I was handed round from one to another and kissed and enjoyed myself hugely.' [113]

Philip Webb lived nearby in Gray's Inn, and sometimes Janey took her daughters to tea: 'jam and more jam, and then pictures to look at, and Mr Webb's jokes, at which we laughed because he laughed and loved us, for I am sure we did not understand them.' [114] Or they would visit Faulkner's mother and sister on the far side of Queen Square and watch while tiles for the Firm were painted with a thin, long-handled brush. Janey and Bessie managed the embroidery side of the business, supervising the outworkers and executing some commissions themselves. Their network of skilled needlewomen included Catherine Holiday, wife of painter Henry Holiday.

Webb was working steadily at a succession of commissions that owed little to Red House architecturally, which lends weight to the picture of it as full of youthful idiosyncrasies, superseded by experience and maturity. After Sandroyd came Arisaig House in Invernesshire (1863–64); a house in Holland Park in London for painter Val Prinsep (1864–65); Washington Hall in Durham for ironmaster Sir Isaac Bell (1864) and a London house for painter George Howard, later Earl of Carlisle (1867–68).

In Kensington Square the Burne-Joneses hosted an evening party with music and dancing. 'The house, being newly decorated in the "Firm" taste, looked charming, the women looked lovely and the singing was unrivalled,' noted Ford Madox Brown, 'and we all escaped with our lives, for soon after the guests were gone, the ceiling of the studio (about 700lb of plaster) came

down just where the thickest of the gathering had been all night.' [115] Morris escaped with his life, for he had been due to bed down on the sofa exactly where the plaster fell. In June 1866, Georgie and Ned welcomed a daughter named Margaret; later the Burne-Jones and Morris children would become play-fellows and, with the Burne-Jones' cousin Rudyard Kipling, produce a house magazine called 'The Scribbler'.

Morris' male friends were now in their late thirties. Rossetti turned 40 in 1868, Webb in 1871, Ned in 1873. Janey was thirty in 1869, Georgie the following year. And by this date, their lives had taken several unforeseen twists and dives. Through a new family of patrons headed by Constantine Ionides, the close-knit circle who had been so often together at Red House met two beautiful young women of Greek ancestry and prosperous families: Marie Spartali and Maria Zambaco. Both aspired to be artists, and Marie became a diligent pupil of Madox Brown, studying alongside his daughters. Ever on the look-out for attractive models, Rossetti asked her to sit for him, but became alarmed when the lovely Marie responded by falling for him. Remarriage was not in his mind, if only because of the complication posed by Fanny, who had the power to make things awkward.

Meanwhile Maria Zambaco had fallen for Burne-Jones. Red-haired and impulsive, she had

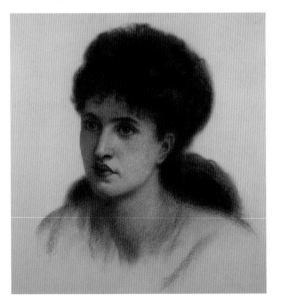

married and left a husband, and in 1866 came with her mother and Marie Spartali to sit for a portrait. 'I am uncertain if, after all, this is a picture which Madame Zambaco or Miss Spartali would have chosen if choice had been possible', Ned wrote incoherently when it was finished, 'for although they express the kindest sympathy with my work generally I could understand how preferable some pictures would be to another – and for that very reason that I have tried to do better in this case I may have failed more completely ...' [116]

Soon, Ned was helplessly smitten, alternately promising to run away with Mary or give her up entirely; when he spoke of the latter, she threatened suicide. Morris was dismayed at Ned's infatuation, on Georgie's behalf as well as his own. But for a group who had set such store by the imperatives of romantic and courtly love and disparaged

ABOVE LEFT Maria Zambaco, in a pastel by Rossetti (1870). Burne-Jones' affair with Zambaco almost destroyed his marriage, but eventually he returned to his wife, Georgie.

the proprieties of bourgeois marriage, he and others could do little. And in virtually the same season, his own romance dissolved when Janey and Gabriel embarked on the affair that had threatened from their first meeting. In Oxford in 1857, Jane had modelled for the adulterous Guenevere while Morris had prophetically written a dramatic monologue in which Guenevere denies all blame without denying the love. Now Rossetti played Lancelot, betraying his friend and comrade. The first act was his oil portrait of Jane wearing a blue silk dress, officially commissioned by Morris for the drawing room at Queen Square. It bore an inscription saluting Morris' fame as a poet, Rossetti's fame as a painter and Janey's 'surpassing beauty'.

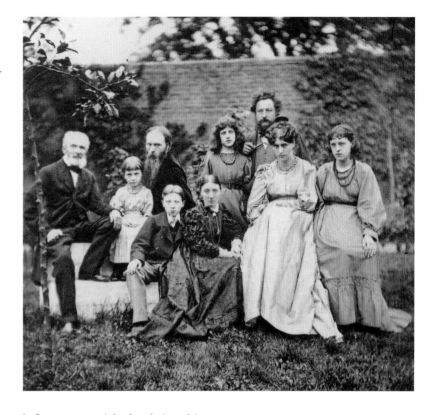

The situation was both simple and complicated, for no-one wished to bring things to a crisis. Divorce was scandalous; children were removed from a 'guilty' mother; husband and lover could hardly remain business partners, let alone friends. Morris sought solace in work and brusque grumpiness; the laughter, riotous games and glorious decorating at Red House must have seemed a lifetime away. He and Georgie consoled each other, stoically and silently. Some of his grief found indirect expression in verse:

> Time and again across his heart would stream
> The pain of fierce desire whose aim was gone,
> Of baffled yearning loveless and alone.

His gift for Georgie's thirtieth birthday was a calligraphic manuscript of poems entitled merely

ABOVE The Burne-Jones and Morris families in the garden of The Grange in Fulham (1874). The figure on the far left is Burne-Jones' father. Georgiana is the diminutive figure in the centre.

'A Book of Verse.' The implication must have been that Janey would have dismissed such a present. Her motives are hard to fathom, though her actions show that her chief desire was to be with Gabriel, without causing a scandal. She loved sitting for him, and being the subject of his new poems:

> O Love! Let this my lady's picture glow
> Under my hand to praise her name, and show
> Even of her inner self the perfect whole

> Lo! it is done. Above the long lithe throat
> The mouth's mould testifies of voice and kiss,
> The shadowed eye remember and foresee.
> Her face is made her shrine. Let all men note
> That in all years (O Love, thy gift is this!)
> They that would look on her must come to me.

They spent a spring month in 1870 lodging close to each other in Sussex. Then the proprieties of the relationship were resolved in a formal arrangement whereby Rossetti and Morris became joint tenants of a country retreat to be used on a daily basis by Gabriel and Janey. Morris took the initiative, finding an old stone manor house at Kelmscott (now in Gloucestershire), on the Thames above Oxford. It was a dream house, of the kind that gave him a physical yearning; ironically, insofar as its main purpose was as a love nest for his wife and her lover.

It answered its purpose in 1871, as Morris noted. [117] He and Charley Faulkner went to Iceland, while Janey and the girls spent an idyllic summer with 'Mr Rossetti' at Kelmscott. But during the subsequent winter in London, Gabriel's state of mind deteriorated. He had sight problems – devastating for a painter – which had prompted a serious return to poetry and publication. To facilitate this, and disguise the fact that his love sonnets were addressed to Janey, he had arranged to exhume Lizzie's coffin and retrieve his manuscript. This was done in great secrecy, Janey and Swinburne were among the few who were told.

When his volume appeared in April 1870, Rossetti got Morris and Swinburne to publicise it. 'I have done my review just this moment – ugh!' was Morris' terse, expressive comment. [118] Some months later, the poems were the subject of fierce and personal criticism, directed against their 'fleshly' or sensual qualities. Unwisely, Gabriel defended himself; the criticism redoubled and in May 1872 his mind collapsed into paranoia and suicidal hysteria. Janey's prospective idyll at Kelmscott was cancelled. It would appear that the tension between Rossetti's sense of honour and his passion for Janey, coupled with the attack on his poems, drove him over the edge. Now Janey had even more reason to be grateful for Morris' forebearance.

William and Janey repaired their marriage, as did Georgie and Ned, though things were never the same again. Morris restructured the Firm, putting it under his sole control. He became a successful manufacturer and supplier of interior design, developing what is now known as the 'Morris style', which was also marketed to Webb's architectural clients, amongst others. Webb continued with commissions large and small, each designed with the same honesty and personal attention to detail. One of the last country houses he designed was Standen, near East Grinstead, for solicitor James S. Beale (1891–92). Also decorated by Morris & Co., this now belongs to the National Trust, and may be interestingly contrasted with his first house, Red House, which it barely resembles, except for a square tower with pitched, red-tiled roof, articulating two wings and anchoring a variety of gables and chimneys.

LEFT TO RIGHT Margaret Burne-Jones, May Morris, Jenny Morris, Philip Burne-Jones up a tree in the garden of *The Grange* in Fulham in the summer of 1874.

In 1877, Webb and Morris were the main movers in the first serious architectural conservation campaign: the Society for the Protection of Ancient Buildings, begun in order to resist the over-restoration of historic properties. Morris increasingly took an interest in current political affairs which was a new direction for his career.

Morris was a man who never looked back. Nor did he ever return to Red House. But he did once return to the district, and one wonders if he considered taking the opportunity to go back to Bexleyheath, out of curiosity if not nostalgia.

IN TWENTY YEARS EVERYTHING WILL BE GONE IN THIS COUNTRYSIDE WHICH TWENTY YEARS AGO WAS SO RICH IN BEAUTIFUL BUILDING ... NOW THAT I AM GROWN OLD AND SEE THAT NOTHING IS TO BE DONE I HALF WISH I HAD NOT BEEN BORN WITH A SENSE OF ROMANCE AND BEAUTY IN THIS ACCURSED AGE ...

William Morris, to Georgiana Burne-Jones, August 1895

After the Morrises moved out in September 1865, Red House stood empty, up for sale or rent. The response of prospective owners to the intensely patterned and coloured interior may well be imagined. However, by the following spring it had new occupants, James Arnold Heathcote, formerly of the Indian navy, his wife Eliza and their two young children Marion and Rennie. They must have liked the decoration, for they retained the mural painting and fitted furniture, and by agreement kept the Red Lion Square chairs. Marion Heathcote recalled that Morris removed the Prioress' Tale wardrobe, 'because it had been a wedding present' and in its place left the two tall chairs, 'two semi-circular ones in which I tried to learn my lessons and a very fine one in oak, like a throne, with beautifully carved arms'. [119]

The chairs must have stood out in comparison to the rest of the Heathcotes' furniture. Marion, who kept the two painted chairs to the end of her life, also kept a volume of Morris' poems, with marks alongside those illustrated on the chairbacks: 'Glorious Gwendolen's golden hair' from *Rapunzel* and 'a knight – Sir Galahad I think – being armed by the saints in Heaven'. [120] Although crudely built and painted, these items were unique; leaving them behind lends support to the idea that Morris was determined to 'move on'.

In the drawing room, paint samples indicate that some of the woodwork was repainted in a shade of dark blue-green. No structural alterations were made to the house, although a greenhouse erected against the south wall of the outbuildings may have been built in this period. When Heathcote died in 1877, Red House was let for a few months to a Mrs Adey, and

LEFT From Charles Holme's album (1890s). View of the ground floor passage leading to the garden porch, showing many oriental objects, a plate shelf and folding Japanese-style screen.

ABOVE RIGHT From Charles Holme's album (1890s). Detail showing some of the many objects in the drawing room.

then bought by Edmund Charlesworth, a London-born stockbroker in his late forties, with a wife, Maria, and a teenage daughter named Laura Maria. The Charlesworths evidently knew that the house had belonged to William Morris, for on the walls of Morris' studio (now converted to a bedroom), they hung the *Daisy* wallpaper from Morris & Co. Did they know the design had been created for Red House?

Edmund appears to have been an invalid, for when he made his will in 1881 he was resident in a London nursing home, although he survived another nine years. A curious link back to Morris occurred in 1884 when a new tenant leased Aberleigh Lodge (the house constantly changed owners and tenants). He was Hall Caine, an aspiring writer, who through the Society for the Protection of Ancient Buildings (SPAB) had occasionally met Morris and Webb. Caine also corresponded with Rossetti and on moving to London in 1880 became the artist's unofficial carer during his last months. Immediately after Rossetti's death, he leapt into print with *Recollections of Rossetti*, an attempt to capitalise on a celebrity connection. Later Caine became

ABOVE LEFT Aberleigh Lodge with Red House in the background. **RIGHT** From Charles Holme's album: dining room.

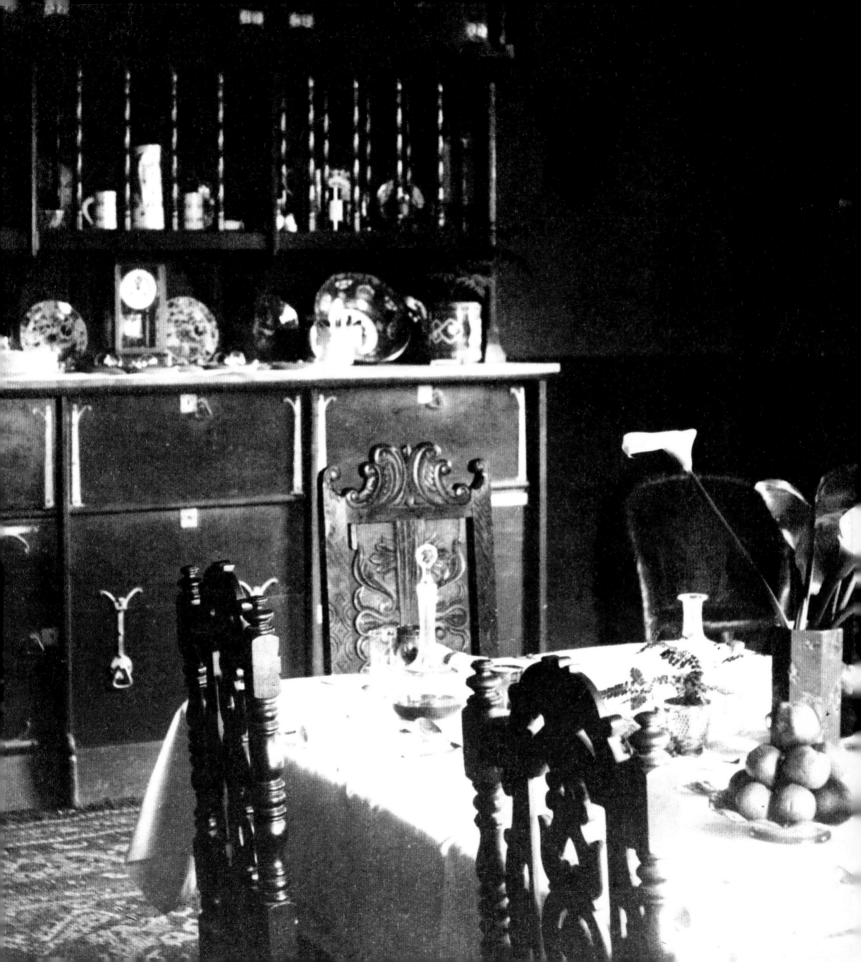

involved with a servant girl who, at the age of fifteen, gave birth to their son. In September 1884 this irregular family moved into Aberleigh Lodge. According to Caine, Aberleigh was a modest house with only three bedrooms, although evidence suggests they were spacious and of double aspect. Proximity to Red House must have been an attraction. An avowed admirer, Caine was ready to become Morris' disciple, and may even have thought of writing a biography. Although such sycophancy was anathema to Morris, he may have spoken to Caine about Upton. It is said that he designed a special 'writing chair' for Caine with an extended seat, although this could merely have been a purchase from the Firm; Caine was something of a romancer. At Upton, he wrote the first of many successful novels. Although brash enough to do so, he seems not to have called on the Charlesworths, or in subsequent years he would undoubtedly have recorded his memories of the famous Red House and its first owner.

ABOVE From Charles Holme's album: the drawing room. The settle is not yet white and its two doors are still on the upper register. Burne-Jones' Sir Degravant murals have been glazed and framed. Battens have been attached to the ceiling.

In 1889 Red House passed from the Charlesworths to Charles J Holme for £2900, rather less than it had cost to build thirty years before. Holme was an oriental goods merchant. Aged forty, he had enjoyed a varied career that brought him in a roundabout manner to William Morris' house. Born in Derby, son of a silk manufacturer, he prospered in the Bradford woollen trade, before a lecture on Oriental travel led to the import of Turkestan products and in 1876 to a trip to establish trading partners in India, central Asia and China. In 1879 he moved to London, became a buyer for Arthur Lazenby Liberty's department store and also set up a company in partnership with designer Christopher Dresser, mainly selling Indian and Japanese wares. 'From the moment we entered we seemed to have left England and to have been transported to Japan, so completely orientalised was everything,' observed a journalist of the Dresser and Holme launch party, citing inlaid tiles, carpets, cane chairs, Indian pottery, Japanese silverware and Benares brassware. [121] The effect would in due course spread to Red House.

With his wife Clara, Holme had three daughters, Millicent, Dora and Gwendolen (names that betray their parents' poetic tastes) and one son, Charles Geoffrey. After Geoffrey's birth, Holme took a world tour in company with the Libertys, mainly to visit Japan. On his return, he purchased Red House and must have been wealthy enough to cease active business, as the Census for 1891 gives his occupation as 'Retired East-India merchant'. Leisure gave him scope for new ventures: he joined the Sette of Odd Volumes, became a founder-member of the Japan Society, and in 1893, at the urging of writers John Lane and Gleeson White, launched *The Studio: An Illustrated Magazine of Fine and Applied Arts*, which rapidly became the leading monthly in the field of contemporary design. With its wide range and high production values, in due course 'it was read by everyone from Picasso in Barcelona to designers in Finland, Germany and the United States.' [122] The first cover was commissioned from the as-yet unknown Aubrey Beardsley who later became renowned for his Decadent images.

Holme must have bought Red House because of its Morris history, and despite the steady urbanisation of the neighbourhood. In 1871, Bexleyheath had just forty-nine dwellings with 219 residents, but was expanding: a row of villas soon appeared on Upton Road and a new church had to be built to replace the chapel. By 1890 all the land north-east of Red House was covered with narrow terraced streets. Across the lane, one field owned by Red House remained

undeveloped. In his will, Alfred Bean, owner of Danson Park, decreed that parts of his estate be sold for housing to a street plan of his own devising. 'Where nineteen families had lived [in 1800] there would soon be accommodation for 1900 families', notes a local historian. [123] Moreover, as head of a rail engineering company, Bean was the force behind the Bexleyheath Railway Project, a new line running from London's Cannon Street station to Dartford in Kent, which was completed in 1895. His role in transforming the locality was commemorated by the re-naming of the lane between Upton and Danson as the present Bean Road. Red House was being hemmed in.

Inside, the house resembled an oriental bazaar or part of Liberty's department store. Photographs show silk and embroidered fabrics, inlaid Indian chairs, Japanese prints, lattice-work lanterns, tea-bowls, figurines, lacquer boxes, Nankin china, folding screens, Kakomon silk paintings, a Paulownia marriage chest, and a Koran stand amongst other Oriental *objets*

d'art. Holme also collected dead butterflies, with bejewelled wings. To complement this exotic assemblage, the woodwork was now painted in dark imitation graining. The current diamond-paned glass was inserted into the oriel window, giving a more archaic impression. Dado panelling was installed in the drawing room together with wooden battens on the ceiling which were stylistically in keeping with the 'more baronial feel' bestowed on the room. [124] Some walls were covered with an embossed Japanese leather paper; those on the stairwell and landing had a luxurious Indian-style design that appears largely gilt. Though this 'eastern' atmosphere had affinities with the house's original polychrome interiors, it was wholly different in character.

Holme probably introduced electric light to Red House; he had friends who had pioneered development of electricity for domestic illumination. He may also have installed central heating and converted the upstairs dressing room into a bathroom, with bath and marble-topped washbasin. One of his first acts was to have a glazed screen built between the hall and the north wing passage, presumably to stop

ABOVE LEFT Pane from screen dividing the entrance hall where Holme's visitors etched their names. Those on this pane include Lazenby Liberty, Aymer Vallance and Hiromichi Sugio.

RIGHT From Charles Holme's album: Display easel in the ground floor passage, in front of the glazed screen doors opening into the entrance hall.

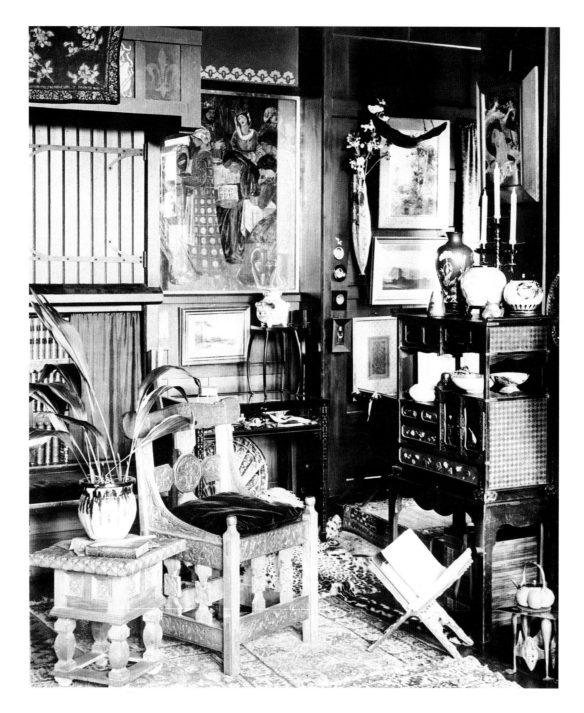

ABOVE From Charles Holme's album: view of oriel alcove in the
drawing room, filled with oriental items.

cold draughts from front door to garden porch. With slightly green blown-glass panes and a black lacquered frame, it fits comfortably into Webb's building. It rapidly became a visitors' book, acquiring diamond-cut signatures from Holme's friends and associates, all involved 'in the new ideas of the time – artistic, literary and scientific – in various overlapping groups'. [125]

The 1890s was the period of Art Nouveau as well as the Arts and Crafts movement, the *Yellow Book*, Oscar Wilde and the Celtic Twilight, the New Drama and the New Woman. A good deal of artistic and literary life took place in clubs and at dinners attended by wealthy connoisseurs. We do not know how often Charles Holme entertained at Red House, but the glass pane signatories suggest a revival of 1860s conviviality, from a different but related constituency. Morris, Webb and Burne-Jones were of course still alive, Morris & Co. still producing its distinctive furnishings, the Kelmscott Press issuing its fine volumes, some of which Holme bought. In general, the decorative objects favoured by Holme and his friends were of more exotic origin. Though the workmanship would often have pleased Morris, by this date he actively disliked the plentiful accumulation of ornaments, metalware and fabrics that filled rich homes, and it is hard to imagine him admiring Holme's interiors. Indeed, he perhaps cursed that his house was now occupied by an associate of Liberty's, Morris & Co.'s main competitor.

Morris also had a particular hatred for the aesthete or 'precious young man', according to his daughter May, 'in the days when preciousness was *la mode de demain*'. [126] This was the very type attracted to groups like the Sette of Odd Volumes, a male-only dining club described as 'one of the most difficult and certainly one of the most interesting to enter'. [127] The forty members or 'volumes' met for convivial monthly dinners and papers on varied topics. Holme was president of the Sette in 1891–92; the menu for his election dinner boasts an etching of Red House by painter Wilfrid Ball. We might imagine Holme hosting a tea-party at Upton for fellow members and their ladies; the names of twelve Odd Volumes are etched on the glass screen, including painter Alfred East, sculptor Onslow Ford, poet Richard le Gallienne, publisher John Lane, retailer Lazenby Liberty, pattern designer George Haite, engineer Conrad Cooke and Arthur Diosy, son of a Hungarian refugee who knew Morris in his political years.

Diosy was also secretary of the Japan Society, of which Holme was a founder member in 1892. Glass signatories with specifically Japanese interests include Mortimer Menpes, artist and

ABOVE From Charles Holme's album: view from the half-landing on the main staircase looking towards the upstairs passage.

collector, whose Chelsea house had a Japanese-style interior, and Diagoro Go, Japanese consul in London. The next, in 1897, were Kosaku Iwamoto and Makoto Saito (later first minister) from the Imperial Navy, for which a warship was being built in Britain. They were followed by Tsumetami Sano, en route for Philadelphia, and Hiromichi Sugio, art advisor to the emperor, who was probably at Red House around 1910, and inscribed his name on the glass panes.

In addition to bibliophilic and Japanese matters, Holme's main interests centred on *The Studio* of which he eventually became editor as well as proprietor. It covered a full range of designs, from the emergent Arts and Crafts movement to the Vienna Sezession and the Scottish 'spook school', produced special numbers and ran competitions. While more committed to the present than the past, in its first year it ran an article on 'Artistic Houses' that alluded to the chimneypieces at Red House, 'that wonderful red brick building which proved to be the prototype of all the beautiful houses [of the] so-called Queen Anne revival'. [128] Though architecturally off-beam, this suggests that the author, J.S. Gibson, had been to Red House, presumably as Holme's guest. A later article echoed the claim, saying the building foreshadowed the work of Norman Shaw, in 'a powerful attempt to combine a beautiful exterior with a comfortable and well-planned interior'. [129]

These mentions represent the beginning of Red House historiography. There is no evidence that Holme or his colleagues sought out either Morris or Webb for a first-hand account. When in 1894 Morris himself was interviewed for *The Studio* by Aymer Vallance, the subject was not architecture but Morris & Co.'s revival of tapestry weaving, in a promotional piece. [130] As he described the process in detail, stressing the beauty of Burne-Jones' designs and the high quality of the workmanship, Morris can be imagined grinding his teeth at the necessity. He and Holme surely must have met in relation to the decorative arts, for they had acquaintances in common, and their mutual silence is probably eloquent of opposed views.

By this period, Morris was sick and increasingly frail and in October 1896, he died aged 62. *The Studio* carried an ambiguous notice, saying 'The loss of William Morris, great as it is, must not be over-estimated; his real work was accomplished years ago.' Holme was the probable author of this piece, which went on to regret Morris' open contempt for modern design and to damn the 'sham antiquity' of his work, but hailed his influence:

Fortunately ... his continual harking back to the spirit and intention of the old work rther than its dead form, inspired younger men with a totally different aim ... Yet the great designer, the great colourist, and the superb craftsman remain untouched by such criticism, and commands your reverence as one who made possible all that we prize, although he himself cared no jot for the experiments or the achievements which seem to many of us the real harvest of the seed he sowed, and the actual outcome of the labour he expended so prodigally in fighting for the revival of the applied arts in England. [131]

His other activities – design, poetry, socialism – were better known to the public than his time at Red House, but obituaries prompted new attention, and new visitors from times past. One early visitor to Red House after Morris' death was Georgie Burne-Jones who returned in April 1897 when the apple blossom was out. Ned did not come; he probably preferred to remember how it had been thirty years before. It must have been a strange experience for Georgie, seeing the once-familiar house filled with an Eastern-Aesthetic *mélange*, and the garden with bedding plants and spiky succulents. She remarked only that the neighbourhood was soon to be wholly built up.

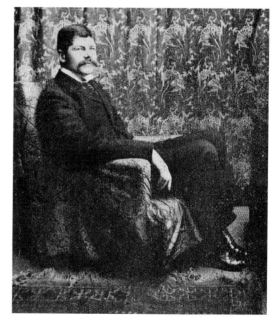

The Burne-Joneses were planning an authoritative biography of their dear friend, in part to prevent others cashing in. Indeed, Aymer Vallance, an Arts and Crafts enthusiast who later gave his own house to the National Trust, had been ahead of the game. Claiming to have first met Morris in 1883, he had suggested a book at the time of his interview for the *Studio*. '[Morris] told me frankly he did not want it done either by myself or anybody else so long as he was alive,' Vallance wrote, 'but that if I would only wait until his death I might do so.' [132] One may doubt the exactness of this report, but shortly before his death Morris acceded to Vallance's request to see the illuminated books he had given to Georgie. She duly, if reluctantly, showed them and Vallance's book was begun.

RIGHT Aymer Vallance (1862–1943),who wrote the first book on Morris, contributed to the *Art Journal* and *The Studio* and is credited with discovering the avant-garde artist Aubrey Beardsley. Vallance also bought and restored Stoneacre, a half-timbered Wealden Hall-house in Kent, furnishing it with a mix of antique and modern Arts and Crafts items. Vallance bequeathed the house to the National Trust in 1928.

Morris' family and friends refused to help and Vallance was obliged to restrict himself to describing Morris' public and artistic career. Regarding Red House, he linked its location to Morris' literary and – rather later – political views:

> The site Morris chose for his new house was an orchard at Upton near Bexley Heath amid "the rose-hung lanes of woody Kent". The highways of the county were dear to the poet through their having been trodden by the feet of Chaucer's Canterbury pilgrims; while its historic memories were illustrious in his eyes because it was there had sprung up the popular movement led by the valorous John Ball [leader of the Peasant's Revolt of 1381]. [133]

Architecturally, Vallance took his cue from *The Studio* articles, stressing the use of red brick rather than stucco and the 'picturesque irregularity' that distinguished the house from the 'ugly, square box order' that had hitherto prevailed. There was no mention of Street, Butterfield, or even Webb (no doubt to Webb's satisfaction):

> It was for its time a bold innovation ... an experiment on the part of a man who had both the hopefulness and the dauntless will necessary to enable him to make a stand against the tyranny of custom ... to William Morris is owing the credit of having initiated in his Red House a new era of housebuilding. [134]

For the interior, Vallance relied on some 'notes' supplied by the unidentified visitor of 1863 interspersed with his own account of surviving decoration, including the ceiling patterning. Mindful perhaps of current Aesthetic tastes, he claimed that in 1860 the colours had been 'bright but not so strongly pronounced as to be staring or in any way disagreeable'. [135] He was unaware that despite its 'glass of antique quality', the hall screen was a recent insertion, or that the stained-glass depictions of Love and Fate in the downstairs passage were by Burne-Jones. He also confidently asserted that inside the hall settle were 'some interesting experiments in diapering in black on a gold ground, by Mr Morris' hand'.

The book, *William Morris, His Art, His Writings and His Public Life. A Record*, appeared within a

year of Morris' death. Its illustrations by H.P. Clifford represent some of the earliest images of Red House, although around this date Holme also had its interior and exterior recorded in photographs, some by Emery Walker, a friend and colleague of Morris. Red House's reputation was starting to grow.

The Burne-Joneses asked their son-in-law Jack Mackail to undertake the official 'life'. Their input was extensive, as was that of Webb, who insisted on remaining unacknowledged. Someone with expert

knowledge helped Mackail define the quality of the building. 'Externally, the house was plain almost to severity,' he wrote, 'and depended for its effect on its solidity and fine proportion.' [136] Illustrations were commissioned from Edmund H. New, a Birmingham-based architect and artist who was also a member of the Art Workers' Guild, where many Arts and Crafts men congregated. When he visited Red House to draw a view of the well-garden with staircase-tower almost overgrown with creepers, he was accompanied by two friends – May Morris and Mary Newill – who also etched their names on the glazed screen. Like May, Mary Newill's craft was embroidery. Together, they represented the developing Arts and Crafts movement of which Red House would later be called the beginning, as many practitioners claimed Morris as inspiration. May, who confessed to no real memories of the house, later wrote accounts largely based on those by Mackail and Georgie, but implicitly informed by this return in her late thirties. Evoking 'a beautiful house and a gathering together of all the arts', she can be imagined as mentally stripping out Holme's interior to reinstate the decoration schemes, furniture and furnishings in place when she lived there.

Published in 1899, Mackail's *The Life of William Morris* gave the first substantial account of Red House. Placing it permanently on the historical map, it also formed the basis of every subsequent account, including this one. Today, the appearance of Red House is so familiar to

ABOVE RIGHT Well court and house from the garden, drawn by H.P. Clifford for Vallance's book on Morris (1897). By this date, however, creepers covered much of the exterior.

many that it is hard to imagine it as an almost unknown entity, lovingly described by Morris' old friends but invisible to others. Its plans and elevations had never been published – Webb did not do this at any stage of his career – and only a few drawings and photos were available. Owing to its walled seclusion, it could not be casually spied from the street. Despite Vallance's claims, it was not well known to younger architects and had minimal influence before 1900. At least two came to see for themselves and left their signatures on the screen. One was Mackay H. Baillie Scott, who became known for romantic, rough-cast country homes with inglenooks and music galleries. In 1897 Baillie Scott wrote on 'An Artist's House' for *The Studio*, which may have prompted his visit. If so, Red House perhaps struck him as dark, Victorian and overstuffed with 'atrocious furniture'. But he may also have noted the architect's care of all detailing: doors, windows, fastenings, handles, fireplaces; all of which were all specifically designed rather than purchased from manufacturers' catalogues. The second architectural visitor was Charles Harrison Townsend, whose best known buildings are the Bishopsgate Institute (1892–93), the Horniman Museum (1896–1901) and the Whitechapel Art Gallery (1899–1901). He probably knew Holme through his brother Horace Townsend, fellow member of the Sette and the Japan Society, and may have visited Red House on the same occasion as Robert Anning Bell, artist and designer, who contributed mosaics to the Horniman Museum and also left his signature on the screen.

A little later, Red House was introduced to Japanese readers through Kenkichi Tomimoto, who became a celebrated ceramic artist associated with the Mingei movement. During postgraduate studies in London, Tomimoto discovered Morris's design work, and on returning home published 'The Story of William Morris' in *Bijutsu Shinpou* (Art News). This describes Red House, with its 'large, heavy, tiled roof, thick walls with red bricks and square windows, large low entrance and big heavy door', standing 'in dignified manner amid a well-designed garden with old fruit trees and many flowers.' [137] The phrasing suggests a personal visit, although Tomimoto's account is largely based on Vallance's book.

And so Red House began to assume its national and international significance in architectural history.

OPPOSITE Detail of a hand-blown glass pane in the glazed screen in the downstairs passage. Notables signatories include: May Morris, Georgiana Burne-Jones, Mackay H. Baillie Scott and Charles Harrison Townsend.

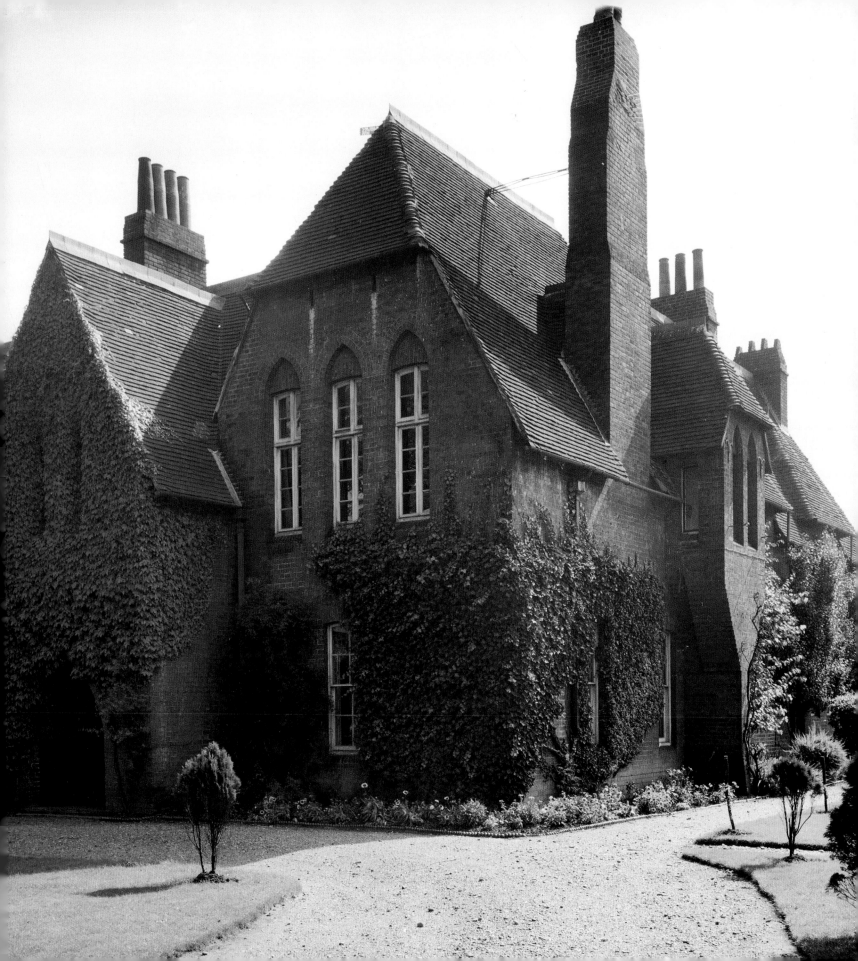

T HAT THING WHICH I UNDERSTAND BY REAL ART IS THE EXPRESSION BY MAN OF HIS PLEASURE IN LABOUR. I DO NOT BELIEVE HE CAN BE HAPPY IN HIS LABOUR WITHOUT EXPRESSING THAT HAPPINESS; AND ESPECIALLY IS THIS SO WHEN HE IS AT WORK AT ANYTHING IN WHICH HE SPECIALLY EXCELS ...

William Morris, *The Art of the People*, 1879

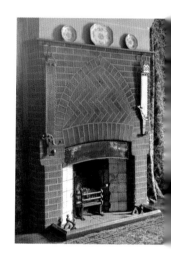

The year 1905 marked another change of ownership for Red House as the Holme family left Bexleyheath for Upton Grey in Hampshire. Their successor at Red House was Henry Muff, a retired cloth merchant from Bradford who being the same age as Charles Holme was perhaps acquainted. Described as a man of 'wide interests and high culture', Muff was something of an artist *manqué*, a talented amateur exhibitor alongside his wife Maude. An admirer of John Ruskin, whose lectures to Bradford businessmen against their worship of the 'goddess of getting-on' he doubtless knew, Muff may also have heard Morris speak on Socialism to a full and attentive audience in the city in April 1886. Muff was not converted, remaining a staunch Liberal, an active member of the Congregational Church and a longstanding supporter of the Peace Society. Maude was a niece of Sir Titus Salt, manufacturer and builder of the model town of Saltaire in West Yorkshire. As well as art, she was active in progressive causes: women's suffrage (with Millicent Fawcett), temperance (with Rosalind Howard, Countess of Carlisle), and public health and international peace (with Lady Aberdeen). She founded a shelter for homeless women in Bradford, 'at a time when such institutions were unknown' and was also active in the British Institute of Social Service, an umbrella for the growing voluntary sector. [138]

The Muffs therefore shared the commitment to art and social reform that shaped the lives of Morris and Webb. On moving to Red House, Maude 'threw herself into local social work' on behalf of the community. [139] Though denied the parliamentary franchise, women were moving into politics through local activity and local elections. Janey Morris' good friend Jane Cobden

LEFT View of the north-west corner of Red House *c.*1910, showing the widened driveway. **ABOVE RIGHT** Dining room fireplace *c.*1910.

was the first woman elected to the new London County Council, while Georgie Burne-Jones became an energetic parish councillor in Sussex. Soon after settling in Bexleyheath, Mrs Muff was elected to Bexley Urban District Council, only the second female councillor in Britain.

Henry and Maude had three children: Herbert, Edward and Hilda, born in the 1880s. Both boys' middle name was Brantwood, after Ruskin's Lakeland home. When the family moved to Red House, Edward was halfway through a pupillage with the London architect William Pite, while his sister Hilda followed her mother into social work. Herbert Muff was a geologist, later becoming director of the geological survey of Southern Rhodesia (now Zimbabwe).

During the Muffs' ownership Red House may have first acquired its paler interior, for lighter colour schemes were now coming into fashion. Paint analysis shows that the dark imitation graining on the woodwork was superseded by seven coats of white or cream paint between

ABOVE LEFT From Charles Holme's album: photograph from the wedding reception of Millicent Holme to Arthur Stone Wainwright on 5th April 1899 in the well court. The marriage took place at St. John's Church, Bexley.

about 1905 and 1940. Holme's imitation leather wallpaper was probably replaced by patterned and floral papers. With the house, the Muffs acquired five cottages on Red House Lane and two others nearby. All open land was under threat of development: the name of the new council signalled the final transformation from a rural parish to an Urban District, with a population of over 15,000. The 1909 OS map shows roads and building plots encroaching on Red House, like a tightening ring round an oasis.

In a watercolour done by Walter Crane in 1907, Henry and Maude are shown seated in the well-court on a summer's day. Crane, now in his sixties, had first encountered Morris and Webb's work at the 1862 International Exhibition. Meeting personally in 1871, he joined them in the Art Workers' Guild and Socialist League, for which Crane designed memorable posters and cartoons. He took a major role in the Arts and Crafts Exhibition Society and also illustrated Morris' *Story of the Glittering Plain* for the Kelmscott Press in 1891. It is possible he met Henry Muff through the Peace Society, and was then invited to Red House.

In August 1909 the Muff family changed their name to Maufe; allegedly a reversion to an older way of spelling. A few months later, Henry died at the relatively early age of sixty. The wreaths were carried to Bexleyheath cemetery in a small carriage drawn by Henry's favourite pony from the Red House stable. The pony was Icelandic, like the one named Mouse that Morris had brought for his daughters from Iceland in 1871, which grew fat at Kelmscott Manor. Maude remained in the house until 1913, when she moved into London. When she died in 1928, her coffin returned to Bexleyheath to be interred alongside her husband. Their son Edward Maufe went on to become a noted if not outstanding architect who acknowledged the early influence of Webb. His first major commission was a seaside house built to the fashionable 'butterfly' plan and decorated externally with knapped flints and grey roof tiles, Arts and Crafts elements characteristic of the 1910s. In the inter-war years he promoted 'modernity with manners', with stylish interiors and silver-lacquered fittings. In 1932 he won the commission for the new Guildford Cathedral, finally completed in 1961, which, like Red House, is built of red brick.

The Maufes' successor at Red House was Arthur Sherwill, who was probably responsible for enlarging the garden by purchasing part of the Aberleigh Lodge plot. The exact date of this purchase is uncertain, but the original boundaries appear on the 1909 map. Virtually double the

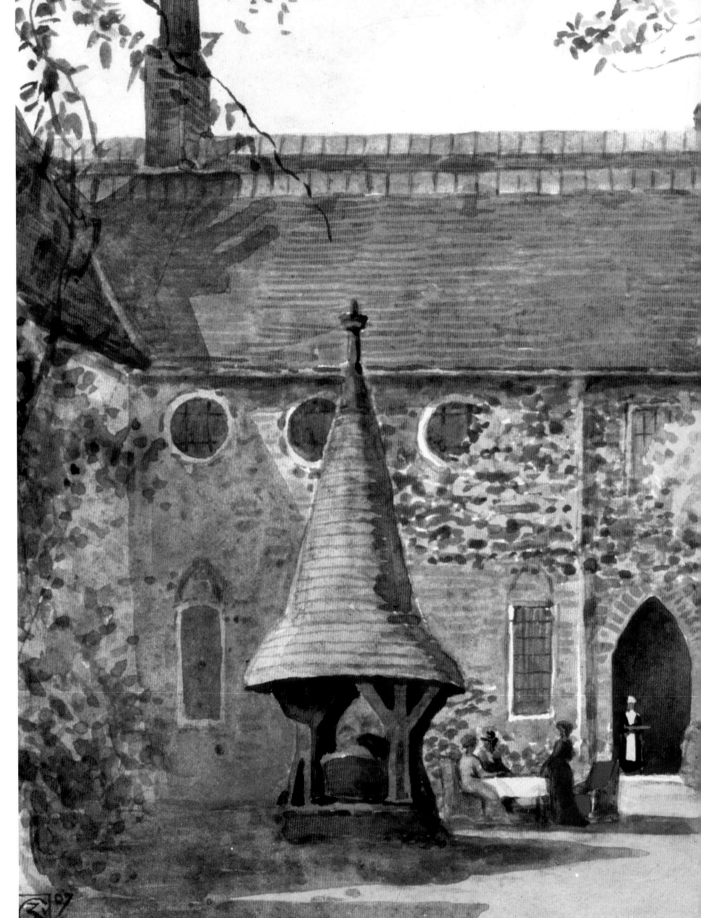

Red House Garden, watercolour
by Walter Crane (1907). Crane
was a colleague of Morris and
Webb in the socialist and
conservationist movements.
The figures in his drawing are
out of proportion and the
garden porch is too tall, but the
mellow atmosphere is well
captured.

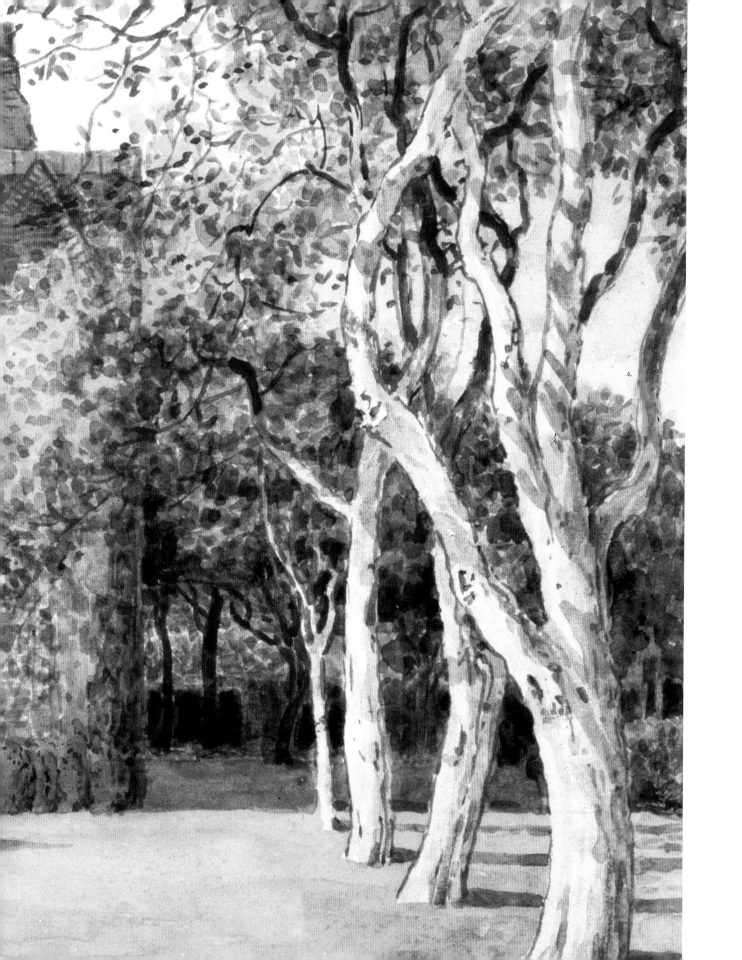

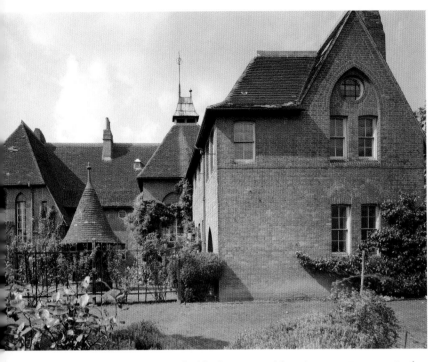

original area, the new space included what is now occupied by the orchard lawn and vegetable areas, plus part of the neighbouring site. The 1933 OS map shows a curious layout with the original west boundary running south from the lane then turning to the kitchen yard, thereby dividing the bowling lawn from the former Aberleigh garden, which stretches unfenced to join Red House's southern section. Perhaps the Aberleigh owners had proposed to sell for development, and the purchase was to preserve Red House from unwanted neighbours.

Open space was now a public as well as private issue in Upton. With the death of Alfred Bean's widow in 1921, Danson Park was up for sale. Bexley Urban District took the enlightened step of buying its 200 acres plus mansion and lodges and laying out playing fields and courts for tennis, football, bowls and athletics, together with an open-air swimming pool and boating pond. At the same time, the Mount estate south of Red House was sold off to become Bexleyheath Golf Club. Golf, like motoring, had become the latest middle-class leisure pursuit.

The decade that included the Great War saw a transformation in British domestic life. By the 1920s, middle-class households kept a car, lit their homes by electricity and found servants hard to afford or retain. Luckily Red House escaped major alterations, but it was always under threat from wholesale development. In 1924, it was bought by W. Scott Godfrey, a wine merchant, who was probably attracted by the reasonable price. He turned the two ground-floor rooms on the north wing into a single library some thirty feet (10m) in length, installing book cases from floor to frieze and inserting an bull's-eye window looking out through the Pilgrim's Porch, 'to give a view of the lawn and rose garden'. [140] Though Godfrey knew little about Webb or the house's

ABOVE LEFT View of Red House from the east taken by S. Newbery c.1910.

history, this window is so in keeping with those in the upper gallery that it attracts no attention.

In decorative terms, the Godfreys' taste was chintzy rather than stylish. The studio, now designated the principal bedroom, was renamed the 'Red Room', which must have been the dominant colour. The original main bedroom was the 'Yellow Room', and the two bedrooms on the rear wing were known as the 'Oak Room' and 'Blue Room' respectively.

By 1930, the house had acquired its historic reputation. Godfrey complained of constant requests to look round. 'I was continually receiving applications for permission to go over the premises,' he recalled, 'and I confess that ... I grew rather tired, but proportionally expert in my role as honorary showman. Over and over again I led admiring folk through the rooms and grounds.' [141] Although Morris & Co. was still in business, its design style was now distinctly out of date. Red House, however, had become a landmark in English domestic architecture. In 1904, the anglophile Hermann Muthesius, who lived in Hammersmith and had met many leading Arts and Crafts architects, had published *Das Englische Haus*, an influential study of recent developments that hailed Red House as 'the first private house of the new artistic culture, the first house to be conceived and built as a unified whole inside and out, the very first example in the history of the modern house'. Citing affinities with Butterfield but paying due attention to Webb's originality, Muthesius noted both the restraint and absence of ornament – the effects being achieved through material, colour and mass – and the fusion of architecture and interior design. [142]

In 1910, it first featured in *Country Life*, in an article by Laurence Weaver which reappeared in his book, *Small Country Houses of Today*. Illustrations show the unchanging appearance of both creeper-clad exterior and interior fitments. The drawing room settle 'duly treasured by the present owner, Mrs Maufe' was still dark-coloured and the cupboard doors were still on the upper register (it is unclear why and when the doors were moved lower down the settle). Following Muthesius, Weaver described the building as 'a fresh starting-point' whose 'importance cannot be exaggerated'. [143] When his book was reissued in 1922, Red House was no longer just one of a series, but in pole position to mark 'the immense influence' Philip Webb was now seen to have exercised 'on the quality though not the form of the work of today.' [144] In a sort of back-projection, the influence of Webb's stylistically different later buildings on domestic architecture enhanced Red House's reputation. While not precisely an Art and Crafts

forerunner, Red House indirectly fed through into contemporary architecture in the designs for England's garden cities and suburbs, even though these houses were typically cottage-sized. At the same time, it was admired by those who upheld more classical tastes. In *Modern English Architecture* of 1924, Charles Marriott accepted the house as an icon of progressive building and by 1934 Webb was 'being claimed by the modernists' on account of his instinct for proportion, functionalism and lack of ornament. [145] This development led in due course to one of the most influential accounts of Red House by Nikolaus Pevsner, in *Pioneers of Modern Design* of 1936, which placed Webb's building at the head of a whole new stream of architectural style.

Weaver's and Marriott's writings were perhaps the cause of Godfrey's insistent visitors. But when he put the house back on the market in 1926, it failed to sell. The following year, it was offered for sale 'at the UPSET PRICE of 4000 guineas' and described as 'A Milestone in the History of English Domestic Architecture', 'Famous as the Home of William Morris (Artist and Poet)' and 'In Many Respects Unique'. To enhance the attractions, the auction prospectus quoted Mackail's lyrical account of the house and added a lengthy foreword in which auctioneer R.C. Wellesley Smith attempted to explain why such a stupendous house had an asking price 'fifty per cent less' than it would fetch in another location. [146] This piece makes curious reading if intended to encourage potential buyers. 'The immediate surroundings do not consist, as might be imagined, of field and wood,' wrote Smith; 'but there have grown up lesser, yet friendly dwellings, which we can assume would have been welcomed by the original Owner, whose socialism was of a kind entirely different from the meaning which that expression conveys to the present generation. 'Did he think Morris' Socialist politics would deter buyers? Verbosely, he continued:

> Those whose occupation has compelled them to reside within the Metropolis at times feel the need for substantial change. Some have gone to the environment of the country, which always has allurements for the City dweller, but after a short while there comes a feeling of loneliness, a silence enhanced by the loss of the frequent and promiscuous calls of friends. All these tend to accentuate a lengthened and tiring journey to and fro each day...

Others, in closer proximity to London, 'literally live on the edge of a volcano, knowing that the time is short before the builder inevitably appears.' At Red House, however, this process was already over, and 'by no means as bad as it might have been'. Moreover, the property was just five minutes from Bexley Heath golf course. Finally, it had 'atmosphere':

> Past leaders of artistic society have left a permanent record of their gatherings, and it is difficult to conceive that any person living there can fail to attain a better outlook on life by imbibing the atmosphere created by this legacy of artistry and refinement. There is always a joy in the possession of the rare and beautiful thing, whether it is a picture, sculpture or house, the discriminating may not choose such a situation but they will appreciate its utility, embracing all the advantages that our City offers, yet with the country and its pursuits immediately to hand.

One hopes Morris would have concurred, despite guffaws.

The sale prospectus reveals that the pricked ceiling patterns survived in dining room, library, studio and two bedrooms on the rear wing. Downstairs, the kitchen had been converted into a 'servants' hall' while cooking was now done by gas in the former scullery. The main rooms also acquired gas-fires, much to May Morris's dismay. [147] The outbuildings held a laundry room, a boot room and two large coal cellars. Outside, the coach house held two cars, while the stables 'could at small expense be converted into a Cottage'. In the garden were 'fine old box hedges' whose antiquity can only be guessed at, together with herbaceous borders, fine shrubs, a 'grass alley nearly 100 yards in length' and a small bowling green. As well as the 'Old Lawn' containing the 'Beautiful Well-Head', there was a rose-garden with sundial, a rose pergola, specimen trees, one heated and one cold glasshouse, potting shed and chicken run. Though well-maintained, the excellent kitchen garden could easily be turned into a tennis court, 'if desired.'

The purchaser was Dr. Alfred H. Horsfall, DSO, an Australian surgeon decorated in the Boer War, who wrote books with titles like *The Anglo-Saxon as Empire Builder* and had political aspirations to become Prime Minister. If serious in his ambition, he may have known the office-holder of the time, Stanley Baldwin, nephew of Georgie Burne-Jones. Sixty years before, during one green summer, Stanley's mother Louisa had sat in Red House garden with her sisters,

listening as Georgie read. (There is a chance that Horsfall was related to Thomas C. Horsfall, of Manchester, in a letter to whom William Morris first used the famous phrase about having only beautiful or useful things in your house).

Horsfall and his wife Gertrude spent five years at Red House before putting the house back on the market in 1932. May Morris wrote around to try and find a purchaser but was without success. 'I am afraid people at present are not interested in my father and his circle,' she reported, 'I am sure that this is only temporary. But meantime all the available records of that productive time will be slipping away.' [148] It again failed to sell, and in October 1934 was put up for auction by Harrods. 'Red House will make its own appeal to those of an artistic nature and is also an opportunity for the City man to acquire a home of some distinction within such easy reach of London by road or rail, yet on the verge of the open country and Kentish woodlands,' declared the sale particulars. The asking price was £4000.

It was in fact at serious risk. If no-one wealthy enough wanted to live in Bexleyheath, the plot would be sold, Red House demolished and replaced with a group of 1930s semis. So at this moment the first move towards preservation through the National Trust took place. Citing a reserve price of £3300, Harrods wrote on Horsfall's behalf to the Trust, whose Secretary replied, suggesting instead the Society for the Protection of Ancient Buildings. But Red House was, of course, too modern a building for SPAB. Concurrently, local supporters urged Bexley Council to prevent it being acquired by speculative builders and instead take it 'for a public purpose as a memorial to the life and work of William Morris'. But Bexley had no power to do this. The Trust was equally unsure: 'Do you think this is a matter over which the National Trust should try to make any special effort?' the Secretary asked his counterpart at SPAB. Support came from individuals, and in January 1935 the National Trust board agreed that 'if William Morris' house, the Red House, Upton is bought as a result of an appeal by ... others, the Trust should accept the property and ... should support proposals for this purpose.'

It would be a terrible pity to let the house be touched, wrote playwright George Bernard Shaw, then at the height of his fame. Labour Prime Minister Ramsay Macdonald expressed a keen hope that 'something may be done by the many friends of William Morris'. 'Could the Pilgrim Trust subscribe?', asked architect Sir Herbert Baker. Sir Raymond Unwin suggested it

RIGHT May Morris c.1890, photographed by Frederick Hollyer
(1837–1933), a contemporary and friend of the Pre-Raphaelite circle.

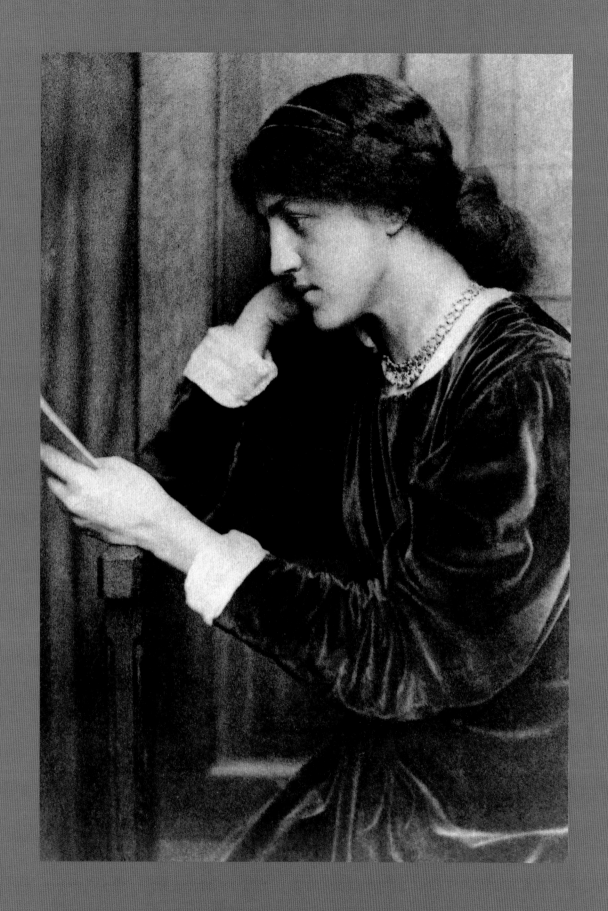

become an art school for Kent County Council. The head of Woolwich Art School came to visit. The Royal Arsenal Co-Operative Society urged 'all progressive forces' to assist but was unable to buy the house. The Workers' Education Association wished it could do so. Woolwich Council of Social Service (WCSS) – a network of voluntary bodies – went to consult with the National Trust. A 'special price' of £3100 was now available and Horsfall was asked for first refusal. But he had just received an inquiry from a developer.

All interested parties agreed to launch an appeal, starting with a letter to *The Times*. After some debate as to who should convene the meeting, the task was undertaken by the WCSS, acting 'at the suggestion of the National Trust'. On 7 March, a committee was formed at the house, chaired by Unwin. *The Times* appeal duly appeared on 1 May 1935, supported by Bernard Shaw, Rudyard Kipling, John Masefield, Earl Ferrers, Stanley Baldwin and Ramsay Macdonald. However, Veteran Labour leader George Lansbury perhaps spoke for others in saying he thought 'this sort of thing was terribly overdone'.

Several cheques arrived, including five pounds from Hilda Maufe, but the response totalled only £207.15s. 00d. in cash, with £310 in pledges. Then Horsfall accepted an offer from local estate agent Thomas C. Hills. 'I think you know we have bought Red House to live in and not to pull down,' his wife Beatrice told the Committee. 'We shall endeavour to keep the house as it is.' As she was a champion bowls player, one hopes that Morris' green was still usable and that the garden heard once more the unmistakeable sound of wooden balls knocking each other out of the way.

Two years later, the Hills proposed to sell and the whole rescue saga started again. 'My impression is that the National Trust wasn't very sorry when the original appeal failed', recalled the former Assistant-Secretary. So Unwin reconvened the Committee. The National Trust asked Bexley Council if the property could become a health or education centre 'in line with William Morris ideals'? But as May Morris observed, people had other concerns. At the end of 1938, the Trust, where James Lees-Milne was now directing the Historic Buildings Committee, formally agreed to take the property if gifted, but not to support an appeal for funds. Failing to find a buyer, the Hills remained in possession.

In 1940 Red House was requisitioned for government use by the National Assistance Board.

APPEAL

For the Preservation of Red House,

HOME OF WILLIAM MORRIS

Bexleyheath, Kent

THIS house, designed by Philip Webb for William Morris and built about 1860, is in danger of destruction to make way for building development. The house is one of great interest. It was one of the first Victorian houses designed without any conscious effort to follow a particular style. The best architecture which has followed grew from the ideals it first represented. The house was furnished and decorated by William Morris, Rossetti, Burne-Jones and other members of the group associated with them. Some of the original decoration and fixtures with painted panels remain. The house and garden are a record of the enthusiasm which, through the work of William Morris and his associates, exercised far reaching influence on the artistic and social developments of the last fifty years.

Some of those who wish that the house should be preserved met in it on March 7th. Ten per cent. of the purchase price was guaranteed by a few of those present to enable negotiations for its purchase to be commenced, and to gain time to raise the greater sum necessary for this. A small provisional committee was formed to give effect to this purpose.

The money value of the house and grounds is said to be in the neighbourhood of £4,000. Knowing, however, that the Committee are anxious to purchase for preservation, the owner, Dr. Horsfall, has offered it to them for £3,100. The open land round the house when it was built is now almost fully developed. It is surrounded by new streets of smallish houses.

The Urban District Council of Bexley are willing to consider responsibility for the care of the building if purchased and put to some public use. The National Trust have also offered to hold and maintain the building if bought. Several suggestions have been made as to the best use for the house. A purpose connected with the development of industrial art and handicraft, for which there is local need, has commended itself to many of those interested. There are, however, alternative uses which would be appropriate and would meet local needs, and in view of the urgency to complete the purchase, the Committee consider that it will be wiser to postpone final determination of the use, and first to secure the purchase on behalf of the National Trust, with whom, and with the local authorities, the question of the most appropriate use can be settled afterwards. In addition to the interest attaching to the building as the home of William Morris, its value as a link in the story of English Architecture is specially stressed. Anyone not familiar with the work of Philip Webb may find it well discussed in a book entitled "Philip Webb and his Work," by the late Professor Lethaby, recently published by the Oxford Press.

The Committee will welcome support and financial assistance towards the project for preserving the building for some appropriate use. Donations may be sent to "Red House Fund," c/o National Trust, 7, Buckingham Palace Gardens, S.W. 1, or to the Secretary of the Committee, Mr. H. R. Ecroyd, 71, Rectory Place, Woolwich, S.E. 18.

RAYMOND UNWIN,
Chairman of the Provisional Committee

April, 1935

The following are among the Supporters of the above Appeal:—

Sir Herbert Baker, K.C.I.E., R.A.
The Rt. Hon. Stanley Baldwin, P.C., M.P.
Sir Reginald Blomfield, R.A., P.P.R.I.B.A.
Detmar Blow
Lord Noel-Buxton, P.C.
Alfred C. Bossom, M.P.
Earl of Crawford and Balcarres, P.C., K.T.
E. Guy Dawber, A.R.A. (*Chairman, C.P.R.E.*)
Earl Ferrers, F.S.A.
Walter H. Godfrey, F.S.A.
Lord Gorell, C.B.E.
°C. H. Grinling (*Woolwich Council of Social Service*)
Rudyard Kipling, D.Litt.
Sir Edwin Lutyens, K.C.I.E., R.A.
The Rt. Hon. J. Ramsay Macdonald, P.C., M.P.
J. W. Mackail, LL.D., O.M.
H. C. Marillier
John Masefield, D.Litt.
Edward Maufe

°Miss May Morris
Dowager Lady Northbourne (*Chairman, Committee for the Preservation of Rural Kent*)
W. Rolfe Nottidge (*Chairman, Kent Education Committee*)
°A. R. Powys (*Secretary, S.P.A.B.*)
L. S. M. Prince, A.R.C.A. (*Woolwich School of Art*)
Sir William Rothenstein, D.Litt.
Sir Giles Gilbert Scott, R.A., P.R.I.B.A.
G. Bernard Shaw
Sir H. Llewellyn Smith, K.C.B.
Mrs. H. J. Tozer
F. W. Troup, F.S.A.
°Sir Raymond Unwin, P.P.R.I.B.A.
Miss Dorothy Walker
°R. Schultz Weir
Clough Williams Ellis, M.C.
°The Urban District Council of Bexley
The Kent Council of Social Service
°The National Trust

° *Member of Provisional Committee.*

THORNS, WOOLWICH, 7156/3

Local people remember it as the place where ration books for food, clothing and furniture were issued. The greenhouse was demolished and a large, reinforced air-raid shelter built on its foundations. More or less neglected, the garden and especially the shrubs around the boundary became overgrown. Behind its wall and high gate, it began to resemble a closed, mysterious site, virtually lost to the world. Inside, a coat of brown paint covered the woodwork, drably suited to wartime austerity.

ABOVE The original Appeal letter to save Red House has a number of notable signatories even though ultimately unsuccessful.

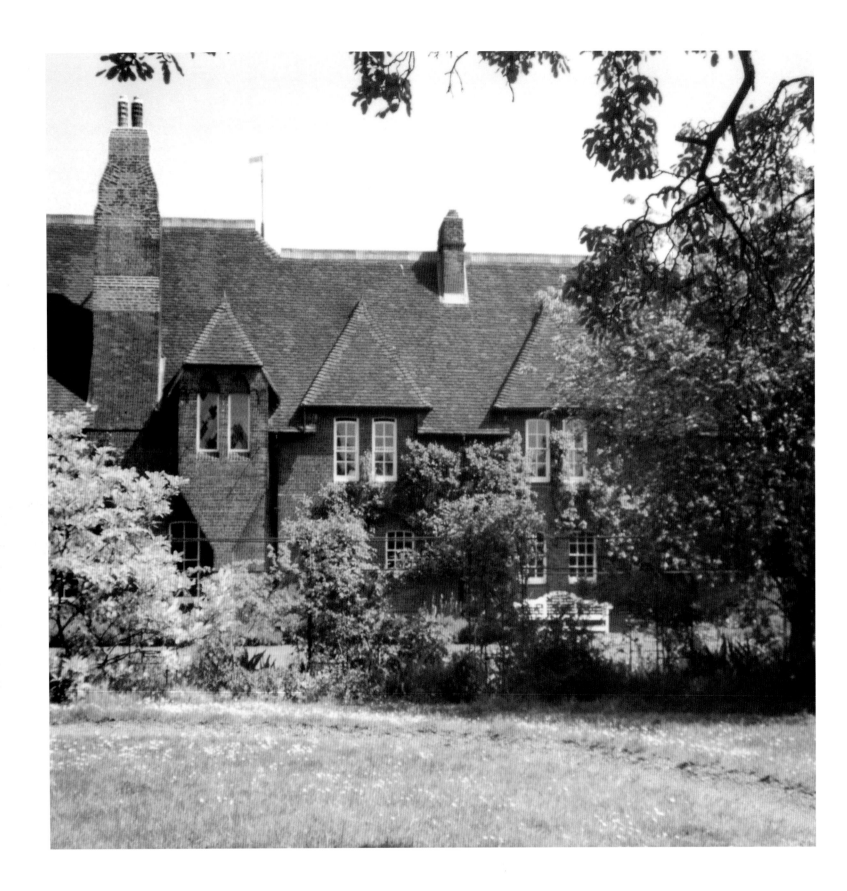

THOUGH THE ORCHARDS AND MEADOWS HAVE
DISAPPEARED, WHEN TODAY'S VISITOR PASSES
THROUGH THE SOLID WOODEN GATES, IT IS TO EXPERIENCE
THE ILLUSION OF ENTERING INTO ANOTHER WORLD, TO
FIND THAT HOUSE AND GARDEN IN THE COUNTRY THAT
MORRIS CREATED ...

Edward Hollamby, 1991

After the Second World War, Red House passed back to the Hills family, and a new search for a secure future began. On 30 March 1950 Mr Hills telephoned the National Trust to plead for it to be bought for £6000. Paying a swift visit, the Trust reported that it was clearly 'a most important house in the history of architecture', which the Historic Buildings Committee would wish to accept. But there were no funds. Throughout the land, houses of much greater antiquity and importance were being demolished. Many people were concerned. 'It is a unique memorial of Morris and his circle and all they stood for, and should be preserved as such,' wrote *The Times'* architectural correspondent. [149] James Lees-Milne paid another visit, noting that the house had hardly been altered since Morris' day, retaining dressers, stained-glass, mural paintings, patterned ceilings, 'original iron lanterns' and a glass-paned door on which – so it was assumed – Morris' guests had scratched their names. But the price was high. If acquired it would be hard to let: surrounding houses were of a 'lower-income-group' type, so any tenant would be 'a person of means rather above those of the people in the neighbourhood.' The terse conclusion was therefore 'Drop it'. [150]

The judgment was indisputable. Before the war, the enlarged Red House garden had covered nearly two acres (0.8 hectares). By 1950, part had been carved off to make a dog-leg plot – presumably sold by Hills – onto which a new house was squeezed. Moreover, though recent planning legislation aimed to control piecemeal development, the orchard beyond the garden had just become Cuxton Close, with fifty-six new council houses. Soon after, both Aberleigh

LEFT View of the west front in the 1960s. The wide ellipse in the foreground was the schooling ring for the Hollamby's horse. It was clearly visible when the National Trust took over the house in 2002, causing much puzzlement.

ABOVE Jean and David Macdonald at Red House in the early 1960s.

Lodge and its new neighbour on the dog-leg plot were to be demolished to make way for the present crescent of houses on the lane.

Under new legislation, the house was also due to be listed as a historic building to prevent demolition. By July Hills was desperate. 'Unless I can get relief from heavy taxation and the cost of upkeep,' he told the National Trust, 'I shall be forced to move and close it up.' Probably exaggerating, he claimed between 700 and 800 visitors a year. 'Sorry,' replied the Trust. But behind the scenes activity was going on. On behalf of the Trust, Lord Chorley asked Prime Minister Clement Attlee if the Labour Party would buy Red House as a memorial to the man whose political writings had inspired many Labour members. 'Sorry,' replied Attlee's office. Then Sir Geoffrey Mander of Wightwick Manor, the Arts and Crafts-influenced house near Wolverhampton (which became the first post-war bequest to the National Trust), stepped forward and offered to present Red House to the Trust for use by the Labour Party or Trade Union movement. 'No thank you,' replied the intended beneficiaries. 'I am at a loss to know what to suggest as all my inquiries in Trade Union and other circles have so far failed,' Mander wrote in November 1951. It seems the lack of interest in their Socialist precursor noted by May Morris in 1930 still prevailed, although it is also hard to see how the house might practically have been used.

Meanwhile the Hills offered the house for £5000 to 'anyone willing to preserve it for the Nation'. Finally, its saviours appeared. 'I have an architect from London interested in buying the property with a view to making living accommodation for two families,' Hills told Mander, early in 1952. And so began a new and fortunate phase in Red House history. In April the new occupants – Richard W. [Dick] Toms and Edward H. [Ted] Hollamby – moved in. 'Two families will be living here … with a total of six children!' Toms told Mander:

303 Secretary.

Drop N

Annexe III to Reports Agenda 16/50

THE NATIONAL TRUST

RED HOUSE, BEXLEYHEATH

Mr. Wallace and Mr. Lees-Milne visited this property on 26th June. Mr. Fedden had seen it a month or two previously, and reported briefly on 11th April, when he stated that on academic grounds the house was undoubtedly important, but that on financial grounds he could not recommend the Trust taking any action. We believe we may feel just a little more strongly in favour of the property than Mr. Fedden did. To begin with, the house has hardly been altered at all since Morris's day (1859), and there are still a number of furnishings inside, put there by him, namely, the built-in gallery and dressers, the painted glass, a glass-panelled door, on the panes of which the names of several of Morris's guests have been scratched in diamond, the original iron lanterns, two mural paintings and the remains of one or two pattern painted ceilings. These things give considerable interest to the interior. Although the surroundings have now been completely built up, the neighbouring houses are not particularly offensive, being of the genteel suburban type. Moreover, when you are in the garden, the trees screen them fairly well.

The structural condition of the house is on the whole very fair, there being only a few noticeable minor defects, such as weakness of chimney structure, etc. The accommodation includes on the ground floor two reception rooms, on the first floor one reception room and four principal bedrooms, and in the servants' wing two lesser bedrooms. The house has electric light, a Robin Hood boiler heating system, wash basins in most of the rooms, and the usual modern conveniences. The garden, however, is nearly 2 acres in extent and consequently more than could be managed by a family without outside help. The same applies to the house, which is too big to be run by the sort of family that lives in these parts, without a servant. In fact, this seems to us to be the chief obstacle to letting the property, for this house now finds itself in the middle of a suburban estate of which all the houses are of slightly "lower-income-group" size. Consequently it would not be very easy to find a tenant, who would have to be a person with means rather above those of the people in the neighbourhood.

The present owner, Mr. Hills, is asking £6000. We feel that if this house were in suburban surroundings of a slightly better type, it might be an investment to buy it, but for the reasons stated above, we cannot recommend its purchase.

C.V. Wallace
J. Lees-Milne.

28th June, 1950.

ABOVE Internal National Trust memo dated 28 June 1950, by C.V. Wallace and James Lees-Milne, outlining the reasons why the Trust could not purchase the property.

Both Hollamby and myself are architects and we both still feel somewhat overwhelmed in having been able to get such a house (and within our means!). We are not of course doing any converting, but will be living semi-communally, that is with separate kitchens and bathrooms for the two families, but sharing the dining accommodation. In fact it would seem this is the only reasonable way to use the house – if it is to be used as a dwelling – it is far too big now for a single family and should not be converted as many other large houses have been ... Actually we feel it is right to retain the house as a dwelling. It wants to be lived in and would lose so much as a museum. And our children will certainly have lovely memories of their early years – the garden, when we get it under control – will be a paradise for them. We are now "camping out" in the house while the builders are in and getting ready for the move. We seem to have spent the weekend doing nothing but removing layers of paint – most of which has just been vandalism destroying the original character of the house. At first we are only working in the kitchen quarters, but even there have discovered many interesting things (including the original ceiling pattern).

ABOVE Sir Geoffrey Mander (1882–1952). Mander's own home Wightwick Manor, near Wolverhampton, contains Morris & Co. furnishing and Pre-Raphaelite paintings, including works by Rossetti, Burne-Jones, Elizabeth Siddal and Madox Brown

He added that the price (£3500) was very reasonable but a mortgage had been nigh impossible; even the Co-Operative Building Society had not helped the purchase of William Morris' home. Ted Hollamby and Dick Toms, who met in the war, had talked of their dream that their families might live and work together. Then both took jobs with the London County Council (LCC), the creative centre for rebuilding the war-damaged capital. They talked of their dream that their families might live and work together. Hearing of Red House through architect Thurston Williams, Ted sent Dick a telegram: 'I've found the house!' [151] Although it was very exciting, taking on such a daunting prospect required a high level of commitment and sheer hard work, much of it done by themselves. In the weeks before he started at the LCC, Dick Toms began to clear rubbish from the overgrown garden, where the grass was like a field and the hedges were now fourteen feet (4m) high. Told that Hills had described the house as 'one you can beat your wife in without the neighbours knowing', he was delighted to find a discarded corset in one of the original *herbers*, which instantly became known as 'Mrs Hills' garden'. [152]

Indoors, Ted and Dick erected scaffolding to clean and repaint the ceiling at the top of the main stairs, removing the ubiquitous brown paint, and installed separate bathrooms and

kitchens. Thanks to the L-shaped house, the decision to live 'semi-communally' was practical; the Toms household taking the north wing plus the drawing room and the Hollambys occupying the rear wing plus the dining room. The original kitchen became the 'eating room', where each family had its own table, while the Toms cooked in the former scullery and the Hollambys in the old pantry. Even the garden had two vegetable patches. 'It would not be communal living', strictly defined, 'but it would be shared living up to a point.' [153]

The Toms had a daughter Jennifer, a son Patrick and twins Alex and Michael. The Hollamby daughters, Marsha and Jill, were soon followed by son Andrew. In 1954, architect David Gregory Jones joined the household, occupying the ground floor rooms that had been made into a library, with the dividing wall reinstated. Red House then contained five adults and seven young children; it was hectic, noisy and wonderfully spacious for the children.

So Red House passed into the keeping of two young architectural couples committed to post-war reconstruction, to Morris's legacy and to the relevance of his socialism to that challenge. Already a landmark in architectural history, Red House's resonance went deeper for many in the LCC, who were less interested in the decorative Pre-Raphaelite phase of Morris' career than his later socialism, when he was preoccupied with bringing beauty to all, in art and daily life. 'The dwellings of all our people', Morris had lamented in 1879, 'are built without any hope of beauty or care for it – without any thought there can be any pleasure in the look of an ordinary dwelling house, and also ... with scarce any heed to real convenience.' And though he hoped that one day it would be 'hard to believe that such houses were built for a people not lacking in honesty, in independence of life, in elevation of thought and consideration for others', all current building exuded only hypocrisy, flunkeyism and careless selfishness. 'We have given it up as a bad job. We are heedless if our houses express nothing of us but the very worst side of our character both national and personal.' [154]

In his later years, Morris had lived in Hammersmith, where Ted and Doris Hollamby were both born and where lively associations with the Morrises, the Arts and Crafts movement and socialism persisted. 'In 1934 I went to technical college at the School of Building Arts and Crafts in west London, where William Morris' daughter taught,' Ted explained, 'that's how it all began.' [155] One of his early LCC projects was a school in Hammersmith, which despite his hopes

CLOCKWISE FROM TOP LEFT Ted and Doris Hollamby in the front entrance porch of the house in the 1980s; The Hollamby family making car parking space at the front of the house in 1958; Mary Toms and her children Jennifer and Alec with Marsha & Jill Hollamby *c.*1955; and left to right: Dick Toms, David Macdonald, Jean Macdonald, Mary Toms in the garden at Red House.

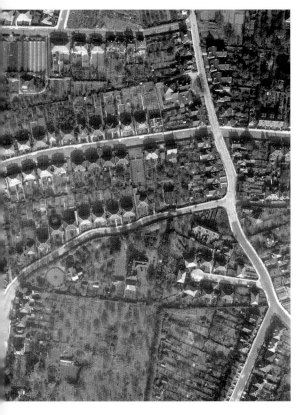

was not named after Morris but in which he managed to hang some Morris wallpapers.

A lineal connection also stretched from Philip Webb to the architects of the LCC, where a number of his disciples had worked in the 1900s, designing fire stations and housing. A group of their successors, notably David Gregory Jones, researched this legacy so that those involved in post-war reconstruction saw themselves as part of a national tradition. This led from the 'progressive Gothic' of Red House to their own work which embraced modern ideas and technology without turning its back on the past. This tradition tallied with the viewpoint of Pevsner and others like Herbert Read, who in 1934 had confidently declared that, 'although the Morris of 1850 [sic] would have little sympathy with the art of today, the Morris of today would be on the side of Le Corbusier in architecture, Picasso in painting and probably Stalin in politics', which rather contradicted Morris' own promise to 'lie down and kick' against any totalitarian coercion. [156]

The Hollambys, the Toms and their colleagues had mainly socialist leanings. Rebuilding London facilitated the attempt to raise the quality of urban life for working people – a goal Webb and Morris could dream of, but never realise. The LCC architects, who were less self-effacing than Webb, believed it necessary to spread the word that architecture could address social problems. They also practised a team culture of design and building for public benefit not personal profit. Inheriting principles developed by architects Raymond Unwin and Patrick Abercrombie, they aimed to create well-planned and well-served communities. Much landscaping was involved, but the core of the work was urban housing. Community services – schools, playgrounds, shops – and wherever possible public art – sculptures, murals, mosaics – were incorporated.

One ensemble in south London that brings together these efforts is the Brandon Estate between Kennington and Walworth, built from 1958 onwards. A copybook example of the 'mixed development' favoured in housing at the time, it is skilfully integrated into the fabric

ABOVE Aerial view of Bexleyheath, 19th October 1945. There was little bomb damage in the suburbs visible during the Second World War, but post-war reconstruction and development in the inner city was a priority for the LCC architectural department, which employed the new residents of Red House.

of the city, and extends from tall towers through a low-rise square to refurbished Victorian terraces – a novelty in those days of enthusiastic clearance. Hollamby led the team that planned Brandon, Gregory Jones designed the tower blocks, while Jean Macdonald (a later Red House resident) also participated. Brandon includes a bronze by Henry Moore and a mural by Anthony Holloway. 'If the style of the estate is remote from anything Webb and Morris would have recognized,' writes Andrew Saint, 'in its own way it represents an updated version of their passion and social commitment.' [157]

At Red House itself, unlike previous owners, the Toms and Hollambys shared social principles that lay in a direct line of descent from Morris and Webb, with an egalitarian spirit that was in its way a return to the original notion of Red House as a place of fellowship. Neighbour Gwen Waring met the new occupants of the house 'where we had previously collected our ration books' soon after their arrival. 'It was not long before we understood that they had purchased it because it has been the house that William Morris had lived in,' she recalled, 'and that Morris had been a fervent Socialist. Socialism to us then was the solution to the ills of the world.' [158] Red House became a site of social activity with summer country dancing on the lawn (Doris provided tea and scones), Christmas parties with a tall tree in the hall and urgent political discussions about the Marshall Plan, the Korean war and the atomic bomb. Following in Morris' footsteps, the families joined marches and demonstrations against government policies: the peace protests of the 1950s. Garden parties were held by the Co-Op Women's Guild, the Woodcraft Folk, the British-Soviet Friendship Society and, in October 1953, the inaugural meeting of the William Morris Society. Thus Red House resumed what some considered its true role, as a place for creative living and politically-engaged sociability.

By 1956, the Toms family was outgrowing its share of the rooms and they decided to move. The Hollambys asked fellow LCC architect Jean Macdonald and her husband David, who were hoping to start a family, if they were interested in sharing Red House. 'We visited the house, fell in love with it, were overwhelmed and daunted by the prospect, but decided to take the plunge,' recalls Jean. In April 1957 they moved in. David Macdonald was an accountant and also a skilled woodworker: Morris' studio became his carpentry-shop. To historian Mark Girouard, this was something that would have delighted Morris. [159]

So the house continued its latest transformation, the new occupants always conscious of Morris' legacy. The settle in the hallway was one challenge and a conservation expert from the V&A was consulted: 'We cleaned areas of paint off to find out exactly what it was like,' Ted recalled, 'the scene runs round the corner and tulips stand up down below. The temptation would be to restore it which is just what Morris said you should never do'. [160] But the existing glass in the front door was replaced by contemporary stained glass panels representing the Four Seasons, commissioned from Anthony Holloway, and the patterning was restored on the rest of the door. 'We remember how excited our father was that a paint firm in Lambeth had been able to re-create the original colours of the front door so that he was able to follow the simple medieval pattern and re-paint it', recall daughters Jill and Marsha. [161]

'Our attitude towards restoration, decoration and furnishing was pragmatic,' writes Jean Macdonald, 'We would restore where we could; decorate, as others had done before us, in ways we liked and felt appropriate; and our furniture would be modern, well-made and true to itself, in a spirit we hoped was in tune with Morris' famous saying "Have nothing in your houses that you do not know to be useful or believe to be beautiful."' David Macdonald completed the removal of brown paint, stripping the woodwork back to bare pine. On the upstairs corridor he found nothing under the brown except a few traces of red and green staining. In the drawing room the black-painted ceiling battens were stripped and varnished while Jean repainted what appeared to be an original pattern over the oriel window. 'I could have sworn it was a pricked pattern similar to those in other parts of the house,' she wrote in 2003. 'However when I went back recently, I found it was not pricked ... My memory had been playing tricks.' [162] Nor was the colour original: Jean chose the present ochre to tone with the exposed floorboards and seat covers.

The next task were shelves for 'our huge number of books'. On the train to work Jean and David Gregory Jones sketched a design to run the length of the drawing room but struggled to find a solution to the obstacle of the large heating pipes along the skirting. 'Why don't you make the supporting frame triangular at the bottom to oversail the pipes?', suggested Gregory Jones. 'There could be the same shape at the top, in a kind of echo', added Jean. That evening, David Macdonald took charge of construction, choosing polished oak for the shelves and

RIGHT 1950s view of the drawing room, showing contemporary-style furniture beside Webb's monumental fireplace, complete with a new hood.

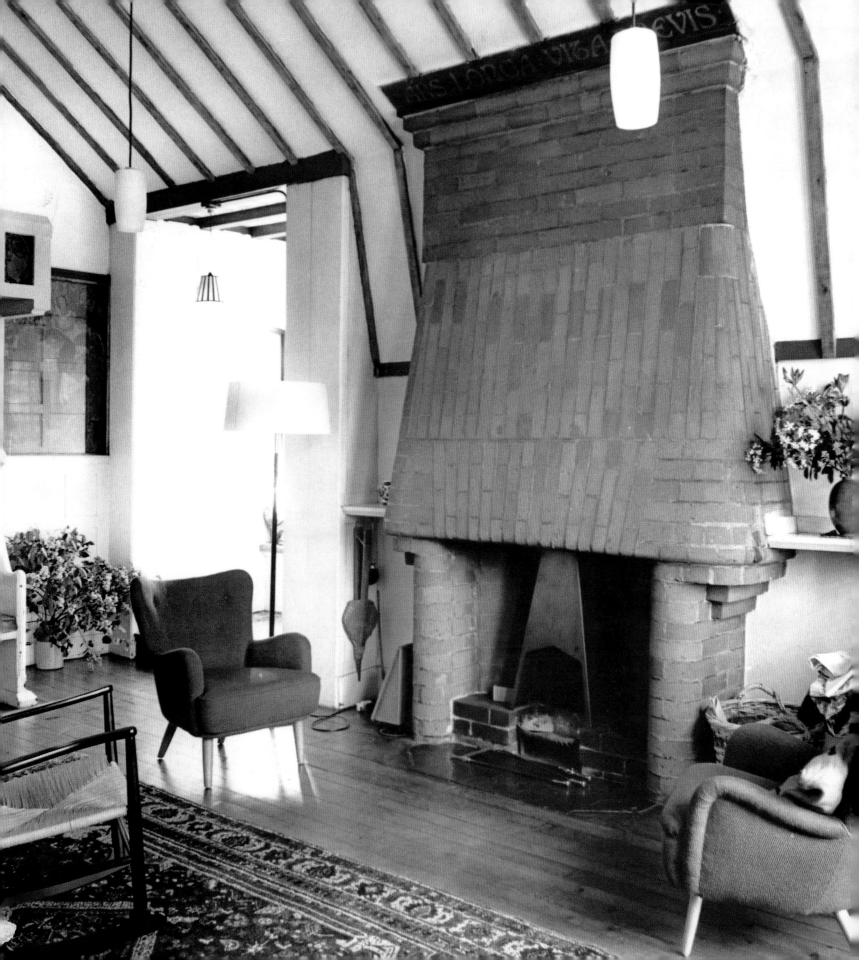

ebonised beech for the frame. In this manner, the lightly-built bookcase, with its slim verticals pushing back to the wall, introduced a modern Scandinavian note into Webb's room. Its three makers were gratified when it was published in a design magazine.

Later, David Macdonald made a telephone table for the lower gallery and the shelf for flowers in the angle of the stairs, while Gregory Jones designed a china cabinet where the original kitchen range had been. In the drawing room, the fire continued to smoke, as it had done in 1860. A brick plinth laid by Ted and a metal hood designed by Bill Alleen cured the problem. For furniture, the families favoured contemporary styles: splay-legged armchairs and wooden tables by Ernest Race and Ercol, modern glass light-fittings from the Merchant Adventurers, Japanese paper lampshades, batik hangings, rush-matting for floors and a Danish rush-seated rocking chair. The settle remained white, and the whole effect was of its era – 1955–65 – representing a return and an extension of the original vision, with new items alongside old. The plate shelf that ran round the hall and along the gallery was removed because, 'it collected dust and had no function.' With hindsight, Jean comments, perhaps this was vandalism. [163] On the walls, layers of paper were stripped off, not revealing any mural decoration and then repapered with the Morris & Co. *Apple* design, which was chosen by a friend and fellow Morris enthusiast named Miss Callard who helped keep the garden in order. On the door to the garden porch, Gregory Jones painted a pattern of his own devising.

The Hollambys had a big dog named Brindy and in due course their daughters acquired a pony. Jean remembers the excitement of arriving home from work to find them riding round the orchard. The huge manure heap was Red House's 'secret gardening weapon', while the whole place had a restorative atmosphere:

> After walking from the station through Bexleyheath suburbia, to open the gate in the red brick garden wall was to enter an extraordinary oasis: there was the pony in the orchard, the barked welcome from Brindy, and the late evening sun lighting up the west wall. We would collect a glass of sherry and take it to a special grassy spot behind the air-raid shelter where we could enjoy the very last of the sun. In autumn, there were apples to be picked and stored in one of the outhouses, and a mature quince tree that produced a good crop from which my mother made jam. [164]

There were down-sides to the house, which remained somewhat impractical even almost a century after Morris had left. The worst job was having to stoke the boiler in the cellar every morning and evening, removing the clinker and filling up with coal, now delivered through the hall and down the cellar steps, leaving dust everywhere. Later, the central heating was converted to gas. Whatever the fuel, the house remained cold. There was no roof insulation and, as Jean points out, the ceilings were high and the solid brick walls lost heat quickly. But, she adds, 'we were hardy by modern standards. We wore thick sweaters, we were young and active.' Incredibly, the Macdonalds slept with open bedroom windows, as Jean writes:

> To wake in that north-facing room on a grey winter morning was not a nice start to the day. But then, open the bedroom door and 'Wow!', shafts of light from the gallery and staircase. The studio was also flooded with light, brilliant as workroom and playroom. The quality of light and the relation between spaces and light are the things to note about Red House. [165]

1960 saw the Red House centenary. Fairly remarkably, it had passed a hundred years in structurally original condition. The interior had changed from riotous colour and patterning to being bright and white while the garden had acquired a dense screen of shrubbery on all sides. The William Morris Society held a party to mark the anniversary; photographs show people milling around the well-head.

In 1964 the Macdonald family left Red House for Blackheath and the Hollambys took over the whole. It was 'a happy, welcoming family home where laughter, fun and good conversation abounded', according to Marsha and Jill. 'The house was ideal for games: hide and seek (too many hiding places to mention), races down the oak stairs bumping on our bottoms, and sliding along the downstairs corridor.' [166] Largely a family home, partly a historic house and at the same time a social dwelling that welcomed friends and strangers, Red House had a multivalent atmosphere that prevailed through various changes. When Red House proved impractical, Morris bit his lip and moved back into the smoky city. The Hollambys were more fortunate, their life in Bexleyheath extending through half a century.

For the last phase of his career, Ted was chief architect with the Docklands Development

ABOVE The inside of the entrance door, repainted to match Morris's original pattern and colours. The new glass panes by Anthony Holloway represent the Four Seasons.

Corporation, created in 1981 to redevelop much of the Isle of Dogs into housing and office space. It was in part through his influence that the great West India Dock basins were preserved for posterity. Indirectly this was a further legacy of the conservation movement that Morris had spearheaded. It may be curious to think of Morris and Webb, on their many companionable excursions looking at old buildings, as forerunners of those on architectural heritage trails today in Wapping, Limehouse and the Isle of Dogs. But as Morris had declared in SPAB's manifesto:

> If it be asked us to specify what kind or amount of art, style, or other interest in a building, makes it worth protecting, we answer: anything which can be looked on as artistic, picturesque, historical, antique or substantial; any work, in short, over which educated artistic people would think it worth while to argue at all. [167]

At Red House, other Morris papers and fabrics, now back in fashion, were introduced. Though none were there in Morris' own time, today his designs are inseparable from the house. The entrance hall, for example, is papered with a modern blue reprint of the *Apple* pattern dating from 1877, while the studio walls are covered with a gentle green version of *Marigold* from 1875. The dining room has *Golden Lily* curtains and *Sunflower* paper. Along the garden passage are long lengths of pink and white *Cray* fabric, named for the river towards which the house once looked. *Rose* curtains hang in the original kitchen, and *Honeysuckle* in the Morrises' bedroom. The back bedrooms are papered with *Anemone* and *Bird*, *Briar Rose* and *Michaelmas Daisy*. Other textile designs hang as alcove curtains.

This profusion of patterns is not like that of the original house. In twentieth-century style, colour and pattern are relieved by white walls and unpainted wood. And at the same time, the rooms were always lived in, with all the incidental, moveable objects of a family home, and never conceived of as a 'design interior' of select, ordered elements. Over forty years the contents accumulated, altered and dispersed. Jill Hollamby notes that it is impossible and misconceived to imagine the 'Hollamby era' as creating a single 'look'.

Ted's view that 'the house should always be a modern house', established the balance

between conservation and modernity, the house always reflecting the period in which it was lived in. [167] Jill remarks that 'Ted and Doris chose Morris wallpapers and wall hangings that did not overwhelm but made the house comfortable and sympathetic to the original atmosphere.' Individual fittings designed by Red House inhabitants from 1952 onwards complemented the house. 'The furniture and refurbishments Dad designed for the house were modern yet elegant, born out of simplicity with features that still echo through the house. Amongst others, the dresser in the eating room, the modernised bathroom and the studio furniture carry these principles'. [169] Yet this did not preclude other classical designs of the day. As Ted explained, 'With us there is Liberty's furniture, there is furniture from Heal's and that is the way I think the way the house ought to be seen, not as a set piece.' [170] It is a nice feature that Lazenby Liberty's signature graces the glazed doors in the hallway.

Throughout their long residence, the Hollambys welcomed visitors, usually on one or two weekend days a month and often during the week from about 1988 onwards, seeing themselves as guardians of the house. The family never forgot the occasion when one of the girls lay ill in bed, as 'the door burst open and Dad showed some impromptu visitor "the maids' room" seemingly oblivious to the figure huddled beneath the bedclothes'. [171] Over the years, 'the famous Ted Hollamby tour' evolved, during which visitors would receive a wide range of views and opinions in addition to the story of Morris and friends at Red House. [172]

Throughout its history, the garden has been an integral part of Red House. Indeed, many of the trees and flowers that provided inspiration to Morris and his friends can still be found and, 'due to the devotion of the Hollamby family, the presence of Morris still pervades the house and garden.' [173] The simplicity of the interior work is matched by the touches Ted wrought outside, especially his painstakingly laid red-brick paths that mirror the house they surround. The regeneration over their fifty-year ownership owes much to Doris, who 'worked hard on re-creating the feel of the garden reflecting fields, hedgerows and the mood of an English cottage garden.' [174] This was achieved by establishing a basic structure for the garden and allowing it to be adapted over the years without compromising the fundamental design.

By the early 1990s, Ted began steps to secure the future of Red House through sympathetic ownership that would ensure public access. He and the William Morris Society discussed

setting up a trust, the National Trust suggested a watching brief, a steering committee was formed and legal advice sought. The initial committee comprised Ted and Jill Hollamby; Hans Brill, Ray Watkinson and Derek Baker from the William Morris Society; Jean Davis and Janet Woods from Bexley Civic Trust; and a representative from Bexley Council planning department. In 1996, Ivor Blomfield, former deputy-director of the National Trust, advised on the formation of an independent charitable trust to purchase the house. But how was the money to be raised? A valuation and a building survey were commissioned. Various feasibility discussions and conversations were held.

Meanwhile, to continue to be able to open the house to the public the Friends of Red House came into existence. The need became acute during 1996, the centenary of Morris' death, when visitor numbers soared. Mainly run by people in Bexley, Sidcup and neighbouring districts, the Friends created a team of volunteer tour guides, helping the Hollambys with the afternoon openings around thirty times each summer. 'So I got the job I really loved – showing visitors round the House,' writes Rob Allen, then Chairman of the Friends of Red House. 'Ted would do the introduction, usually at the well if the weather was okay. It varied from fifteen minutes to half an hour and, though unpredictable in terms of content, he always ensured that people knew a lot more than when they came – on anything from medievalism to modernism. Visitors loved the sense that Ted and Doris gave of inviting them personally into their house as guests, and their sheer enthusiasm for and love of the House. It was a hard act to follow.' [175]

During 1998 the Red House [Bexleyheath] Trust (RHT) was established. Trustees came from various bodies including English Heritage, the Victorian Society, Bexley Heritage Trust and the National Trust, with the majority of representatives being affiliated either to the William Morris Society (WMS) or the Friends of Red House. Sonia Crutchlow (WMS) was chair; others included Linda Parry (V&A), Ivor Blomfield (NT), Richard Holder (Victorian Society), Paul Drury, formerly of English Heritage, June Slaughter and Janet Woods (Friends of Red House), Derek Baker and Penny McMahon (WMS). The aim was to 'save' the house so that public knowledge and enjoyment were retained, enhanced and developed. Many of those involved knew of disastrous outcomes when historic buildings had passed into the hands of indifferent or absentee owners, which was not the intention of the Hollamby family.

In September 1999, the RHT decided that the house could not viably be run as a museum or educational centre, and that finding a long-term tenant would be very difficult. The most feasible option was purchase and transfer to an existing heritage organisation. The Landmark Trust, which buys and converts historic buildings for holiday use, was willing to create apartments to let in the kitchen wing, while keeping public access to the main rooms through tours by the Friends. Sadly, Ted Hollamby died at the end of the year, before any plans were finalised.

With Doris' health deteriorating, the question of what to do became urgent. 'Eventually,' recalls Rob Allen, 'the Friends Committee sat down with Jill Hollamby in the kitchen at Red House and discussed whether the Friends could take over all the organisation of the visitor side of things, as well as the stream of enquiries that came regularly about all aspects of the House and the Morris circle.'

With some trepidation, the Friends decided to take up the challenge. 'We had a few weeks space before the House was reopened in May ... No bookings had been made, correspondence had not been dealt with, the garden was rampant.' Somehow they 'muddled through', booking tours, selling teas, hiring a gardener, writing a brochure and generally looking 'as though we had been doing it for years.' Later in the season, family and Friends held a memorial service for Ted in the garden.

Keeping the House open was one task, securing its future another. 'Ted and Doris took a very strong (and very Morris-like) view that it should not become a museum – preserved in aspic – and wanted it to be lived in as it had been through nearly all its history.' Discussions continued. The Red House Trust looked to fundraising. Bexley Borough Council lent its support, Bexley Heritage Fund paid for a new valuation, maintenance plan and updated structural survey. Was there room for another Morris museum? Water House in Walthamstow, was home of the William Morris Gallery; Kelmscott Manor in Oxfordshire, managed by the Society of Antiquaries was Morris' country house; Kelmscott House in Hammersmith, part of which is occupied by the William Morris Society, was Morris' London home. The uncertain future caused anxiety to all. Early in 2002 Doris Hollamby moved into a care home, leaving the building empty. Unless a very large purchase sum was speedily forthcoming, Red House would return to the open market. It was valued at £1.25 million.

As Ted and Doris' daughters have remarked, their parents:

wanted the house to remain available to the public yet while there was general interest in this notion there was no single body seemingly able to help make this happen and this, coupled with the intransigence of local bureaucracy, seemed the threaten the whole aim. Fortunately there was a kindred spirit in Jill, Duchess of Hamilton. She became aware of the problem and was instrumental in generating the support the family needed. [176]

And at the eleventh hour, an anonymous benefactor and admirer of Webb offered – in the spirit of Sir Geoffrey Mander half a century before – to buy the house for the National Trust. In June 2002, things began to move in a new direction. In normal circumstances, new National Trust properties remain closed for some time after acquisition while research and conservation are carried out. At Red House, the hope was to carry on from where the Hollambys left off with the assistance of the Friends. Rather to National Trust amazement, the Friends offered to open and run the house at once. They began and continue to conduct tours, make teas and sell books as well as plan and maintain the garden; without this invaluable input, visitors would not have been able to enjoy Red House so swiftly. In respect of the whole speedy and successful transfer, particular tribute is also due to Jill Hollamby and Julia Simpson, National Trust area manager.

Doris Hollamby died in April 2003, shortly before the House opened for what would be the first 'National Trust' season. 'It was a difficult but invigorating summer,' according to Allen. It was exciting, because despite the Hollambys' generosity, only a fraction of those interested in Morris had previously been able to visit. Suddenly, an almost legendary place was open. The Friends and National Trust staff, including the newly appointed custodian, opened Red House for five days every week. Nearly 20,000 visitors came that year; a number that continues to grow despite the small capacity for tours and the need to book ahead. Morris and Webb would have been amazed at the level of interest that their creation still generates; Morris' dictum of 'having nothing in your houses that you do not know to be useful or believe to be beautiful' is as true today as it ever was.

Chapter 12 Epilogue

IN 1881 MORRIS AND HIS COLLEAGUE William de Morgan were searching for new workshop premises for textile printing and weaving, wallpapers, stained-glass and ceramics. They travelled like 'eccentric millionaires', 'raising the hopes of many owners of clearly unsuitable properties by going over the premises minutely, allocating the rooms ...' [177] Mutually fond of puns, they called their ideal factory 'the fictionary', because it seemed quite unattainable. One of the places they visited was in Crayford, where textile bleaching and printing were long established; indeed, this industrial development had partly contributed to the residential rise of Bexley Heath. The mill buildings were 'old and solid' and cheap. [178] Although there were in fact two rail lines into London, Morris dismissed the location as inaccessible. Perhaps his judgement was clouded by memories of commuting into Holborn twenty years before. Now he lived in west London; how long would it take to reach Crayford?

However, he and de Morgan took the chance to walk through the water-meadows towards Bexley. They passed Hall Place, the handsome flint-and-brick Tudor mansion. Seeing this again, Morris reported, 'made the stomach in me turn around with desire of an old house.' [179] As by this time he already had an old house, Kelmscott Manor, he was not yearning, merely recording his visceral response to ancient buildings.

From Hall Place to Upton is perhaps a mile and a half (2.4 km). Surely Morris remembered and contemplated re-visiting Red House. He would have recalled a new building standing amid cherry blossom, and feared, correctly, to find a rash of newer, rawer villas all about. To Jane, he remarked on the despoliation of the remaining countryside. So he and de Morgan headed back into town, probably from Bexley station. A few days later they went to Merton, where the historic Abbey site and district was equally despoiled and 'woeful beyond conception' but the former silk-weaving mill had 'a certain melancholy charm'. Optimistically, Morris calculated that from Hammersmith to Merton would 'scarcely' take longer than to Queen Square and decided in its favour.

And that was the closest he came to revisiting Red House.

LEFT View of well-head from bull's-eye window on the first-floor.

ABOVE RIGHT Detail of the 'Si je puis'– If I Can – Morris' adopted motto on stained glass in a first-floor window at Red House.

Endnotes

CHAPTER 1

1 *The Times*, 01.05.1935
2 MS in private collection, 28.12.1937

CHAPTER 2

3 J.W. Mackail, *The Life of William Morris*, 2 vols, 1899, 1, 83
4 Mackail, 85
5 Mackail, 106–7
6 C.Y.Lang (ed.), *The Swinburne Letters*, 6 vols, 1959–62, 1, 18
7 H. Allingham & D.Radford (eds.), *William Allingham A Diary 1824–1889*, 1907 (reprinted 1965), 139
8 W.R.Lethaby, *Philip Webb and his Work*, 1935 (reprinted 1979), 252
9 P. Webb to William Kent on 16.06.1859, quoted in S. Kirk, *Philip Webb, Pioneer of Arts & Crafts Architecture*, 2005, 20

CHAPTER 3

10 W.E. Fredeman (ed.), *The Correspondence of Dante Gabriel Rossetti*, 4 vols, 2002–4, 60.12 & 62.3
11 N. Kelvin, (ed.), *The Collected Letters of William Morris*, 3 vols,, 1984–96, 11, 32
12 W. Cobbett, *Rural Rides*, 1830, 1, 41
13 J.C.M. Shaw, *The Bexley Heath Phenomenon*, 1983, 15
14 Lethaby, 25; Kirk, Chapter 11
15 A.W.N. Pugin, *Apology for the Revival of Christian Architecture in England*, 1843, 38
16 G. Giles Scott, *Remarks on Secular & Domestic Architecture Present & Future*, 1857, 124
17 Kirk, 23, 29–30
18 M. Hall, 'Red House in its architectural context', National Trust Symposium at the Art Workers Guild 2004
19 Kirk, 30

20 British Library Add.MS 45343
21 P. Webb notebook April 1859 quoted in D. Baker, *The Flowers of William Morris*, 2001, 44

CHAPTER 4

22 Mackail, 142
23 Fredeman, 56.59; Mackail, 113; S. Wildman, (ed.), *Waking Dreams: the Art of the Pre-Raphaelites from the Delaware Art Museum*, 2005, items 1997–12/13
24 H. Price, quoted in P. Kirkham, 'William Morris's early furniture', *Journal of the William Morris Society*, Summer 1981
25 M. Heathcote, quoted in Christies Sale Catalogue 29.10.1997, 33
26 Mackail, 113; the table is now in Cheltenham Museum
27 Fredeman, 60:55
28 F. MacCarthy, *William Morris: A Life for Our Time*, 1996, 107
29 G.E. Street, 'The Future of Art', The *Ecclesiologist*, 1858, 232-40
30 W. Bell Scott, *Autobiographies*, 1892, II, 61
31 Kelvin, 16
32 Fredeman, 56.59
33 Initially, the firm of Morris, Marshall, Faulkner and Co., intended to sell art works as well as decorative items.
34 Fredeman, 64.37
35 With thanks to Jane Bliss
36 'GBJ' [Georgiana Burne-Jones] *Memorials of the Life of Sir Edward Burne-Jones*, 2 vols, 1904, 1, 209
37 MacCarthy, 159
38 Fredeman 61.49; J.C. Troxell, (ed.), *Three Rossettis: Unpublished Letters to and from Dante Gabriel, Christina, William*, 1937, 8
39 British Library Add MS 45341
40 G. Burne-Jones, 1, 209
41 British Library Add MS 45341
42 A.R. Dufty, *Morris Embroideries, the Prototypes,*

1985, 12, 41,

43 British Library Add MS 45341

44 L. Parry, quoted in Dufty, 14

45 J.M. Crook, *William Burges and the High Victorian Dream*, 1981, 87

CHAPTER 5

46 G. Burne-Jones to E. Walker, quoted in S. Rutherford, *Historic Landscape Survey*, 2 vols., I, 30. Following Webb's incorrect notation, Georgie Burne-Jones actually described this as the 'East elevation'.

47 Rutherford, 27–8

48 First published in *Oxford & Cambridge Magazine*, January 1856

49 P. Webb pocketbook 12.11.1859, quoted in Baker, 44

50 G. Burne-Jones, I, 212

51 W. Morris, 'Making the Best of It' (1879), quoted in *Hopes & Fears for Art*, 1882

52 G. Burne-Jones, I, 212.Only three such plots are shown on the 1862 OS map.

53 Mackail, 148

54 Quoted in A. Vallance, *William Morris His Art, His Writings and His Public Life. A Record*, 1897, 49

55 G. de Lorris & Jean de Meun, *Le Roman de la Rose*, Bodleian Library MS Douce 195, f.6r

56 W. Morris, 'Making the Best of It'

57 Ibid

58 W. Morris, *A Book of Verse* (facsimile reprint), 1982, 31

CHAPTER 6

59 G. Burne-Jones, I, 210

60 Ibid, I, 211

61 Ibid, I, 210

62 Ibid, I, 212

63 British Library Add. MS 45341

64 G. Burne-Jones, I, 213

65 Fredeman, 60:36

66 Tate Gallery, *The Pre-Raphaelites*, 1984, No.68, quoting F.Madox Brown's account book, with reference to 'work done for Morris at Red House'.

67 M. Morris, (ed.), *William Morris: Artist, Writer, Socialist*, 2 vols, 1936, I, 395

68 1861 Census RG 465, 35b

69 British Library Add.MS 45336

70 M. Morris, 1936, I, 393

71 Kelvin, 22

72 G. Wardle, quoted in C. Harvey & J. Press, *The Life and Works of William Morris*, 1996, 104

73 'Frank's Sealed Letter', 1856, quoted in Mackail, I, 79

74 Kelvin, 24

75 Virginia Surtees, (ed.), *The Diaries of George Price Boyce*, 1980, 32

76 Fredeman, 61.5

77 Parry, (ed.), *William Morris*, 1996, J.9

78 Mackail, I, 161

79 G. Burne-Jones, I, 223

80 Mackail, I, 151–2

81 Ibid, I, 147

82 G. Burne-Jones, I, 215

83 Mackail, I, 158

84 Ibid I, 160

CHAPTER 7

85 Fredeman, 61.49; Troxell, 8.

86 British Library Add.MS 45336, f9v

87 Mackail, I, 159

88 Fredeman, 62.3

89 Parry, 1996, M.12

90 Bell Scott, 1892, II, 61

91 Quoted in Vallance, 49

92 Ibid, 50–51

93 Still employed by Morris & Co. when Vallance was writing his book.

94 Allingham & Radford, 106

95 Tate Gallery, 1984, No.68

96 Mackail, I, 161
97 Kirk, 30
98 G. Burne-Jones , I, 277
99 G. Burne-Jones, I, 279
100 Kelvin, 26
101 Mackail, I, 163
102 A.W. Baldwin, *The Macdonald Sisters*, 1960, 94
103 Baldwin, 94
104 J.Marsh, *The PreRaphaelite Circle*, 2005, 86
105 'Frank's Sealed Letter'; in Mackail, I, 79
106 J. Marsh, *Dante Gabriel Rossetti: Painter and Poet*, 1999, 310
107 Fredeman, 65.87
108 G. Burne-Jones, I, 294
109 Quoted in M. Morris, *Introductions to the Collected Works of William Morris*, 2 vols, 1973, I, 68
110 M. Morris, 1973, I, 78
111 M. Morris, 1973, I, 8

CHAPTER 8

112 Wardle, quoted in Harvey & Press, 64
113 M. Morris, 1973, I, 80-81
114 M. Morris, 1973, I, 80
115 P. Fitzgerald, *Edward Burne-Jones: A Biography*, 1975, 104
116 Fitzgerald, 114
117 Kelvin 180
118 Kelvin, 111

CHAPTER 9

119 Christies Sale Catalogue, 29.10.1997, 33
120 Ibid
121 *Furniture Gazette*, June 1879 quoted in H. Lyons, *Christopher Dresser*, 2005, 42
122 National Trust, notes by J. Evans and T. Wild, 2004
123 R. Hutcherson, *The History of Danson*, 1996, 35
124 'Paint Investigations in the Drawing Room', 2004 report by National Trust conservator K. Lithgow
125 National Trust, notes by J. Evans and T. Wild, 2004
126 M. Morris, 1936, ii, 618
127 *Black & White*, 12.12.1891, 774. Thanks to L.K Hughes and other contributors to the Victoria Research web
128 J.S. Gibson, 'Artistic Homes', *The Studio*, 1, 1893, 215-26
129 'G', 'The Revival of English Domestic Architecture', *The Studio*, 1896, 26
130 *The Studio*, 1896, 134
131 *The Studio*, 1894, 99–101
132 Vallance, 1897, preface
133 Ibid, 43
134 Ibid, 44
135 Ibid, 51
136 Mackail, I, 142
137 *Bijutsu Shinpou* [Art News] Feb and March 1912; Thanks to Prof. S. Nakayama, University of Kobe. For more details about Tomimoto, see Y. Kikuchi, 'The Mingei Movement', and R. Faulkner, 'A New Generation of Artist-Craftsmen', in K. Livingstone and L. Parry, *International Arts & Crafts*, 2005.

CHAPTER 10

138 *Kentish Times* 26.10.1928
139 Ibid
140 *Kentish Times* 13.08.1926
141 *The Times* 03.05.1935
142 H. Muthesius, *Das Englische Haus*, 1904, (ed.) Dennis Sharpe; Janet Seligman (trans.) 1979, 17–19; quoted in N. Cooper, 'Red House: some architectural histories', National Trust Symposium 2004
143 L. Weaver, *Small Country Houses of To-day*, 1910, 180
144 L. Weaver, *Small Country Houses of To-day*, 1922, 5
145 N. Cooper, 2004

146 Ewart Wells & Co., auction schedule for 12.03.1927
147 MS in private collection, 24.02.1935
148 Correspondence in NT Archive, file 303

CHAPTER 11

149 *The Times* 12.05.50
150 Correspondence in NT Archive, file 303
151 E.H.Hollamby, interview with J. Lever, 21.08.1997, British Library Sound Archive
152 J. Macdonald, 'Red House after Morris', *William Morris Society Newsletter*, winter 2004, 5
153 Ibid, 4
154 W. Morris, 'Making the Best of It', 1879
155 Interview in *Period Living & Traditional Homes*, 1999
156 H. Read, *William Morris 1834–1934, An Appreciation*, 1935, 28–9
157 Communication from Prof. A. Saint, January 2005
158 G. Waring, 'Doris Hollamby', *Friends of Red House Newsletter*, December 2003
159 M. Girouard, 'Red House', *Country Life*, 16.06.60, 1384
160 'Halls of Fame', interview with Ted and Doris Hollamby, BBC Radio 4, 1998.
161 Communication Jill Hollamby, April 2005, on behalf of herself and Marsha Nicholson
162 J. Macdonald, 'Red House after Morris', 6
163 J. Macdonald, 'Red House after Morris', 7
164 J. Macdonald, 'Red House after Morris', 9
165 J. Macdonald, NT Symposium 2004
166 J. Hollamby and M. Nicholson, 'Growing up at Red House', *Friends of Red House Newsletter*, December 2004
167 M. Morris, 1936, I, III
168 'Halls of Fame', 1998
169 J. Macdonald, 'Red House after Morris', 9
170 'Halls of Fame', 1998
171 *Friends of Red House Newsletter*, December 2004
172 Communication from J. Hollamby, 2005

173 Duchess of Hamilton, 'Morris's Garden of Inspiration', *Country Life* 19.09.2002
174 Ibid
175 Communication from R. Allen, 19.09.04
176 J. Hollamby 2005

CHAPTER 12

177 MacCarthy, 430
178 Kelvin, II, 32
179 Ibid

Further Reading

FURTHER READING

Derek Baker, *The Flowers of William Morris*, 2001

Georgiana Burne-Jones, *Memorials of Edward Burne-Jones*, 1904

Penelope Fitzgerald, *Edward Burne-Jones, A Biography*, 1975

Mark Girouard, *The Victorian Country House*, revised 1979

Edward Hollamby, *Red House: Philip Webb, Arts and Crafts Houses 1*, 1999

Norman Kelvin (ed.), *The Collected Letters of William Morris*, 1984–96

Jill, Duchess of Hamilton, Penny Hart and John Simmons, *The Gardens of William Morris*, 1998

Sheila Kirk, *Philip Webb, Pioneer of Arts & Crafts Architecture*, 2005

Karen Livingstone & Linda Parry (eds.), *International Arts and Crafts*, 2005

Fiona MacCarthy, *William Morris: A Life for our Time*, 1996

J.W. Mackail, *The Life of William Morris*, 1899

Jan Marsh, *Elizabeth Siddal, Pre-Raphaelite Artist*, 1991

Jan Marsh, *Jane & May Morris: A Biographical Story*, 1986

Jan Marsh, *Dante Gabriel Rossetti: Painter and Poet*, 1999

Jan Marsh, *The Pre-Raphaelite Circle*, 2005

Chris Miele (ed.), *From William Morris: Building Conservation and the Arts & Crafts*, 2005

May Morris, *William Morris: Introductions to the Collected Works of William Morris*, reprinted 1973

Gillian Naylor, *William Morris by himself: Designs and Writings*, 1996

Linda Parry, *William Morris Textiles*, 1983

Linda Parry (ed.), *William Morris*, 1996

Tony Pinkney (ed.), *We Met Morris: Interviews with William Morris 1885–96*, 2005

Giles Walkley, *Artists' Houses in London 1764–1914*, 1994

ACKNOWLEDGEMENTS

The author and publisher would like to thank all those who have contributed to the production of this book, including:

Rob Allen, Linda Hubbard and the Friends of Red House; Derek Baker; Grant Berry, Oliver Garnett, James Parry and Margaret Willes (National Trust Publications); Jane Bliss; Peter Blundell-Jones; Jeremy Capadose, Robert Morris, Tina Sitwell and Tessa Wild (National Trust); Nicolas Cooper; Peter Cormack and Amy Clarke (William Morris Gallery, Walthamstow); Sonia Crutchlow; Jean Davis; Lizzy Gray and Polly Powell (Chrysalis); Michael Hall; John Hammond; Jill Hollamby and Marsha Nicholson; John Kendall; Karan King, Robert Quarm and Carole Moulton (Red House); Sheila Kirk; Katy Lithgow; Jean Macdonald; John and Olive Mercer; Tristan Molloy (Kelmscott Manor); Andrew Saint; Prof. Shuichi Nakayama (Kobe University); Brenda Norrish;Linda Parry and Roxane Peters (V&A); Dr. Sarah Rutherford; Jessica Sutcliffe; Frances Sweeny (Bexley Local Studies); Yasuko Suga; Malcolm and Sheila Young; William Morris Society.

PLACES TO VISIT

National Trust:
For opening times see www.nationaltrust.org.uk
or the National Trust Handbook

Red House,
*William Morris' first home and Philip Webb's first
commission*
Red House Lane, Bexleyheath, DA6 8JF

Standen,
Philip Webb's last commission
West Hoathly Road, East Grinstead, West Sussex
RH19 4NE

Stoneacre, home of Aymer Vallance (occupied as a
private residence, special arrangements apply)
Otham, Maidstone, Kent ME15 8RS

Wightwick Manor, home of Sir Geoffrey Mander
Wightwick Bank
Wolverhampton,
West Midlands
WV6 8EE

Hardwick Hall
Doe Lee
Chesterfield
Derbyshire
S44 5QL
01246 850430

Ightham Mote
Ivy Hatch
Sevenoaks
Kent
TN15 0NT
01732 810378

Chastleton House
Chastleton
nr Moreton-in-Marsh
Oxfordshire
GL56 0SU
01608 674355

*Other places to visit and societies associated with
William Morris and the Arts and Crafts Movement*

Kelmscott Manor,
William Morris' last house
Kelmscott, Lechlade, Gloucestershire GL7 3HJ
Telephone 01367 252486
www.kelmscottmanor.co.uk

Kelmscott House,
*Morris' London house, part of which houses the William
Morris Society & Museum (International)*
26 Upper Mall, Hammersmith, London W6 9TA
Telephone 0208 741 3735
www.morrissociety.org

William Morris Gallery,
Morris' family home in 1840s–50s
Water House, Lloyd Park, Forest Road,
Walthamstow, London E17 4PP
Telephone 020 8527 3782
www.lbwf.gov.uk/wmg

Friends of Red House
www.friends-red-house.co.uk

William Morris Society
www.morrissociety.org

Society for the Protection of Ancient Buildings
www.spab.org.uk

PICTURE CREDITS

Page numbers in **bold** denote illustrations

Abercrombie, Patrick 136
Aberdeen, Lady 117
Aberleigh Lodge 22, 75, 102, **102**, 104, 122, 131-2
Adey, Mrs 101
All Saints (Margaret Street, London) 28
Alleen, Bill 138
Allen, Rob 145, 146, 147
Allingham, William 81
Apple design 140, 143
April Love 46, 81
Arisaig House (Invernesshire) 95
Art Nouveau 109
Art Workers' Guild 113, 119
Arts and Crafts movement 109, 113
Attlee, Clement 132

Bailey, Henry 75
Baillie Scott, Mackay H. 115
Baker, Derek 144, 145
Baker, Sir Herbert 9, 126
Baldwin, Stanley 125, 128
Beale, James S. 99
Bean, Alfred 20, 106, 122
Beardsley, Aubrey 105, **111**
Bell, Robert Anning 115
Bell, Sir Isaac 95
Bell Scott, William 77, 88
Belle Iseult, La 12, 37, 66
Benfleet Hall (Surrey) 16
Bess of Hardwick (Elizabeth Shrewsbury) 52
Bexley **8**, 19, 20
Bexley Civic Trust 144
Bexley Council 126, 146
Bexley Heath (painting) **20**
Bexley Heritage Fund 146
Bexley Heritage Trust 145
Bexleyheath 19, **20**, 21, 105-6, **136**
Bexleyheath Golf Club 122
Bexleyheath Railway Project 106
Bijutsu Shinpou (Art News) 115
Biling, John 16
Bishopsgate Institute 115
Blomfield, Ivor 144, 145

Bodley, George Frederick 25
Brandon Estate (London) 136
Brill, Hans 144
British Institute of Social Service 117
Browne, Robert 72
Burden, Elizabeth (Bessie) 53, 86-7, 95
Burden, Jane *see* Morris, Jane
Burges, William 53
Burgkmair, Hans 46
Burne-Jones, Edward 11, 12, 14, 39, 66, 79, 81, **92**, 96
 affair with Maria Zambaco 96
 The Backgammon Players **58-9**, 60
 caricatures of Morris **90**, **91**
 Green Summer **82-3**
 The Knight's Farewell 46
 repairing of marriage 99
 and Sir *Degravant* mural 37, **44-5**, 47, 51, 66, **72**
Burne-Jones, Georgie (wife) 14, 49, 56, 65, 72, 73, 81, 86, 90, 95, 96, 97, **97**, 111, 118
Burne-Jones, Margaret (daughter) 96
Burne-Jones, Philip (son) 76, 86
Butterfield, William 25, 28

Caine, Hall 102, 104
Callard, Miss 140
Camden Society 47
Campfield, George 73, 79
Cardiff Castle (Wales) 53
Celtic Twilight 109
Chambers, William 20
Chapman, Jane 68
Charlesworth, Edmund 102
Chastleton House (Oxfordshire) 29, **31**
Chaucer, Geoffrey
 Canterbury Tales 60
 Legend of Goode Wimmen 52
 Parlement of Fowls 76
Chorley, Lord 132
Christchurch chapel (Bexleyheath) 72
church building 25
Clifford, H.P. 113
Cobbett, William 20
Cobden, Jane 117-18

Cooke, Conrad 109
Cooper, Charlotte 68
Cornforth, Fanny 69, 88, 96
Country Life 123
Crane, Walter 119
 Red House Garden **120-1**
Cray design 143
Crayford 149
Crutchlow, Sonia 145

Daisy design 7, 51, **51**, 79, **81**, 102
Danson Park 29-20, 106, 122
Dantis Amor (Rossetti) 38, **42**
Davis, Jean 144
de Morgan, William 149
Defence of Guenevere and Other Poems, The (Morris) 12
Diosy, Arthur 109
Docklands Development Corporation 141
Dresser, Christopher 105
Drury, Paul 145
Dürer, Albrecht 46

Earthly Paradise, The (Morris) 90, 93, 95
East, Alfred 109
English Heritage 145
Eyck, Jan van 49

Faulkner, Charles 14, 39, 65, 66, 71, 73, 86, 93
Fawcett, Millicent 117
Ferrers, Earl 128
Firm, The *see* Morris & Co.
Follows, John 22
Ford, Onslow 109
Friends of Red House 145, 146, 147
Froissart Chronicles 7, 49, 51
Fruit design 79, 81, **93**
furniture (Red House) 35-9, 79, 140
 antique items 37
 chairs 36, **36**, **37**, 101
 dining room dresser **49**
 settle 37-9, **40-1**, 48, **67**, 123, 137-8

Gallienne, Richard le 109

gardens 55-63, 144
 fruit trees 56, 63
 herbers 56-7
 inspiration for Morris's wallpaper designs **54**, 61, 63
 map showing layout **56**
 originality of 60
 planting 56, 57, 63
 use of wattle fencing 56
Gibson, J.S. 110
Gills, Emmanuel 22
Girouard, Mark 137
Go, Diagoro 110
Godfrey, W. Scott 122-3, 124
Golden Lilly design 143
Great Baldersby (Yorkshire) 28, **28**
Great War 122
Green Dining Room (V&A) **94**, 95
Green, Stephen 22
Green Summer (Burne-Jones) **82-3**
Gregory Jones, David 134, 136, 138, 140
Guildford Cathedral 119

Haite, George 109
Hall, Michael 28
Hall Place (Bexley) 19, 149
Hardwick Hall (Derbyshire) 52
Harrods 126
Hayfield 81
Heathcote, Eliza 101
Heathcote, James Arnold 101
Heathcote, Marion 101
Hills, Thomas C. 128, 131, 132
Holder, Richard 145
Holiday, Catherine 95
Holiday, Henry 95
Hollamby, Doris 134, **135**, 140, 144, 145, 146, 147
Hollamby, Jill 143, 146, 147
Hollamby, Ted 132-3, 134, **135**, 137, 141, 144, 145
Holloway, Antony 137
Holme, Charles J. 105, 106, 109, 110-11, 113, 117
Honeysuckle design 143
Horniman Museum 115
Horsfall, Dr. Alfred 125, 126, 128
Horsfall, Gertrude 126

Horsfall, Thomas C. 126
Howard, George (later Earl of Carlisle) 95
Howard, Rosalind (Countess of Carlisle) 117
Hughes, Arthur 46, 73

'If I Can' bird and tree hanging 49, 51
Ightham Mote (nr Sevenoaks) 85
International Exhibition (1862) 76-7, 119
Ionides, Constantine 96
Isle of Dogs 141
Iwamoto, Kosaku 110

Japan Society 109
Jasmine Trail design 61
Jekyll, Gertrude 63

Kelmscott Manor from the Summer House **62**
Kelmscott Manor (Gloucestershire) 29, 35, 37, 53, 63, 98, 146, 149
Kelmscott Press 109, 119
Kent, William 16
Kipling, Rudyard 9, **9**, 96, 128
Kirk, Sheila 25, 85

Landmark Trust 145
Lane, John 109
Lansbury, George 128
LCC (London County Council) 136
Le Corbusier 136
Lees-Milne, James 128, 131
Legros, Alphonse 88
Liberty, Lazenby 109, 144
Liberty's 109
Life and Death of Jason, The (Morris) 93
Life of William Morris, The (Mackail) 113
London County Council *see* LCC
Lovers Listening to Music **76**
Lutyens, Sir Edwin 9

MacCarthy, Fiona 39
Macdonald, Agnes 81
Macdonald, Alice 53

Macdonald, David **131**, **135**, 137, 138
Macdonald, Jean **131**, **135**, 136, 137, 138, 140, 141
Macdonald, Louisa 81
Macdonald, Ramsay 9, 126, 128
Mace, Alfred 22
Mackail, Jack 48, 81, 113, 124
McMahon, Penny 145
Maddox Brown, Emma 14, 71
Maddox Brown, Ford 12, 14, 46, 65, 66, 87, 88, 95, 96
Mander, Sir Geoffrey 132, **133**, 147
Marigold design 143
Marriott, Charles
 Modern English Architecture 124
Marshall, Peter Paul 72
Masefield, John 9, 128
Masquerade at the French Court **50**
Maufe, Edward 118, 119
Maufe, Henry 117, 119
Maufe, Herbert 118
Maufe, Hilda 118, 128
Maufe, Maude 117, 118, 119
Medieval Society 53
Menpes, Mortimer 109-10
Meredith, George 88
Millais, John Everett 69
Morris & Co. (The Firm) 71-3, **71**, 76-7, 79, **80**, 81, 90, 93, 95, 99, 109, 110, 123
Morris, Jane (nee Burden) (wife) **11**, 31, 51, 66, 68, 69, 71, **74**, 75, 76-7, **89**, 95
 affair with Rossetti 97, 98
 background and character 14
 drawing of by Rossetti 88, 90
 and the Firm 95
 ill-health 86, 87
 marriage 12, 14
Morris, Jenny (daughter) 71, 72, 81
Morris, May (daughter) 9, 51, 63, 68, 76, 81, 91, 95, 109, 113, 126, **127**, 128
'Morris' style 99
Morris, William **6**, **92**
 birth 11
 and birth of daughter 71
 caricatures of by Burne-Jones **90**, **91**

character and appearance 14, 87
 daily workload 93
 death 110
 and *The Earthly Paradise* 90, 93, 95
 engagement and marriage to Jane Burden 12, 14
 experiments in embroidery 49
 finances 81, 93
 and the Firm (Morris & Co) 71-2, **71**, 73, 81, 93, 99
 and furniture design 35-7
 and garden design 60
 hatred for the aesthete 109
 influence of 110-11
 interview for *The Studio* 110
 and Kelmscott 98
 leaving of Red House and reasons 87-8, 93
 member of volunteer militia corps 75
 and music 36
 notebook 68-9, 76
 painting career 11-12, 14
 poetry 3, 12, 48, 90, 93, 95, 97-8
 repairing of marriage 99
 selling of picture collection 81
 and Socialism 117, 124, 134, 137
 and Society for the Protection of Ancient Buildings 99, 141, 143
 wallpaper designs **54**, 61, 63, 79, 81
 and wife's affair with Rossetti 97, 98
Morte Darthur, Le (Malory) 48
Mount Stewart (Scotland) 53
Muff *see* Maufe
Murray, Charles Fairfax 10
Muthesius, Hermann
 Das Englishce Haus 123

National Assistance Board 128
National Trust 7, 126, 128, 131, 132, 144, 147
New Drama 109
New, Edmund 113

New Woman 10
Newill, Mary 113

Oxford Union 43
 murals 12, **13**

Parry, Linda 145
Pavillion, Charles 20
Pevsner, Nikolaus 136
 Pioneers of Modern Design 124
Poynter, Edward **94**
Pre-Raphaelite Brotherhood 11
Prinsep, Val 95
Pugin, Augustus 25

Race, Ernest 140
Rae, George 81
Read, Herbert 136
Red House
 acquisition by National Trust 147
 Appeal to save 7, 9, 128-9
 building on land surrounding 131-2
 building of 16
 cost of site and building 22
 decision of Morris to leave and reasons 87-8
 description of by anonymous visitor 77, 79
 description of in *The Life of William Morris* 113, **113**
 downsides to 140
 exterior **18**, **19**, 22-3, 24, **24**, **26-7**, 28, **116**, **122**, **130**
 entrance door **142**
 gardens *see* gardens
 well-head **148**
 windows 23, 24, **24**, 75, **78**, 79, **79**
 growth in reputation and interest in 123-4
 influences on 25, 28-9
 interior 23-5, **23**, 28-9, **100**, **101**, 112
 bedrooms 29
 ceilings 43, **64**
 cellar 31-2
 changes made under Godfrey's ownership 122-3

changes made under
 Holme's ownership 106,
 107, 108, 109
changes made under
 Maufe's ownership 118-19
changes made under
 Toms/Hollamby
 ownership 133, 143-4
changes made under
 Macdonald's
 ownership 138, 140
decorative scheme 39,
 43-6, 53
dining room 29, **103**
drawing room **104, 138**
fireplaces 24, **24,** 31, **117**
furniture *see* furniture
glass planes with
 signatories 106, **115**
kitchen 31
northward orientation of
 rooms 29, 31
painted mottoes 46
picture collection 46-7
staircase 23, **23,** 28-9, **34**
tapestries and textile
 hangings 47, 49, 51, 51-3,
 52, 53
wall paintings and murals
 47-9, **48**
lack of rear access 32-3
later days at 75-91
life at in early days 65-73
location of 19-22, **22**
opening up to public and
 tours 144, 145
owners after Morris 101-15,
 117-23, 125-6, 132-4, 137-
 44
plans for additional wing and
 failure to materialise 81, **84,**
 85-6
plans and architectural
 drawings for 16, **17, 32, 33**
public preservation of 144-7
requisitioned by National
 Assistance Board (1940)
 128-9
servants 68
setting up of trust 144-5
stable 29

Red House (Bexleyheath) Trust
 (RHT) 145, 146
Red House Garden (watercolour)
 120-1
Reynolds, Elizabeth 68
Reynolds, Thomas 68
Robinson, William 63
Roman de la Rose, Le 48, 60
Rose design 143
Rossetti, Christina (sister) 88
Rossetti, Gabriel 11, 12, 14, **15,**
 38, 51, 69, 87, 96
 affair with Jane Morris 97
 and Caine 102
 Dantis Amor 38, **42**
 death of Lizzie and
 withdrawal from social life
 after 76
 drawing of Jane Morris 88, 90
 and Fanny Cornforth 88, 96
 and the Firm 71-2, 93
 four 'Seasons' panels 38, **38,**
 39
 and Marie Spartali 96
 marriage to Lizzie Siddal 69
 mental deterioration of mind
 98, 99
 pencil sketch of Lizzie Siddal
 70
 poetry 98-9
 settle panels **40-1**
 watercolours on medieval
 themes 46
Royal Arsenal Co-Operative
 Society 128
Ruskin, John 77, **77,** 117

Saint, Andrew 136
St James's Palace 95
Saito, Makoto 110
Salt, Sir Titus 117
Sandroyd 95
Sano, Tsumetami 110
'Scenes from the Fall of Troy' 48
Scott, Sir Giles Gilbert 9, 25
'Scribbler, the' 96
Sette of Old Volumes 109
Shaw, George Bernard 9, **9,** 126,
 128
Shaw, Norman 110
Sherwill, Arthur 119
Siddal, Lizzie 12, 14, 38, 69

birth of stillborn daughter
 and depression 75-6
death 76
drawings and wall painting
 by **48,** 49, 76
pencil sketch of by Rossetti
 70
relationship and marriage to
 Rossetti 69
Simpson, Julia 147
Sir Degravant murals 37, **44-5,**
 47, 51, 66, **72**
Slaughter, June 145
Smith, R.C. Wellesley 124
Socialist League 119
Society for the Protection of
 Ancient Buildings (SPPAB) 85,
 99, 102, 126, 141, 143
Spartali, Marie 96
Standen (nr East Grinstead) 99
Stanhope, John Roddam
 Spencer 16
Stoneacre (Kent) **111**
Story of the Glittering Plain
 (Morris) 119
'Story of the Unknown Church'
 (Morris) 55
Street, George Edmund 11, 25,
 43
Studio, The 15, 110, 112, 115
Sugo, Hiromichi 110
Sunflower design 143
Swinburne, Algernon 12, 14, 73,
 73, 81, 88

Taylor, Robert 19
Tennyson, Alfred
 The Palace of Art 85
Tomimoto, Kenkichi 115
Toms, Dick and Mary 132-3, **135,**
 136, 137
Townsend, Charles Harrison 115
Townsend, Horace 115
Trellis design **54,** 61, 79

Unwin, Sir Raymond 9, 126, 128,
 136
Upton 19, 20, 22

Vallance, Aymer 110, 111-12, **111**
Victorian Society 145

Walker, Emery 113
wallpaper designs 61, 63, 79, 81,
 143 *see also* individual designs
Wardle, George 71, 93
Waring, Gwen 137
Washington Hall (Durham) 95
Water House (Walthamstow)
 146
Watkinson, Ray 144
Weaver, Laurence 123
 Small Country Houses of Today
 123
Webb, Philip **10,** 11, 14, 25, 79,
 81, 95, 96, 123, 124, 134
 architectural commissions
 after Red House 95, 99
 background and character 16
 design of Red House 16, 25,
 29, **30,** 33
 designs for additional wing
 to Red House 81, **84,** 85
 furniture design 49, **49,** 72
Wells, H.G. 9
Whistler, James 88
Whitechapel Art Gallery 115
Wightwick Manor
 (Wolverhampton) 81, 132, **133**
Wilde, Oscar 109
*William Morris, His Art, His
 Writings and His Public Life*
 (Valance) 112-13
William Morris Society (WMS)
 137, 141, 144, 145
Williams, Thurston 133
Woods, Janet 144, 145
Woodward, Benjamin 12
Woolwich Art School 128
Woolwich Council of Social
 Service (WCSS) 128
Workers' Education Association
 128

Yellow Book 109

Zambaco, Maria 96, **96**

Portrait of William Morris

by Cosmo Rowe *c.* 1895.